123446

DATE DUE

Ohio Dominican College Library
1216 Sunbury Road
Columbus, Ohio 43219

DEMCO

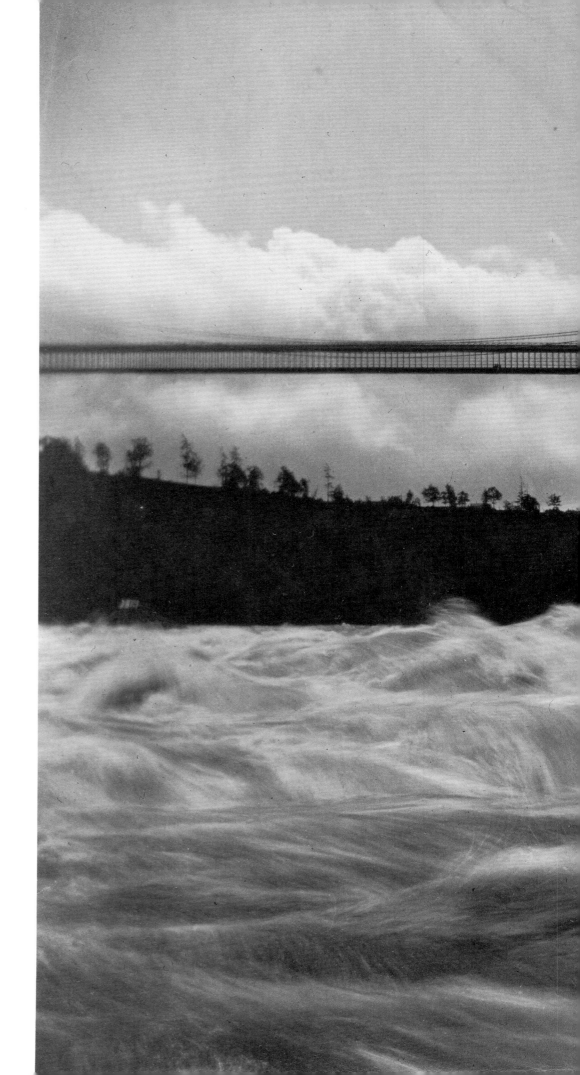

CHARLES BIERSTADT
The Rapids, Below the Suspension Bridge,
ca. 1870, albumen print,
17.8 x 23.5 cm (7 x 9 ¼ in.)

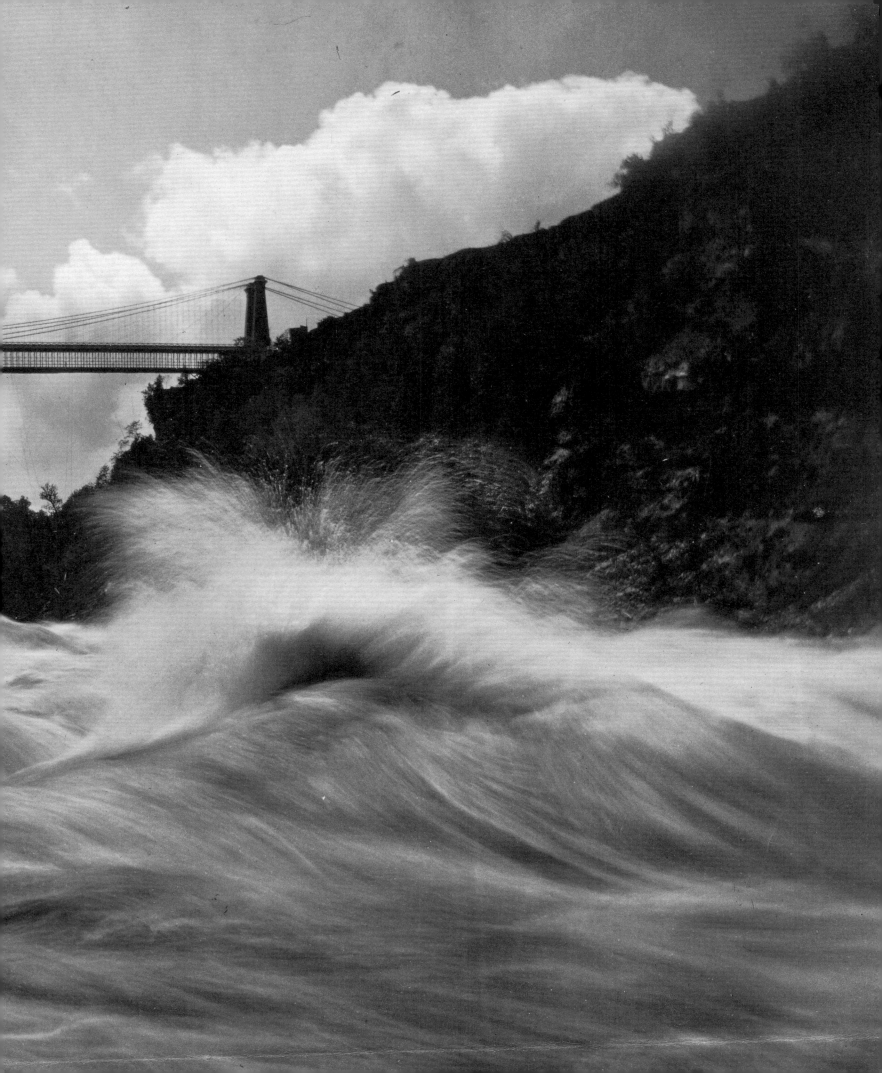

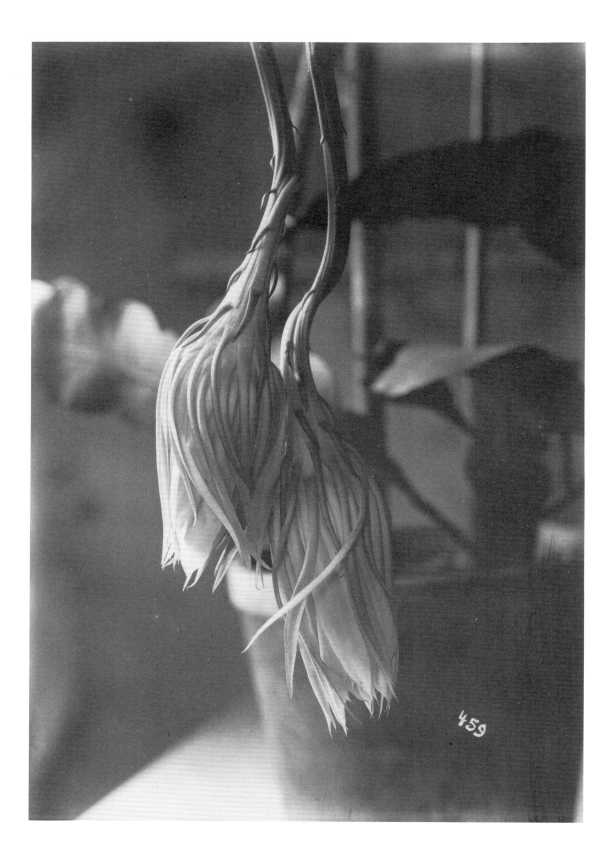

459

AMERICAN PHOTOGRAPHS

The First Century

From the Isaacs Collection in the National Museum of American Art

Merry A. Foresta

NATIONAL MUSEUM OF AMERICAN ART
SMITHSONIAN INSTITUTION

SMITHSONIAN INSTITUTION PRESS
WASHINGTON AND LONDON

Published on the occasion of the exhibition *American Photographs: The First Century, from the Isaacs Collection in the National Museum of American Art*, organized by the National Museum of American Art, Smithsonian Institution, and presented from November 22, 1996, to April 20, 1997. The exhibition is made possible by the Consolidated Natural Gas Company Foundation's partnership with the National Museum of American Art. This ongoing partnership is dedicated to preserving the nation's heritage through photography.

Curator: Merry A. Foresta

Editor: Janet Wilson
Designer: Steve Bell
Printed by Stinehour Press, Lunenburg, Vermont

ISBN 1-560987-18-9 (cloth)
ISBN 1-560987-19-7 (paper)

The National Museum of American Art, Smithsonian Institution, is dedicated to the preservation, exhibition, and study of the visual arts in America. The mu-seum, whose publications program also includes the scholarly journal *American Art*, has extensive research sources: the databases of the Inventories of American Painting and Sculpture, several image archives, and a variety of fellowships for scholars. The Renwick Gallery, one of the nation's premier craft museums, is part of NMAA. For more information or a catalogue of publications, write to the Office of Publications, National Museum of American Art, MRC-230, Smithsonian Institution, Washington, D.C. 20560.

Front cover: Frank A. Rinehart, possibly Adolf F. Muhr, *In Winter, Kiowa,* 1898

Back cover: William Bell,
Perched Rock, Rocker Creek,
Arizona, 1872

Frontispiece: Unidentified Artist,
Night-Blooming Cereus, Closed after Blooming, 1884

Library of Congress Cataloging-in-Publication Data
Foresta, Merry A.
American photographs : the first century / Merry A. Foresta.
p. cm.
Includes bibliographical references (p.).
ISBN 1-560987-18-9 (cloth). — ISBN 1-560987-19-7 (pbk.)
1. Photography, Artistic—Exhibitions. 2. Photography—United States—History—19th century—Exhibitions. I. Title.
TR645.W18N37 1996
779'.0973'074753—dc20 96-25338
CIP

Contents

Foreword

Painting and photography have long had a love–hate relationship. The conversation between them has often taken the form of an argument—usually a lovers' quarrel, ending in reconciliation and renewed attraction. Painting, with its hallowed traditions and institutions, dominated in the nineteenth century; photography, tainted by its industrial reputation, tried to fit in through flattery and imitation but always stretched the conversation further. In this century, however, the balance has gradually shifted as we come to understand that the camera more than the brush has determined how we understand the universe. Photography sets the terms and conditions of our visual culture, while painting is now uneasy and ambivalent about its place.

"American Photography: The First Century" takes us back to the beginning, to the 1840s when new photographic media took the country by storm. Not coincidentally, this clever invention of the industrial age prospered in part because of other technological advances, including railroads and steamships, newspaper printing presses, and the telegraph, which spread the word far and wide. Within weeks after the first daguerreotypes were made on American soil, photography studios started appearing across the land. Since then, a camera always seemed to be present to record the progress of the nation, the successes and failures of its people, the wilderness and the changes rapidly developing there.

As one looks at the collection assembled by Charles Isaacs, with its infinitely fascinating images, it is hard to understand how a Smithsonian museum dedicated to American art could have waited so long to acquire this key part of our visual history. The Smithsonian Institution was founded just seven years after photography was invented; a great many photos found their way into the natural history collections over the decades, but not into the art museum, which pursued the "higher, nobler" arts of painting, sculpture, and graphics.

By acquiring 303 photographs from the Isaacs Collection through purchase and gift, the museum has added images that are individually extraordinary while complementing the painting collection in specific ways, almost like missing pieces of a puzzle. Two sides of a single coin, photography and painting are distinct but inseparable parts of one visual history. Already it is impossible to study western landscapes by Albert Bierstadt and Thomas Moran without consulting geological-survey photographs by Timothy O'Sullivan and William Bell. Portraits of Indians and children, views of Niagara and Minnehaha Falls, pictures of gold mines and railroads, botanical and ethnographic studies, memorials to the dead, and allegories of motherhood—all these subjects and more exerted equal attraction for painters and photographers, producing related but different images. Neither paintbrush nor camera caught the action of the Civil War, but many great photographs of its aftermath help fill that void in our pictorial past. Having paintings and photographs from the same period is like hearing family stories told by two different members of the same generation. It increases understanding exponentially, helping us separate fact, point of view, and historical style.

The emphasis in the past decade on the subjects of art demands that photography assume a prominent place in our pantheon, for no other visual medium snares information as dense or as reliable about the past. But the more abstract qualities of style and expression are embedded in these images as well, guaranteeing that photography will retain its meaning as concerns shift again.

Merry A. Foresta, curator of the museum's photography collection since its inception in the early 1980s, marked the 150th anniversary of the invention of photography with a landmark exhibition of contemporary photo-art titled "The Photography of Invention,"

co-curated with Joshua Smith. That 1989 anniversary inspired a revival of early photography and led Foresta to organize historical exhibitions about panoramic photography and American daguerreotypes, always emphasizing the freshly modern aspect of the camera's image. She also began searching for the right historical collection for the museum and found it in the hands of Charles Isaacs. Now she celebrates the 150th anniversary of the Smithsonian by sharing with the public this major new acquisition.

Fortunately for the museum, Charles Isaacs had a collector's eye for striking images, a conservator's passion for pristine condition, a curator's appreciation of history, and a dealer's understanding of the market. Working near Philadelphia, he built a business selling early photographs, mainly French, to collectors and museums. The American pictures he found, including a surprising number from around Philadelphia, were usually by unknown or obscure artists and lacked a market. So he kept them for himself, trusting that one day their worth would be recognized. Over the years, these American views, portraits, and scenes of daily life grew into a major collection, including most of the artists now recognized as important, as well as others yet to be researched. Understated themes running through the collection index Isaacs's personal interests: eastern views to balance the great western landscapes, pictures of children, images that reveal the casual, unposed, spontaneous qualities captured by the camera lens—a distinguishing quality of photography.

Negotiations for the acquisition of this landmark collection led to a combination of generous gifts from Charles Isaacs and his parents, Dr. and Mrs. Charles Isaacs, and the museum's purchase of a portion of the collection. The discussions with Charles Isaacs also inspired a warm friendship that has made work on this exhibition and book so rewarding. We look forward to many more years of collaboration.

"Years of collaboration" is also the phrase that can be applied to the Consolidated Natural Gas Company Foundation (CNG), which recently announced a five-year partnership with the National Museum of American Art for the purpose of preserving and presenting the nation's heritage through photography. The CNG Foundation began its association with NMAA in 1987 by providing funds for the acquisition of 300 contemporary landscape photographs, offering a varied portrait of America's land at the end of the twentieth century. The foundation then contributed funds to exhibit the collection, publish it in a handsome book titled *Between Home and Heaven,* and circulate it nationwide. The newly announced partnership will provide support for the Isaacs Collection exhibition and book, for a World Wide Web site devoted to the museum's photography program, and many more photography initiatives through the year 2000. The CNG Foundation has our deepest appreciation for this remarkable encouragement and support.

Elizabeth Broun
Director
National Museum of American Art

Acknowledgments

Earlier moments of photographic practice in America appear to be of great interest today. Perhaps it is the dawning of the computer age, which prompts us to reflect on other moments of visionary awakening. Or we may be looking for something new clothed in the certainty promised by something old. Often we are most captivated by those photographic images that defy the categories of history or style we had first laid out for them. This was certainly the case when I first encountered the pictures in Chuck Isaacs's collection of early American photography, now part of the National Museum of American Art's permanent collection.

I am exceedingly grateful to Chuck for his help with the complicated activity of looking back at the work of one century from the vantage point of the next and for his support and good humor throughout this project. I could not have asked for a better adviser.

I would also like to thank Consolidated Natural Gas Company for its continued support of the photography program at the National Museum of American Art. CNG successfully, and from a curatorial point of view very satisfyingly, extends the concept of corporate and museum partnership. In particular, I would like to thank Beverly Jones, vice president for external affairs and policy development, and Ray Ivey, vice president and executive director of the CNG Foundation, for their interest in the museum and American photography.

Many of the photographs in this exhibition are by unknown or little-known photographers. The importance of many subjects has now been lost to us. Consequently, our research led us to many individuals, historical societies, and museums. They provided not only information about the photographs but also enthusiastic encouragement for this project. I would like to mention a few individuals in particular. Andrew Robb, independent conservator, helped sort through and explain the variety of "types" included in the collection.

Scholarly assistance came from numerous individuals, particularly Clifford Ackley, curator of prints, drawings, and photographs, Museum of Fine Arts, Boston; Denise Bethel, specialist in charge, Sotheby's Photography, New York City; John Carnahan, Brattleboro Historical Society, Vt.; Leslie Calmes, assistant archivist, Center for Creative Photography, University of Arizona, Tucson; Michelle Delaney and Debbie Griggs, Division of Photographic History, National Museum of American History, Washington, D.C.; Paula Fleming, National Anthropological Archives, National Museum of Natural History, Washington, D.C.; Delores Morrow, Montana Historical Society, Helena; Barbara McCandless, assistant curator, Amon Carter Museum, Fort Worth, Tex.; Peter Palmquist, independent photo-historian, Arcata, Calif.; Sally Pierce, curator of prints and photographs, Library of the Boston Athenaeum; Jeff Rosenheim, curatorial assistant, Metropolitan Museum of Art; Sara J. Weatherwax, curator, Library Company of Philadelphia.

Others who provided invaluable assistance include Gail Kana Anderson, registrar, Fred Jones Jr. Museum of Art, University of Oklahoma, Norman; Barbara Beroza, collections manager, Yosemite Museum, Yosemite National Park, Calif.; Georgeanna Linthicum Bishop, assistant curator, Baltimore Museum of Art; Peter C. Bunnell, curator of photographs, The Art Museum, Princeton University; Chicago Historical Society; Ann Calhoun, archivist, and Dennis Fulton, collections manager, Baltimore and Ohio Railroad Museum; Ann Clifford, archives assistant, Society for the Preservation of New England Antiques, Boston; E. Jane Connell, curator of collections and exhibitions, Grand Rapids Art Museum, Mich.; William Copeley, librarian, New Hampshire Historical Society, Concord; Gordon Cotton, director, Old Courthouse Museum, Vicksburg, Miss.; Gary Edwards, Gary Edwards Photography,

Washington, D.C.; Lynne Fonteneau, Williams College Library, Williamstown, Mass.; Kirsten Froehlich, curator, Harriet Beecher Stowe Center, Hartford, Conn.; Douglas M. Haller, museum archivist, University Museum, University of Pennsylvania, Philadelphia; Michael Hargraves and Anne Lyden, Getty Center for the History of Art and the Humanities, Santa Monica, Calif.; David A. Jackson, county historian, Litchfield, Ill.; Olivia Lahs-Gonzales, curatorial assistant, Saint Louis Art Museum; Craig Laing, Haverhill Public Library, Haverhill, Mass.; Alison Kemmerer, assistant curator, Addison Gallery of American Art, Andover, Mass.; Carole C. McNamara, collections manager, University of Michigan Museum of Art, Ann Arbor; Christine Montgomery, State Historical Society of Missouri, Columbia; Nelson Morgan, Hargrett Rare Book and Manuscript Library, University of Georgia, Athens; Leslie Nolan, Museum of the City of New York; Carolyn Peter, Mellon intern, Herbert F. Johnson Museum of Art, Ithaca, N.Y.; John Pultz, curator, Spencer Museum of Art, University of Kansas, Lawrence; Linda A. Ries, head, appraisal section, State Museum of Pennsylvania, Harrisburg; Karin Rothwell, assistant to the registrar, Hood Museum of Art, Dartmouth College, Hanover, N.H.; Brooks Johnson, curator, and Irene Roughton, associate registrar, Chrysler Museum, Norfolk, Va.; Josephine Rupe, director, Dale Schaffer, historian, and the volunteers of the Salem Historical Museum, Ohio; Aaron Schmidt, Boston Public Library; Wendy Shadwell, curator of prints, New-York Historical Society, New York City; Terry Shaw, chairman, and George Marple, superintendent of the Friends of Bonaventure Cemetery, Savannah, Ga.; Stanwyn Shetler, National Museum of Natural History, Washington, D.C.; Carolyn Singer, Haverhill Historical Society, Haverhill, Mass.; Rachael Stuhlman, head librarian, and Becky Simmons, assistant librarian, and Joe Strubel, archivist, George Eastman House, Rochester, N.Y.; David Travis, curator of photographs, Art Institute of Chicago; Mario Vasquez, assistant collections manager, California Museum of Photography, Riverside; Elisabeth Wilterdink, librarian, Silsby Free Library, Charlestown, N.H.; Terry Winschel, historian, Vicksburg National Military Park, Miss.; Kelly Woolbright, graduate assistant, McKissick Museum, University of South Carolina, Columbia; Georgia W. York, registrar, Mystic Seaport Museum, Conn.; Georgianna Ziegler, research librarian, Folger Shakespeare Library, Washington, D.C.; Sara Zumwalt, director, Litchfield-Carnegie Library, Litchfield, Ill.

My greatest debt is to my colleagues at the National Museum of American Art. Lynn Putney, collections manager for graphic arts, and her assistant, Denise Dougherty, managed the collection with skill and good humor; conservator Kate Maynor oversaw the condition of the photographs; librarian Pat Lynagh showed unbelievable patience even with the oddest of questions; the exhibition was designed by Robyn Kennedy; Martin Kotler supervised the framing; NMAA interns Leo Costello and Susan Nalezyty helped with the early stages of the exhibition; the catalogue was designed by Steve Bell, and edited with superb skill, finesse, and patience by Janet Wilson.

Two people deserve special mention. Christine Donnelly-Moan assisted me on all aspects of the exhibition. Her dedication and contribution to the project were manifested in many ways. Judith M. Moore, who graciously volunteered her research services, was equally indispensable. While all exhibition projects are collaborative in nature, few have been as satisfying as this one. My thanks to my assistants, colleagues, and friends for making this possible.

—Merry A. Foresta

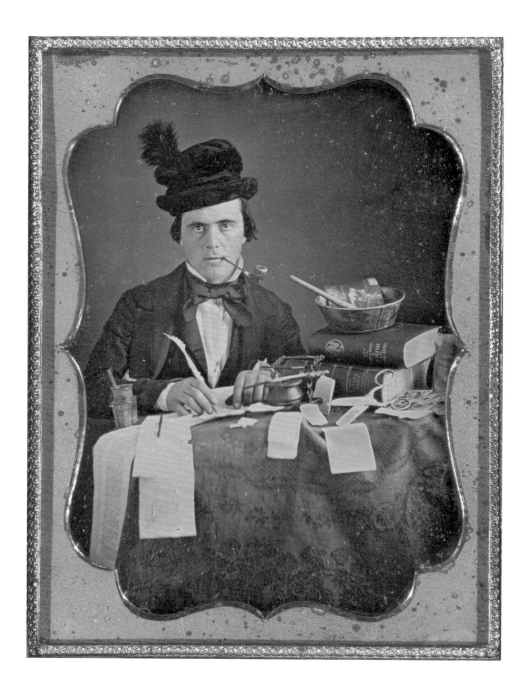

Unidentified Artist,
Editor, ca. 1855,
daguerreotype, quarter plate
Gift of Charles Isaacs

American Photographs: The First Century

Merry A. Foresta

The young democracy of America embraced the potential of photography from the moment its invention was announced. The nation eagerly welcomed a medium that functioned as both an effective witness and a powerful new art. Photography, first in the form of the mirrorlike daguerreotype, served not only as a reflection of the world around it but also as a validation of what that visual world—"measured by the angle at which [man] looks at objects," according to Ralph Waldo Emerson—meant to society at the time.[1] During the next hundred years, as our perceptions of the medium changed, turning an awe-inspiring new process into an accepted way of recording and interpreting the world, the relationship between photography and American culture was struck and held firm. *American Photographs: The First Century* is less an attempt to identify an indigenous and exclusive "American" style of photography than it is a reconsideration of the medium as a powerful force in the development of American visual culture.[2]

It is also an opportunity to reconstitute the meaning of photography in nineteenth- and early-twentieth-century America. This is a more complex enterprise than it might seem. Since its introduction to America, photography has cut across many lines, attracting diverse practitioners and audiences. Here the medium developed through the cross-cultivation of many activities. Art, documentation, science, business and advertising, entertainment: the variety of purposes for which the camera was used during its first century suggests the growing influence of a large, many-faceted photographic archive. This exhibition, comprising images chosen from the Charles Isaacs Collection recently acquired by the National Museum of American Art, is not intended as a comprehensive account of the history of photography in America, nor is it simply a recognition of individual connoisseurship. Rather, it offers an opportunity to reconsider and revitalize the way we look at photographs.

The frequent intersection of photography and art has been at the heart of a debate over a century and a half old concerning their compatibility. In America, discussion about which discipline photography would serve—art or science—was fittingly introduced by painter and inventor Samuel F. B. Morse. After seeing the product of another painter and inventor Louis Daguerre's experiments with optics and chemistry in Paris in the late winter of 1839, he wrote home to the United States that he had seen in the Frenchman's small images on silver-coated copper plates "one of the beauties of the age."[3] The new art of the daguerreotype was, in Morse's mind, as comparable to the etchings of Rembrandt as to the distant images of the moon made possible by the perfection of the telescope by Caroline Herschel and her brother Sir Wiliam Herschel. Perhaps realizing a new source of romantic inspiration, Edgar Allan Poe regarded photography as "the most important, and perhaps the most extraordinary triumph of modern science...[that would] exceed the wildest expectations of the most imaginative."[4] "Drink up your aquafortis and die!" was still another writer's advice to American artists bracing for the new medium's arrival.[5] Having thus gained his readers' attention, the author of "New Discovery in the Fine Arts" also issued a challenge. Proclaiming photography "a discovery...that must make a revolution in art," he eagerly demanded, "In what way, in what degree, will art be affected by it?"[6]

It is, of course, a question we are still wrestling with. Until recently, we have been more interested in how this question was answered in photography's second century rather than its first. In the early decades of this century, photographer, gallery proprietor, and publisher Alfred Stieglitz instilled in the photographic community—or the part of it that interacted with museums and wrote about art and photography—a prejudice against images

that did not fit modern aesthetic expectations. In an effort to win acceptance in art museums and the marketplace, neat categories of photographic discourse were developed around the question "Is it art?" A critical terminology was devised that distinguished pictures—art—from photographs—document—and a canon of masters and masterpieces was created separate from the larger, more anonymous, visual archive.[7]

What, however, was the original impact of a technology that could translate the actual into the pictorial? The 1989 retrospective exhibitions occasioned by the 150th anniversary of photography's first public announcement suggested that the medium had a longer, broader history that included images and photographers who may have been missed as we rushed through the initial telling.[8] To a great extent, the integrity of the photographic image—defined earlier by histories written during photography's centennial anniversary—now mattered less than its ability to transact between other disciplines and media.[9] The technical evolution of the medium and the creative achievements of its most talented practitioners, as well as photography's unique quality of cross-functionality, were joined as issues of equal importance. For example, though tintypes have long been treated as a kind of American folk art of photographic form, in these newer, broader histories, vernacular types and aesthetic prints received an equal share of critical attention. At the same time, photography's antecedents could be caught in the "butterfly net" of art history since the Renaissance, and its invention regarded as coincident with major developments in Western intellectual thought.[10]

By an inevitable irony, some of the most unruly works of photography—the unsigned photographs of crime, science, or commerce, for example, or the multitude of snapshots created by Kodak's pictorial army—earned an important place in the realm of art. The model of "'new' old photographers" and anonymous images was in part provided by iconoclastic collectors such as Samuel Wagstaff.[11] If Julien Levy, hoping to emphasize the scientific aspects of art, had unsuccessfully tried to intrigue an American audience with a surreal mix of daguerreotypes and contemporary photography in his New York gallery in the 1930s, in the late 1970s Wagstaff turned his ideas into popular touring exhibitions.[12]

Conversely, the earliest photographs, often having been ripped from their historical context—quite humble and utilitarian ones at that—for a more lofty aesthetic purpose, were reunited with their origins. Landscapes by Timothy O'Sullivan, for example, made for the government-sponsored western surveys, might seem less costumed as great art but more available to discuss geology, archaeology, commerce, and philosophy. To the constructed beauty of an anonymous daguerreotype portrait might be added the larger perception of a new technology, one, in the words of Albert Sands Southworth, "better suited to compile a new view of art in life."[13] Other questions were raised. Why, we began to ask, had photography not been included in the major art histories of the nineteenth and twentieth centuries? Now in the digital homogeneity of an electronic age, when the questions "What is art?" and "Is photography art?" seem to be inextricably linked by new media at least as revolutionary as, and infinitely more prodigious than, the first daguerreotype, we search for a more integrated history of picture-making.[14]

The recent coming of age of research in the history of American photography joins a more general postmodern cultural discourse. The unsystematic, if not quirky, way in which nineteenth-century photographs have survived or passed into institutions for study means that many images have been removed from the context of their original presentation. Serious inquiry into the effects of an all-inclusive environment of photographic imagery has made the medium's intersection with other critical discourses inevitable. Just as the study of American history has benefited enormously from the work of feminist, Marxist, and cultural historians, so, too, has our understanding of the development of photography. In the last decade, the suggestion that our image of the world is made up of images has required a reconsideration of modernist ideals of originality.

Twentieth-century modernism—the stuff of Stieglitz and Newhall—directed photography to define the photographic, those qualities unique to the medium, as compared, for example, with those qualities that distinguish painting. Upon reconsideration, the most captivating photographic images, such as a daguerreotyped still life of a pumpkin, sweet potato, and a book of Shakespeare (p. 166), seem to be those that defy the categories of history or style first laid out for them—those images that not only present solutions to some technical problem or serve some utilitarian purpose but also lift themselves into the less explainable, more evocative categories of expression. Interest in style and

artistic intention have shifted to the question of how one conceives of the world. In the last decade, as chemical processes were challenged by electronic systems, the interrogation of the photographic experience has extended far beyond traditional topics of technique and content. The dialogue between connoisseurship and context rephrased the question "Is it art?" to "What kind of art is it?"[15]

To consider the first century of American photography is to confront the question of originality in all the arts. Added to a mid-nineteenth-century roster of useful inventions, photography, in the words of a writer for *The Crayon*—nineteenth-century America's foremost art journal—would "drive Juggling out of Art" because "the more minutely we see, the more we see."[16] The visionary vocabulary of the Transcendentalists, beyond identifying the poet with the seer, suggests connections between, in Emerson's words, "the act of seeing and the thing seen." He concluded: "Our age is ocular."[17] Within a few years, John Ruskin's call for a careful and devoted study of nature as a basis for artistic imagination inspired a generation of rebellious American artists committed to "no past, no masters, no schools."[18]

Invented by scientists and welcomed as art, photography, and the notion that it could serve as the mirror of God's works, suggested new possibilities. It was a medium that could serve both the reporter *and* the poet. Beyond its capacity as an expedient drafting tool, the medium encouraged American artists to dismiss the European classical tradition for a more determined realism.

As the bank of photographic images grew, it was also a tool for interpretation—in the words of Morse, "an exhaustless store for the imagination to feed on."[19] Simultaneously an original moment and a facsimile of the world, photography's "determined realism" provided a way of expressing ideas about how the world can be known—about truth and falseness, appearance and reality. The distinction between the real and a picture of the real became part of the creative equation itself. Interesting are the overlapping functions of the photograph as record, advertisement, source of information, and art. What, however, are we to make of images that, irrespective of how they appear to us now, were made by artists not intentionally working in an art tradition? In what way are we to understand such photography as both document and work of art? In what terms should we discuss it and how is it to be understood, both in relation to the photographic production of the nineteenth

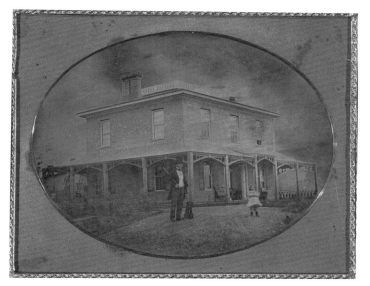

UNIDENTIFIED ARTIST, *Square House, Man, Child, and Dog on Lawn*

and early twentieth centuries and its meaning for us now? For some photographs—likewise for folk materials, tribal goods, and decoration—the question of "art" is so perplexing it may have outlived its usefulness.

The "inexhaustible store" of American photography suggests one way of ordering an answer.[20] Here, and evidenced by the various themes in the Isaacs Collection, the medium evolved as a means of accumulating things as ideas, a way of creating new worlds, a practice of cultural reckoning: daguerreotyped portraits and places, albums of war, government geological surveys, railroad commissions, family albums, archives of indigenous peoples, child laborers, collections of scientific specimens, camera-club expeditions, photographic salons. In the dense photographic weave of the social, the political, the economic, and the cultural, the individual image is a reference to a larger visual archive.

American photography began as an art woven from commonplace prosperity and created an inventory of everyday experience. Serving a new middle-class audience, photographers pictured what was near at hand and important as fact: the beloved child, the newest house, the promised progress of industry, the experience of loss. Family relationships were enacted for the camera. Occupations were pictured as both entertainment and advertisement. Seizing the challenge of depicting a new world without a long tradition of visual models, daguerreotypists engaged a realistic, vernacular style of plain expression. The sharply focused view of mid-nineteenth-century industry at Seneca Falls, New York (plates 5 and 6), in which both the industry and the

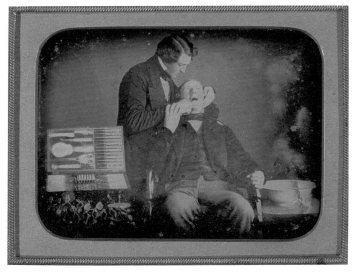

UNIDENTIFIED ARTIST, *Dentist*

method of recording it were new, encompasses the pure realism of the American Romantic movement.

Such an accumulation of images into a catalogue of people and places not only established photography as an art form of use to a wide audience but also linked the medium to the larger philosophical issues of the time. Although the particular reasons for making those images may now be lost to us—perhaps they served as lessons for a rising and prosperous democracy; perhaps they offer observations about the look of a nation, or the self-reliance of the individual in that state—they offer up an intensity of observation that goes far beyond mere description toward cultural expression.

The enormous production, both official and private, of photographic documentation of architecture, historic sites, and natural landmarks was to a certain extent fueled by the passion for documentation itself. In America the nineteenth century was a great period of taking stock, of retrospection and recovery as well as expansion, and photography was considered the truest agent for listing, knowing, and possessing, as it were, the significance of events. History, both personal and national, was collected as photographs. "George Washington slept here" is a fact made more evident by John Whipple's ca. 1855 photograph of the Cambridge, Massachusetts, house the general called home for two years (p. 164). Although by 1855 the house where Thomas Jefferson drafted the Declaration of Independence was already decked with signs announcing its importance, it nonetheless appears less a tourist trap than a dignified

memorial to American Independence in James McClees's photograph.

There is also a contradiction between the photographer's professed intentions (purely documentary) and the quality of the work itself. McClees's image of the Philadelphia waterworks at the base of Fairmount Park (plate 10) and James Ford's photograph of San Francisco's first telegraph office (plate 9) seem as stamped with personal expression as any in photography's first century. We might, for example, compare the minimal elegance used by McClees to describe a civic utility based on a natural resource with Ford's information-laden image, which even includes the time of day, for a patron whose new business was rapid communication. Belief in the definitive truth of the photograph, however, was granted with a wide margin of faith. That the photograph of the 1850s did not produce color or clouds or anything moving, that the world it depicted was largely unpopulated, was very quickly taken for granted, and such deficiencies were discussed almost exclusively in the context of the critical debate that focused on photography versus painting. While the photograph acknowledged the "beautiful and accurate,"

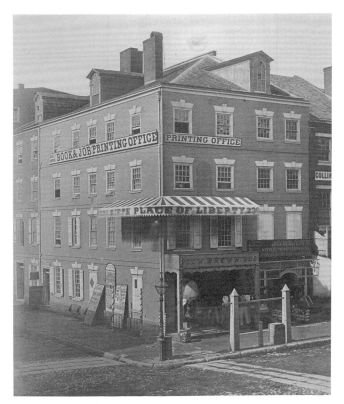

JAMES McCLEES, *Jefferson's House, Philadelphia*

16

Rembrandt Peale insisted that the "painter ha[d] sympathy with his subject."[21] It was, in fact, the very quality of unmediated verisimilitude that was perceived as photography's greatest weakness as an art form.

Perhaps, then, the greatest connection to historical context is seen in the vernacular photograph, characterized by the popular and the utilitarian. If the 1860 image of Brattleboro, Vermont (p. 153), tells us something about nineteenth-century commercial pride, it also speaks of the impulse in that period toward clearly defined, straightforward information. Oliver Wendell Holmes wrote in 1859 that photography was a kind of "skin" collecting: "Form is henceforth divorced from matter. In fact, matter as a visible object is of no great use any longer, except as the mould on which form is shaped. Give us a few negatives of a thing worth seeing, taken from different points of view, and that is all we want of it. Pull it down or burn it up, if you please."[22] For the practice of photography as a whole, Holmes's prediction for the future heralded the new modern equation of things and pictures of things. Nine years after an anonymous photographer made his view of prosperous Blake Block, it burned to the ground, an event noteworthy enough to lead another of the town's photographers, Caleb Lysander Howe, to produce a stereoscopic view of the destruction (p. 153).

In the course of the century there were other documentary projects. Mathew Brady daguerreotyped and photographed "representative" Americans in the plush parlors of his New York and Washington, D.C., studios. Rendered as lithographs by Francis D'Avignon, Brady's twelve portraits were published in 1850 as "The Gallery of Illustrious Americans." Brady also hung these portraits and others in his gallery exhibitions. Alluding to national events at mid-century, together the portraits claim a civic function for American photographs. Having oneself photographed, as did Mr. Samuel Wilkeson, a prominent New York journalist, ca. 1859 (plate 12), in the same style that Brady might have used for President Abraham Lincoln, Senator Daniel Webster, or artist John James Audubon, ensured membership in the larger historical scheme of national enterprise.

Archives of war were assembled. The Civil War, the so-called first modern war, was also the first to be thoroughly photographed. Some 1500 individual photographers produced thousands of images in urban studios and temporary locations in the field. Aside from the photographic portraits affordable to even the poorest

soldier, the public could purchase group pictures of important officers, scenes of camp life, marvels of military engineering such as bridges and fortifications, and battlefields. The great bulk of Civil War photographs form a kind of grand portrait of Union purpose. Battlefield photographs taken shortly after military action form a much smaller category. Photographers carrying cumbersome equipment kept their distance from the fighting, so almost no images exist that depict the action of battle. Though ironically the most often published, photographs of bodies rarely were taken; the ravage of war is more often seen in photographs of a natural landscape decimated by the firestorm of battle.

Albums of photographs form a narrative that transforms scenes of war into sacred memories. "Verbal representations...may or not have the merit of accuracy," Alexander Gardner wrote, but "photographic presentments of them will be accepted by posterity with undoubting faith."[23] In 1866, the year after the war ended, he published *Gardner's Photographic Sketch Book of the War*. Two volumes, with one hundred images by several photographers (printed along with the name of the maker of the negative and the print), each accompanied by a text written by Gardner, covered the entire war. Just as the term "sketch book" implies, he memorialized particular places, battlegrounds, and encampments with firsthand, accurate impressions. And though his self-imposed task was to gather "mementoes of the fearful struggle," the images, his own in particular, have a skillful plainness. Made after the fact of battle, images such as *Burnside Bridge, Across Antietam Creek* (p. 128) and

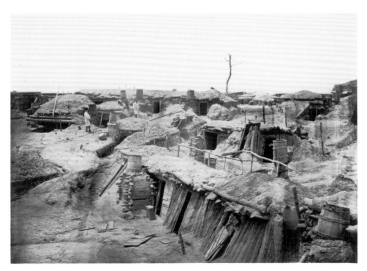

TIMOTHY O'SULLIVAN, *Quarters of Men in Fort Sedgwick, Known as Fort Hell*

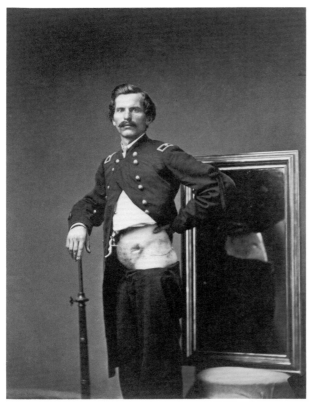

WILLIAM BELL, *General H. A. Barnum, Recovery After a Penetrating Gunshot Wound...*

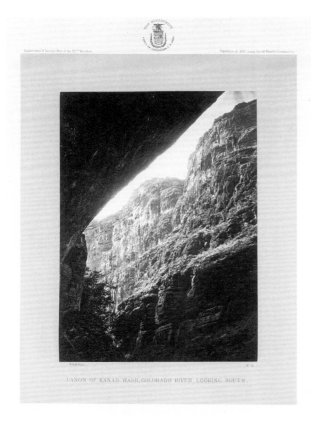

WILLIAM BELL, *Cañon of Kanab Wash, Colorado River, Looking South*

Timothy O'Sullivan's *Quarters of Men in Fort Sedgwick* are ironic landscapes, remarkable only for the dreadful conflict that took place there.

Retracing General William T. Sherman's celebrated route from Chattanooga to Atlanta and Savannah, George P. Barnard's album, *Photographic Views of Sherman's Campaign*, also pictures battlefields, ruined buildings, and forts, along with more scenic landscapes. Including sixty-one photographs made between 1864 and 1866 and a booklet with a narrative and maps, the album was presented as an art book, with richly toned albumen prints, each mounted on a separate page of heavyweight paper.[24] The ambiguity of the camera's truthful bias, which minutely detailed the "terrible distinctness" of war's effects, was enveloped in the tasteful execution.[25] It was a seamless integration of picture and information.

William Bell's description of "subjects created by war," however, provides a visual index to destruction different from the better-known albums.[26] The seven-volume *Photographic Catalogue of the Surgical Section of the Army Medical Museum*, begun in 1865, includes detailed case histories and fifty tipped-in albumen prints. Photographs of shattered bones and skulls display an appropriately clinical approach to the subject of scientific inquiry. The portraits of the wounds of survivors, however, demand the greatest attention to context. Bell's elegant studio-style "portraits" combine emotional detachment and unnerving physical intimacy. Formal science is linked with artistic formality. Precise, accompanied by detailed descriptions of the affliction and the appropriate medical procedure, the photographs were useful to medical researchers. Constructed as pictures, even as they were surrounded by the technical props of Bell's Medical Museum portrait studio, they distanced the subject, and the audience, from the horrible actuality. Like Brady's renderings of industrious citizens as heroic types, Bell's studio portraits of mutilated soldiers suggest the near-impossibility of simultaneous looking and seeing. How can one experience the pain of war and describe it rationally at the same time?

At the end of the war many photographers continued their relationship with the government and joined surveyors assessing the potential for western expansion. These photographers and others were also hired by the railroads, mining companies, Indian expeditions, or real estate developers. Their photographs, for the most part, are relatively close examinations of specific phenomena:

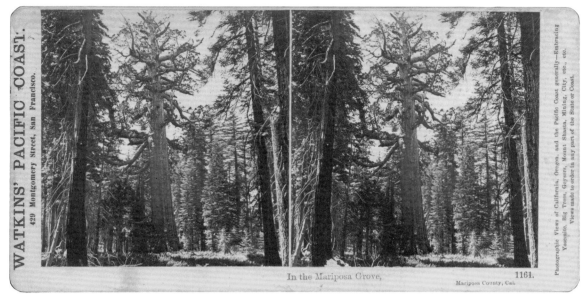

CARLETON E. WATKINS/I. W. TABER & CO., *The Grizzly Giant, Mariposa Grove, Yosemite*

the dome-shaped tufa mounds in Pyramid Lake, geyser mouths and pools. Going west, photographers described both the magnitude of the space and the details of location. It is human scale rather than nature's being measured.

A newly reverent attitude toward landscape, the so-called cult of wilderness, coincided with the opening of the West through exploration, and also with the production of photographs made outdoors in album-size publications for promotion of the survey enterprise. Aside from their aesthetic qualities, the images suggested ways in which the views might serve the needs of government institutions mapping and opening the West. Also sold as stereographs for the mass market and picture albums for Victorian parlors, pictures of giant trees, spouting geysers, balancing rocks, and breathtaking gorges were by the 1870s familiar staples of the popular picture trade. More than the illustrators and artists who accompanied the earliest expeditions, photographers injected proof of experience to the business of national expansion.

The expeditionary archive—in most cases a collaboration between photographer and survey team—was a comprehensive work to explore, catalogue, order, and then disseminate the accumulating mass of information about the landscape—information that was geological and geographical as well as sociological, economic, metaphysical, spiritual, and philosophical. By 1863 the American Pre-Raphaelite journal, *The New Path*, published by the Society for the Advancement of Truth in

Art, stressed photography and geology as providing the two chief guidelines for landscape painting. Especially as landscape, especially by photographers working for Clarence King, a geologist and charter member of the Society, photography introduced a more accessible and recognizable spirituality of natural forms properly recorded.

In some cases the purpose of the expedition was art itself. In search of material for his paintings, the artist William Bradford hired Boston photographers John Dunmore and George Critcherson to accompany his 1869 expedition to the Arctic. In what must have been

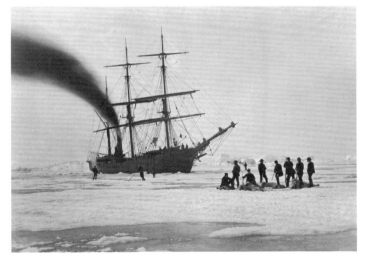

JOHN L. DUNMORE & GEORGE CRITCHERSON, *Hunting by Steam in Melville Bay...*

19

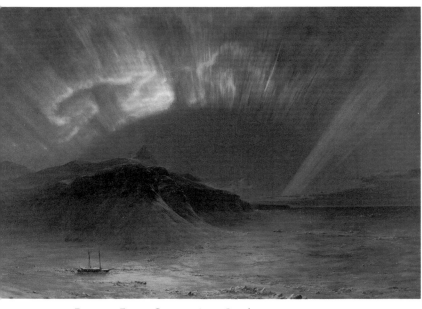

FREDERIC EDWIN CHURCH, *Aurora Borealis*

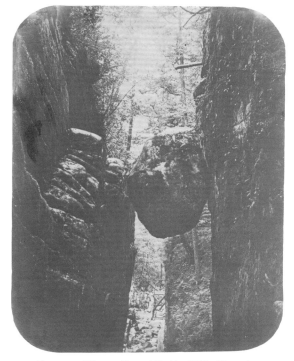

FRANKLIN WHITE, *Trapped Boulder, White Mountains*

extremely difficult for photographers with delicate equipment, frozen wilderness was, in this case, collected not as territory but as picture. Their sumptuous book, *The Arctic Regions Illustrated with Photographs taken on an Art Expedition to Greenland*, published in 1869, was offered for sale to the same discerning art collectors who might also own Gardner's or Barnard's albums or a painting by Bradford or Frederic Church. If the painters could occupy, both literally and critically, more artistic space, the photographer could offer a more enticing element: the tinge of the real that heightened any personal possession of the view.

Philadelphia landscape photographer John Moran, brother of the landscape painter Thomas Moran, wrote in 1865: "It is the power of seeing and deciding what shall be done, on which will depend the value and importance of any work, whether canvas or negative." And if, as he believed, the most important thing in art is to know what is most beautiful, "We claim for the photograph the ability to create imagery which calls forth ideas and sentiments of the beautiful."[27] How that beauty was determined was a complex arrangement of science, theology, and aesthetics.

Photographs also brought a pragmatism to pictorial conventions. If "happened upon" nature studies by painters such as Frederic Church and Asher B. Durand are the exception, they are the rule in photography. Matter-of-fact records of things, photographs beg us to look upon the subject bare and see in it an icon for the forces that shape the world in which we live. Franklin White's terse image of a trapped boulder, from his album of panoramic views of the White Mountains of New Hampshire, suggests the relative limits of

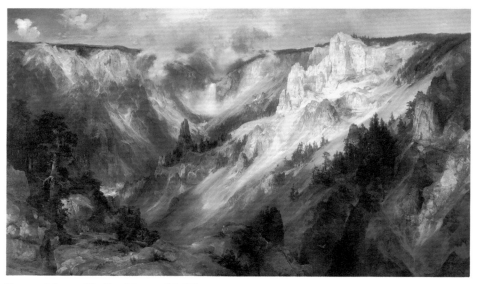

THOMAS MORAN, *The Grand Canyon of the Yellowstone*

space. The scale and sweep of Carleton Watkins's Yosemite vistas, fixed by the camera for contemplation, made to be hung on the wall, pose equally complex questions about the manner in which the things of our world are bound up in a larger natural discourse. Nowhere is the nineteenth-century conflict between the conventional and the empirical more sharply joined than here, in the frisson generated by a new medium as it enters a relatively new landscape. Simultaneously collecting, interpreting, and celebrating nature and the American landscape, the photographic medium synthesized various functions into "superb...illustrations" designed to induce "grand impressions."[28]

The scale of natural distance implied by the photographs *was* astonishing, often the result of contrast between the effect of detail and the sweep of distant view. As early as 1861, Watkins recorded the High Sierra of California with mammoth glass negatives—usually eighteen by twenty-two inches. While photographers such as Watkins, Eadweard Muybridge, and Charles Weed integrated painterly and literary landscape ideals

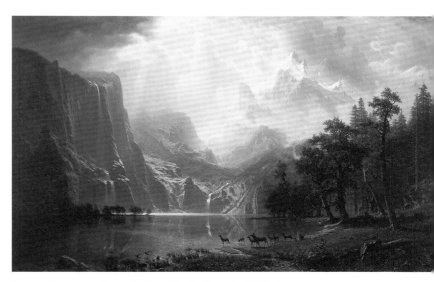

ALBERT BIERSTADT, *Among the Sierra Nevada Mountains, California*

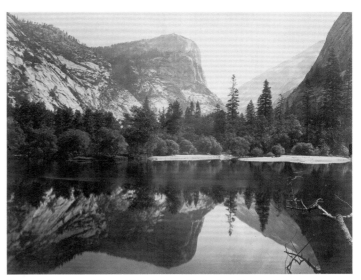

CHARLES LEANDER WEED, *Mirror Lake and Reflections, Yosemite Valley, Mariposa County, California*

and traditions into the making of photographs, their images in turn recharge the sublime cliché with some of its original conviction. W. H. Jackson's photographs of Yellowstone, or those of Yosemite taken by Watkins and Muybridge, in contrast to paintings by Albert Bierstadt or Thomas Moran, expose painterly stylization.

Reflections dominate. In Weed's 1865 view of Mirror Lake the reflection occupies about half of the surface image, assuming a tangibility that recalls the Swedenborgian world of correspondences that so dominated the mid-century.[29] The model of the western view was used by eastern landscapists. An unknown photographer's image of Echo Lake (p. 155), by 1870 a well-known New Hampshire tourist site, is an almost

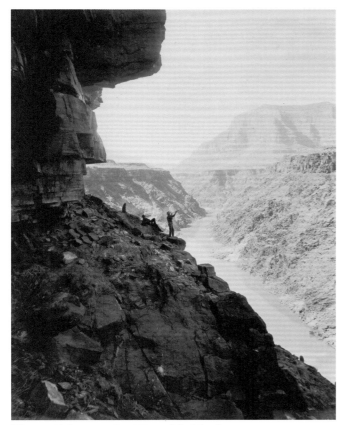

WILLIAM H. JACKSON, *Grand Cañon of the Colorado*

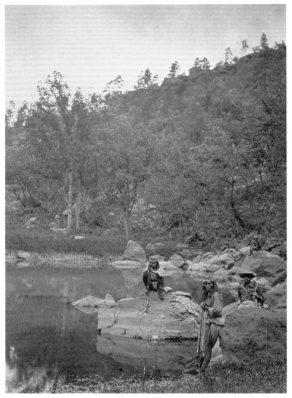

Timothy O'Sullivan, *View on Apache Lake, Sierra Blanca Range, Arizona, with Two Apache Scouts in Foreground*

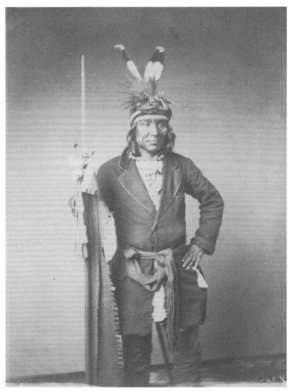

Julian Vannerson, *Shining Metal*

witty division of the landscape into real place and reflection. Equally a reminder of Thoreau's Walden Pond ("Sky water...a mirror which no stone can crack") and Emerson's more industrial metaphor of a "dial plate of the invisible," such photographs, along with painting parallels, were part of an integrated system of visual recognition. By the 1870s enough of the country had been pictured to suggest that it was known as much through image as through experience.

Photographs also collected and interpreted the vanishing presence of the Native American. As ethnographic photographs, they tell us a number of things—about domestic living, clothing, tools. John K. Hillers, working primarily for the Bureau of Ethnology, reminded his viewers that the regions were already home to native cultures. O'Sullivan's image of Apache scouts for the 1873 Wheeler survey is yet another way of suggesting not only the labor of survey but the act of photographic perception itself. Contrasting knowing and exploration—the difference between the scout and the photographer—the picture, as an unromantic version of the western experience, sets itself apart.

Julian Vannerson's portraits of Native Americans in Washington, D.C., were part of a more systematic effort. Throughout the late 1850s the U.S. government invited Native American delegations to Washington to negotiate treaties. Delegation photography was a routine part of every state visit, and many portrait studios, including that of James McClees, for whom Vannerson worked, profited from the business. Vannerson's task was to document the participants, not only for the profit he could make by satisfying public curiosity but also to document individuals whose way of life was vanishing. "The gallery of portraits includes those of some of the principal Chiefs, Braves, Councilors," advertised McClees. "To the student of our history, as additions to libraries and historical collections, and as mementoes of the race of red men, now rapidly fading away, this series is of great value and interest."[30] The collection, including the standing portrait of Shining Metal, a chief of the Mdewakanton Dakota, was offered as a bound volume or as separately mounted hand-colored prints. In spite of the coerciveness they represent—or perhaps, in an ironic reversal of intention, because of it—they possess a power of communication that reveals more than most conventional studio portraits.

The use of photography as a tool to aid in the classification of people and things was widespread in the 1880s

city street—took time to operate. The brief exposures of the Kodak promoted both speed and looseness. The "Kodak," as any picture made with the new camera technology was called, and its implied truth in candid spontaneity, led to a new conception of what photographic accuracy could mean. The camera joined the inventions of the wireless, telephone, phonograph, automobile, and airplane in a radically new world in which, it seemed, time and space had been conquered. It coincided, too, with the rise of "on the spot" newspaper illustrations (made originally in the form of wood engravings). Single images transformed themselves into personal and commercial archives by the thousands. How to maintain interest in the singularity of images when confronted with the power of the anonymous archive became the focus of artists who for the first time became self-conscious about making art.

At the turn of the century, photographers who aspired to art believed the medium's true aim was to record not facts but the impression of facts. There were now two functions combined in a photograph, one "as a record of truth, the other as a work of art."[33] Turn-of-the-century art photographers felt compelled to separate their activity from the broad spectrum of the medium's uses, viewing it as intrinsically superior to that of both the professional commercial photographer and the ordinary Kodak user.

In response to the industrial age and the dehumanizing implications of mass production, the Pictorialists extolled the photograph as an original, handcrafted object. They not only worked in silver but experimented with the effects of other, more complex processes. Exhibition prints of this era, such as George Seeley's *Still Life with Vase and Apples*, created by complex combinations of platinum and gum bichromate, used a grand scale and unprecedented depth of tone for powerful aesthetic effect. Like the Arts and Crafts movement, which stressed the dignity of work and the beauty of fine materials, photographers, still focusing on those subjects near at hand, sought to unite beauty and craft.

New aesthetic strategies were employed. Like other American artists during this period, photographers

and 1890s. To the archives of indigenous peoples were added images of immigrants and child laborers. Lewis Hine traveled the country photographing children working in fields, mills, mines, and city streets. He was equally familiar with Alfred Stieglitz's New York gallery, known as "291," and his journal, *Camera Work*, both of which established a seriousness in fine-art photography and strategy upon which the expanding photographic community drew. "Now there are two ways to look upon your work," Beaumont Newhall wrote to Hine in 1938. "The most obvious is the documentary or historical approach—the other is the photographic."[31] Though Hine performed his artistic labors within the institutional framework of Progressive reform movements, which included public lectures and publications as well as picture-making, he based his conception of photography as social work on an exacting aesthetic theory, the documentary.[32] Avoiding artistic rhetoric—the ideal photographic document would appear to be without author or art—Hine frees us to regard the photographs of child-labor practice as life itself.

By 1888, with the appearance of George Eastman's hand-held camera, everyone had the means to document his or her life and surroundings, as well as the potential to express finer aesthetic inclinations. The instancy of the snapshot popularized photography in a way that had not occurred since the daguerrean era. The process of the earlier view camera—in wilderness, suburb, or

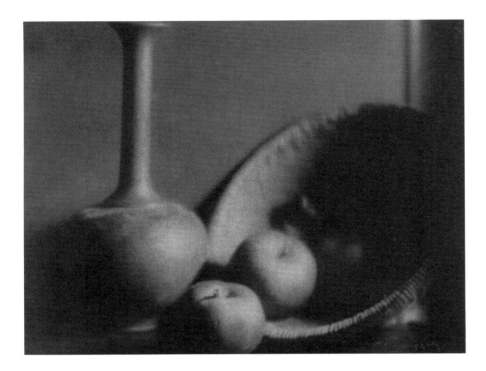

GEORGE SEELEY,
Still Life with Vase and Apples

turned to the graphic art of Japan for compositional structures. In particular, the idea of *notan*—the orchestration of shapes and tones within the confines of the frame—attracted photographers.[34] Meaning became less tied to photographic illusion. Unhinging realistic picture space, photographers perceived the external world as inseparable from the domain of the inner self. Clarence White's seemingly casual arrangement of figures before an open window, *Rest Hour (Columbia Teachers College)* (plate 73)—made the year he began his influential teaching career at Columbia University—owes much of its refined mood to the proper adjustment of his subjects to the spaces they occupy.

Portraits, women in nature, private interiors, and solitary, quiet landscapes were favorite subjects. Like the work of painters such as Thomas Dewing and Childe Hassam, photographers artfully posed figures and subtly arranged natural settings to evoke a dream world in which time and logic play no role. Encouraging introspection rather than observation, softly focused images such as Anne Brigman's *The Dying Cedar* (plate 66) and John Bullock's *Marjorie in the Garden* (plate 67) suggested a larger, more spiritual realm for photography.

To describe their work, photographers now used terms that not only indicated a continuity with classical antiquity and tradition but literally transformed the history of art into modern photographic reprises. As described by fellow Pictorialist Joseph T. Keiley,

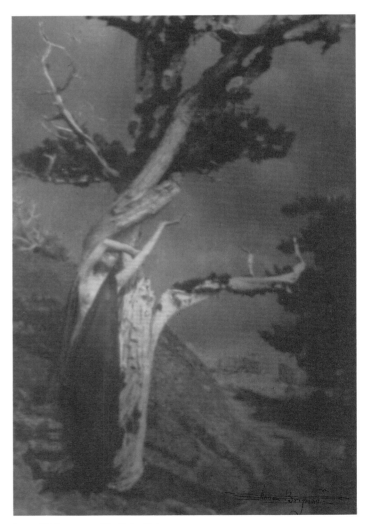

ANNE W. BRIGMAN, *The Dying Cedar*

24

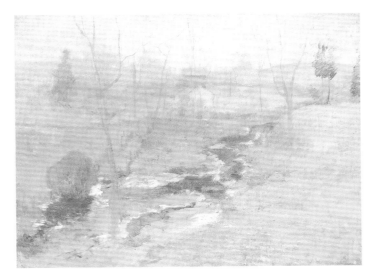

John Henry Twachtman, *End of Winter*

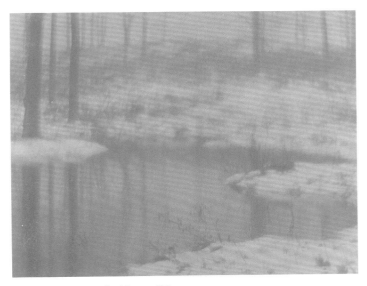

John Chislett, *Woodland Stream, Winter*

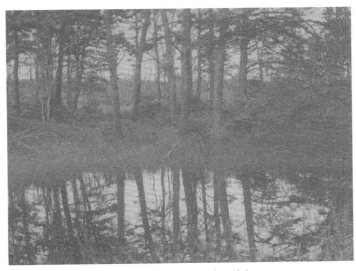

William James Mullins, *Trees Reflected in a Pond, Twilight*

photography, especially images like Brigman's, now "grasped the very soul of nature.... It is reminiscent of the Ovidean metamorphoses, and the 'Midsummer Night's Dream'—pervaded with a certain bigness of feeling that the splendor of our Western nature seems to infuse into the soul."[35] Though muted in effect, landscapes like those of John Chislett and William J. Mullins are pictures to suggest a depth of feeling rather than a breadth of view (plates 59, 61).

In America, banded into photographic societies and local camera clubs, they contributed to the perception of photography as a serious and exacting art form as capable of eliciting sensuous enjoyment as communicating information. The discussion of art and photography was amplified by a variety of publications, among them *Wilson's Photographic Magazine*, *The Camera*, *Photo-Era*, Stieglitz's *Camera Notes* and *Camera Work*, and *American Amateur Photographer*. With richly toned photogravures of original photographs tipped in as illustrations, *Camera Work*, published from 1903 to 1917, was an exhibition space for Pictorialists such as Brigman and Gertrude Käsebier (featured in the first issue of *Camera Work*) as much as it was a finely wrought photographic object.

Curiously, for all the discussion of photography's place in the fine arts, there were no coherent histories of the medium's first century. The only history of photography in America was Marcus Aurelius Root's *The Camera and the Pencil*, published in 1864. Rather, Stieglitz, in the impresarial guise of gallery owner and publisher, conceived of American photography as a "Photo-Secession," linking it with artistic secessions in Europe that had fostered a break with academic forms. He also cast photography into the mutual idealism of individuals with widely divergent interests—painters, poets, musicians, suffragettes, bohemians, anarchists— all who saw themselves as part of a movement dedicated to social and intellectual change.

Like many privileged young moderns, Doris Ulmann was attracted to the excitement and self-consciousness generated by photography during this period. A student of Lewis Hine at the Ethical Culture School in New York City, and then of Clarence White at Columbia Unversity Teachers College and his own school of photography, she represents an intriguing combination of the medium's goals. Active in the Pictorial Photographers of America, she primarily took portraits, photographing her friends and acquaintances in the cultural milieu of New York during the late 1910s and early 1920s.

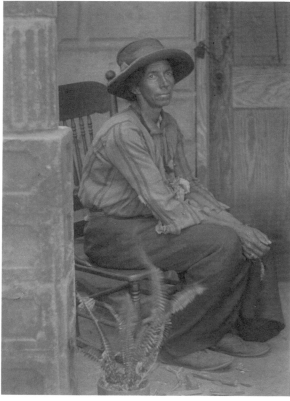

DORIS ULMANN, *Woman on a Porch*

Ulmann's most striking photographs are rural portraits taken in southern Appalachia, the Mennonite and Shaker communities of New York, Pennsylvania, and Virginia, and the French Creole and Cajun communities in Louisiana. She traveled thousands of miles to document America's vanishing cultural past, searching for "types," as her contemporaries described her portraits. Her images of farm laborers commemorate a changing way of life, not only as social reformer Lewis Hine had documented the physiognomies of new citizens but as a record of the character of the changing American landscape.

Others were similarly occupied. Though he worked during the week as a bookkeeper in a fish market, John Frank Keith spent every Sunday making photographs.

His informal archive is more than a catalogue of individuals; it is an intimate portrait of a 1920s neighborhood. Like the itinerant photographers of the nineteenth century who counted on the similarities of circumstance and dress to compose a picture, Keith rarely changed the major elements of his photographs.

But the documentary intention of Ulmann's and Keith's photographs is seemingly belied by the images themselves; the stark visual information that a photographic record is ideally suited to convey is absent. Keith's amateur equipment and single-minded intention dictated the implied modernism of his images' restricted frame. As an archive, his catalogue of individuals subsumes the architecture of picture-making. Long after more advanced equipment was available, Ulmann worked with a view camera and soft-focus lens without a shutter. For each exposure she manually removed and replaced her lens cap; her subjects had to be carefully—and self-consciously—posed. Printed, like most self-consciously Pictorialist works of art, in the luxuriously rich tones of platinum, the images are equally ideal and romantic.

Balancing "picture" and "photograph" is a tense exercise. During its first century, the many-intentioned enterprise of American photography shaped not only a new art but a new archive of visual reference. By and large, photography is a method of exploration and verification: exploration of those characteristics of the medium that had been so unexpectedly granted—mobility, instantaneousness, optical veracity—and verification of purpose, including the sometimes divergent contexts of making and viewing. At once picture and message, the photographic enterprise successfully collapses the void between the provinces of art and description. American photographers, using a variety of photographic methods for diverse purposes, sought to shape the world into meaningful images that conformed to cultural ideas of reality. Considered today, "the exhaustless store" of photography reflects the wider medium of vision.

NOTES

1. Ralph Waldo Emerson, *Natural History of Intellect and Other Papers* (Cambridge, Mass.: Riverside Press, 1893), 9.

2. Recent interest in the initial effect of photographic practice in this country has produced several important and comprehensive studies. These include: Martha A. Sandweiss, ed., *Photography in Nineteenth-Century America*, with essays by Alan Trachtenberg, Barbara McCandless, Martha A. Sandweiss, Keith F. Davis, Peter Bacon Hales, and Sarah Greenough (Fort Worth and New York: Amon Carter Museum and Harry N. Abrams, 1991); Keith F. Davis, *An American Century of Photography from Dry-Plate to Digital* (Kansas City, Mo.: Hallmark Cards in association with Harry N. Abrams, 1995); Alan Trachtenberg, *Reading American Photographs: Images as History, Mathew Brady to Walker Evans* (New York: Hill & Wang, 1989).

3. Samuel F. B. Morse, letter dated 15 March 1839 to his brothers Richard and Sidney, publishers of the *New York Observer*, who published it 20 April 1839. Morse was in Paris during the winter of 1838, awaiting a French patent for his invention of the telegraph. Morse visited Daguerre's studio and saw his finished images on 5 March 1839.

4. Edgar Allan Poe, "The Daguerreotype," *Alexander's Weekly Messenger*, 15 January 1840, 2. Reprinted in Jane M. Rabb, ed., *Literature & Photography: Interactions 1840–1990* (Albuquerque: University of New Mexico Press, 1995), 4–5.

5. "New Discovery in the Fine Arts," *New Yorker*, 13 April 1839. Reprinted in Merry A. Foresta and John Wood, *Secrets of the Dark Chamber: The Art of the American Daguerreotype* (Washington, D.C.: National Museum of American Art and Smithsonian Institution Press, 1995), 223–25.

6. "New Discovery in the Fine Arts. The Daguerreotype," *New Yorker*, 20 April 1839.

7. In his review of the 1893 Joint Exhibition of Amateur Photography in Philadelphia, Alfred Stieglitz made the distinction between pictures and photographs. Pictures were like those of British photographer George Davison, one of whose photographs, *Onion Field*, received Stieglitz's highest praise for having the quality of "suggestiveness." In comparison, "absolutely sharp" photographs were reserved for the appreciation of those "imbeciles, who strut about examining pictures with a magnifying glass stuck in their eye." Alfred Stieglitz, "The Joint exhibition at Philadelphia," *American Amateur Photographer*, 5 May 1893, 203.

8. Among the sesquicentennial exhibitions mounted in 1989 or thereafter were *On the Art of Fixing a Shadow* (National Gallery of Art, Washington, D.C., and the Art Institute of Chicago); *The Art of Photography, 1839–1989* (Royal Academy of Art, London, and the Museum of Fine Arts, Houston); and *Photography Until Now* (Museum of Modern Art, New York).

9. Two histories in particular served as initial guideposts. Beaumont Newhall, writing in the catalogue for the exhibition *Photography 1839–1937*, which he organized for the Museum of Modern Art in 1937, described the development of the medium in Europe and America and discussed masters and masterpieces of the art of photography. Beaumont Newhall, *The History of Photography from 1839 to the Present*, 5th ed. (New York: Museum of Modern Art, New York Graphic Society Books, 1982).

As the title suggests, Robert Taft's 1938 book, *Photography and the American Scene: A Social History 1839–1889* (New York: Dover, 1964), is a history of the medium that takes into account the events of American history, including the histories of technology, commerce, and the popular uses of photography, as well as the activities of individual photographers.

10. John Szarkowski's retelling of the history of the medium in *Photography Until Now* includes a variety of photographic types by photographers well known, little known, and unknown. Grounding his history in pictorial inventions since the Renaissance, he discusses the earliest photographic processes of calotype and daguerreotype as two processes of photographic vision, not as "the tools of rival tribes" but rather as distinct choices for different kinds of human perception: "How did the idea evolve that one might catch a picture in a net, as one might catch not only the butterfly but the piece of sky in which it flew? One might best look for the beginning of an answer in fifteenth-century Italy, where two new intellectual tools became fundamental levers in the transformation of medieval culture into what would later be called the modern world: perspective drawing and modern mapmaking." *Photography Until Now*, 15.

11. Sam Wagstaff, interview with Howard Chapnick, "Markets & Careers," *Popular Photography* (February 1978): 158–60.

12. In 1931 Levy opened a gallery in New York City, in part because he felt a need for a center for the study and exhibition of photography. Organized in association with Alfred Stieglitz, his first exhibition (November 1931) was a retrospective, *American Photography*. Predictably, given Stieglitz's involvement, the show included photographs by Stieglitz, Edward Steichen, Paul Strand, Charles Sheeler, Clarence H. White, Frank Eugene, Gertrude Käsebier, and Anne Brigman. Levy's contributions included Edward Weston, Mathew Brady, and a selection of daguerreotypes from Levy's personal collection.
 A Book of Photographs from the Collection of Sam Wagstaff (New York: Gray Press, 1978) accompanied an exhibition organized by the Corcoran Gallery of Art, Washington, D.C.

13. Albert Sands Southworth, "Comments at the National Photographic Association," 1873. Reprinted in Foresta and Wood, *Secrets of the Dark Chamber*, 305–10.

14. Carl Chiarenza first called for this broader approach to the history of photography in 1979. See "Notes toward an Integrated History of Picturemaking," *Afterimage* 7, no. 1–2 (Summer 1979).

15. It was a question that arrived with photography. What kind of art would the photographer, "schooled to severe discipline," produce? asked the anonymous writer of "New Discovery in the Fine Arts. The Daguerreotype," *New Yorker*, 13 April 1839. Photography's use as science, art, and commerce was considered, even its use for law enforcement. Criminals, it was predicted by the "New Discovery" writer, would "see handed in as evidence against them their own portraits, taken by the room in which they stole, and in the very act of stealing."

16. As an artist, photographer, and editor of *The Crayon*, William Stillman was probably the author of this article. "Sketchings," *The Crayon*, 14 February 1855, 107.

17. Ralph Waldo Emerson, journal entry, 24 October 1841, quoted in F. O. Matthiessen, *American Renaissance: Art and Expression in the Age of Emerson and Whitman*, 10th ed. (New York: Oxford University Press, 1966), 51.

18. For a complete discussion of John Ruskin, the American Pre-Raphaelite movement and the Society for the Advancement of Truth in Art, and the proposed reform of American art, see Linda S. Ferber and William H. Gerdts, *The New Path: Ruskin and the American Pre-Raphaelites* (Brooklyn: Brooklyn Museum, 1985).

19. Samuel F. B. Morse to Washington Allston. See Samuel Irenaeus Prime, *The Life of Samuel F. B. Morse, LL.D.* (New York: D. Appleton, 1875), 405.

20. Several historians and critics have advanced various ideas about the importance of the archive. Most recently, Eugenia Parry Janis points out the larger nineteenth-century connection to photographic series in "Itself and Its Own," in *At the Still Point: Photographs from the Collection of Manfred Heiting*, vol. 1 (Los Angeles and Amsterdam: Cinubia Productions, 1995). Writing for the *Art Journal*, Rosalind Krauss suggests that the context in which a photograph is made and that in which it is viewed create two distinct kinds of knowledge: "One would say that they operate as representations within two separate discursive spaces, as members of two different discourses" ("Photography's Discursive Spaces: Landscape/View," *Art Journal* (Winter 1982). Even earlier, Jacques Lacan's ubiquitous reminders that images and symbols cannot be isolated from the context of their making serve as a keystone for late-twentieth-century criticism.

21. Rembrandt Peale, "Portraiture," *The Crayon*, 1857.

22. Oliver Wendell Holmes, "The Stereoscope and the Stereograph," *Atlantic Monthly* (June 1859), reprinted in Beaumont Newhall, ed., *Photography: Essays and Images* (New York: Museum of Modern Art, 1980), 60.

23. Alexander Gardner, *Gardner's Photographic Sketch Book of the War*, 1866. Reprinted as *Photographic Sketch Book of the Civil War* (New York: Dover, 1959), text opp. pl. 36.

24. Barnard had been allowed to keep many of the large-format negatives he made during 1864–65. In the spring of 1866, to supplement this group, he retraced Sherman's route. Returning to New York, he spent the summer and early fall printing over one hundred copies each of the album's sixty-one photographs. The volume was completed in November 1866.

25. Oliver Wendell Holmes used this phrase to describe images of the dead at Antietam in an article for the *Atlantic Monthly* (July 1863).

26. In 1866 the editor of the *Philadelphia Photographer* visited Bell, then director of the photographic department at the Army Medical Museum, and described his operations: "The principal work of the photographer is to photograph shattered bones, broken skulls, and living subjects, before and after surgical operations have been performed on them. Of course, all these subjects were created by the war." *Philadelphia Photographer*, 3 July 1866, 214.

27. John Moran, "The Relation of Photography to the Fine Arts," *Philadelphia Photographer* (March 1865): 3–5.

28. Reverend H. J. Morton, D.D., "Yosemite Valley," *Philadelphia Photographer* (December 1866): 376–78.

29. Barbara Novak, "Landscape Permuted: From Painting to Photography," *Artforum* (October 1975), reprinted in Vicki Goldberg, ed., *Photography in Print: Writings from 1816 to the Present* (New York: Simon & Schuster, 1981), 174.

30. James McClees advertising circular, in W. W. Turner Papers, Smithsonian Institution National Anthropological Archives, Washington, D.C., accession nos. 76–112. As quoted in Paula Richardson Fleming and Judith Luskey, eds., *The North American Indians in Early Photographs* (New York: Harper & Row, 1986), 22. In his circular McClees also claimed authorship of the portraits, probably on the basis of his ownership of the studio.

31. Beaumont Newhall to Lewis Hine, February 1938. Elizabeth McCausland Papers, Archives of American Art.

32. Trachtenberg provides an extensive and complete discussion of Hine's relationship to the art photography movement and the photography of Alfred Stieglitz in "Camera Work/Social Work," *Reading American Photographs*.

33. Arthur W. Dow, "Mrs. Gertrude Käsebier's Portrait Photographs," *Camera Notes*, no. 3 (July 1899): 22.

34. One of the most influential proponents of this aesthetic was Arthur Wesley Dow, curator of Japanese art at the Museum of Fine Arts, Boston. His book *Composition* introduced the idea of *notan*, along with other aspects of Japanese style.

35. Joseph T. Keiley, "The Buffalo Exhibition," *Camera Work* 33 (1911), in Jonathan Green, ed., *Camera Work: A Critical Anthology* (Millerton, N.Y.: Aperture, 1973), 210.

Plates

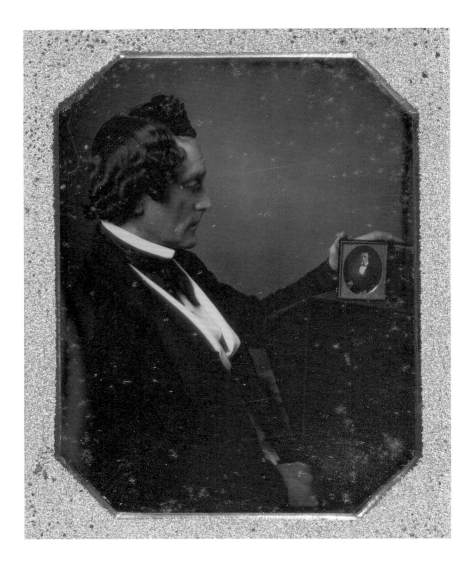

PLATE 1 **UNIDENTIFIED ARTIST**
Young Man Looking at Daguerreotype, ca. 1885,
daguerreotype, quarter plate

PLATE 2 **FRANK A. RINEHART**, possibly **ADOLF F. MUHR**
Buried Far Away, Cocapah, 1899,
platinum print, 24. x 18.8 cm (9 ½ x 7 ⅜ in.)

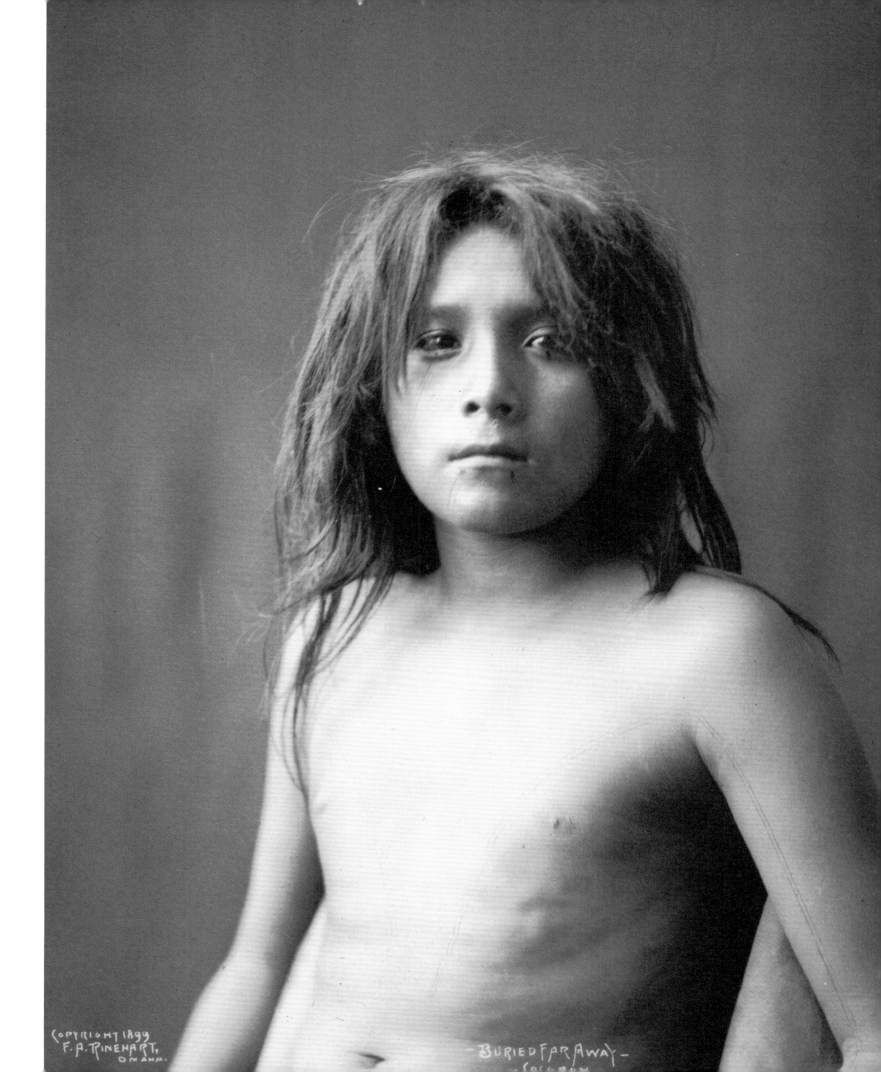

- BURIED FAR AWAY -

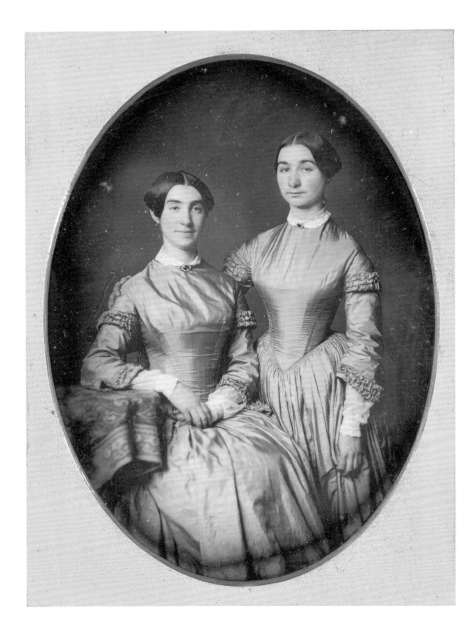

Plate 3 **Unidentified Artist**
Caroline Greig and Sister Julia, ca. 1855,
daguerreotype, half plate

32

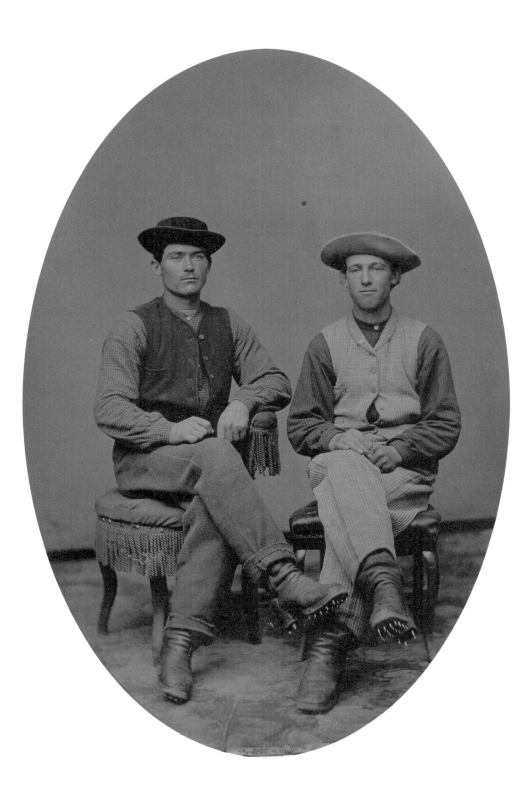

PLATE 4 **SAMUEL W. SAWYER**
River Drivers, Maine, ca. 1867,
tintype, 17.8 x 12.7 cm (7 x 5 in.)

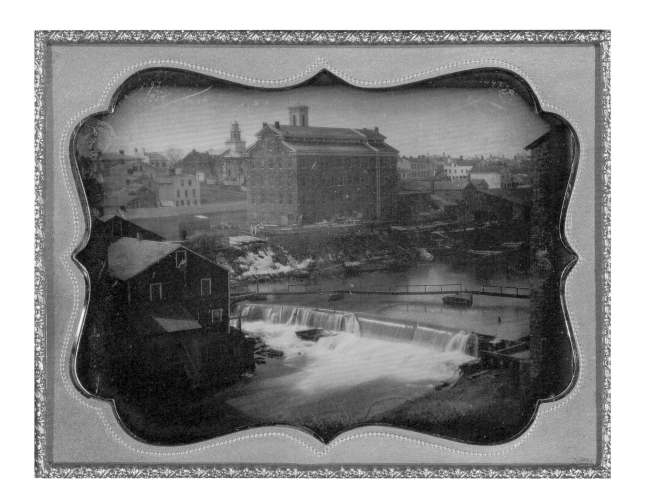

PLATE 5 **UNIDENTIFIED ARTIST**
Seneca Falls, New York (upstream), 1850,
daguerreotype, half plate

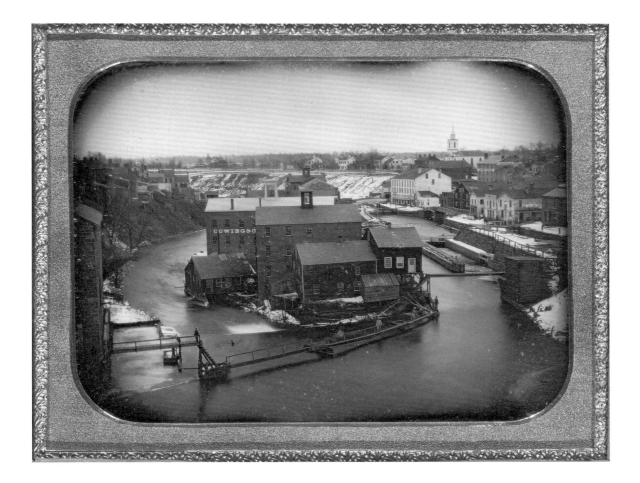

Plate 6 **Unidentified Artist**
Seneca Falls, New York (downstream), 1850,
daguerreotype, half plate

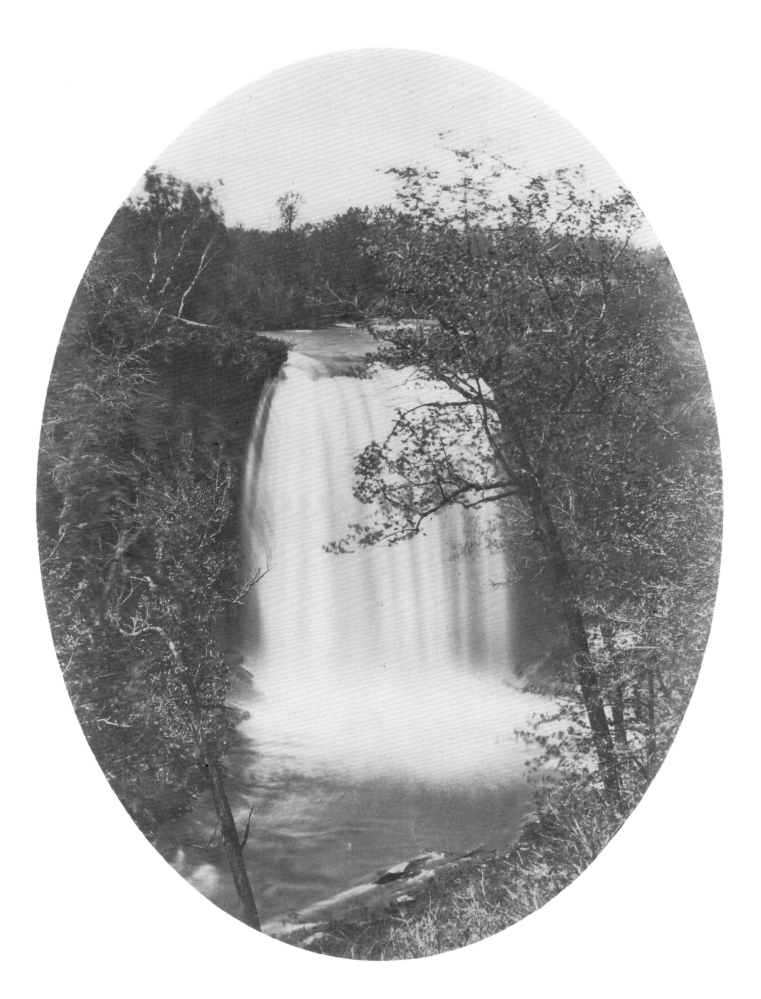

PLATE 8 **SAMUEL MASURY**
*Looking Outward from the Barn, Loring Estate, Beverly
Farms, Massachusetts,* ca. 1858, coated salted paper
print, 26.7 x 34.6 cm (10 ½ x 13 ⅝ in.)

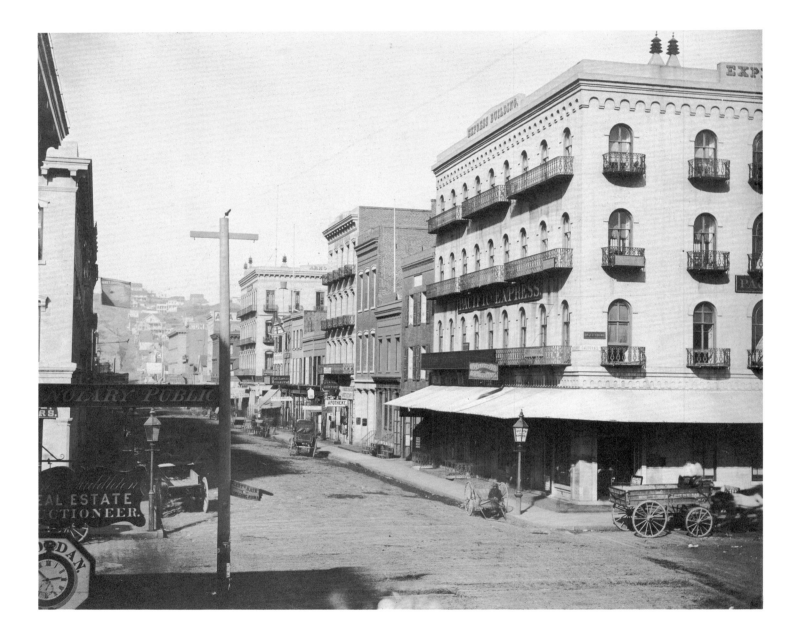

PLATE 9 **JAMES FORD**, possibly **CARLETON E. WATKINS**
San Francisco, Corner of California and Montgomery Streets, ca. 1857,
coated salted paper print, 25.4 x 32.1 cm (10 x 12 ⅝ in.)

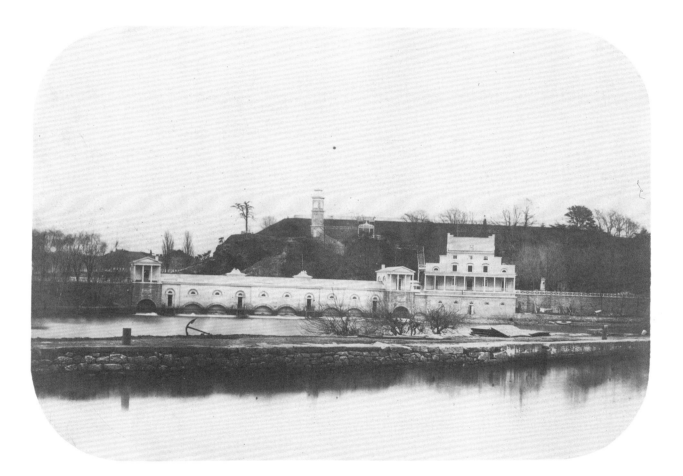

PLATE 10 **JAMES McCLEES**
The Waterworks, Fairmount, Philadelphia, 1855,
salted paper print, 15.9 x 22.5 cm (6 ¼ x 8 ⅞ in.)

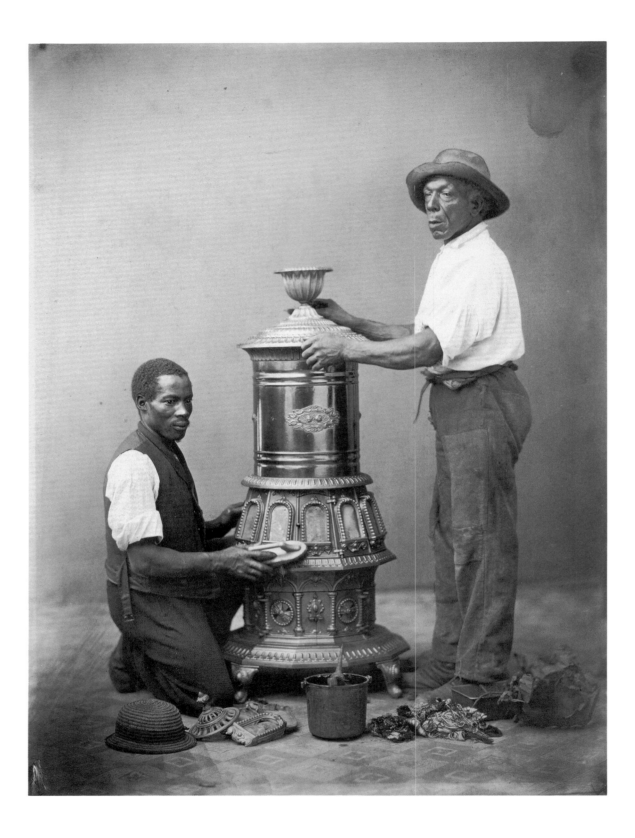

PLATE 11 **UNIDENTIFIED ARTIST**
Two Workmen Polishing a Stove, ca. 1865,
albumen print, 35.9 x 28 cm (14 ⅛ x 11 in.)

PLATE 12 **BRADY STUDIO, PHOTOGRAPHER: ALEXANDER GARDNER**
Mr. Wilkeson, ca. 1859,
salted paper print, 47 x 36.2 cm (18 ½ x 14 ¼ in.)

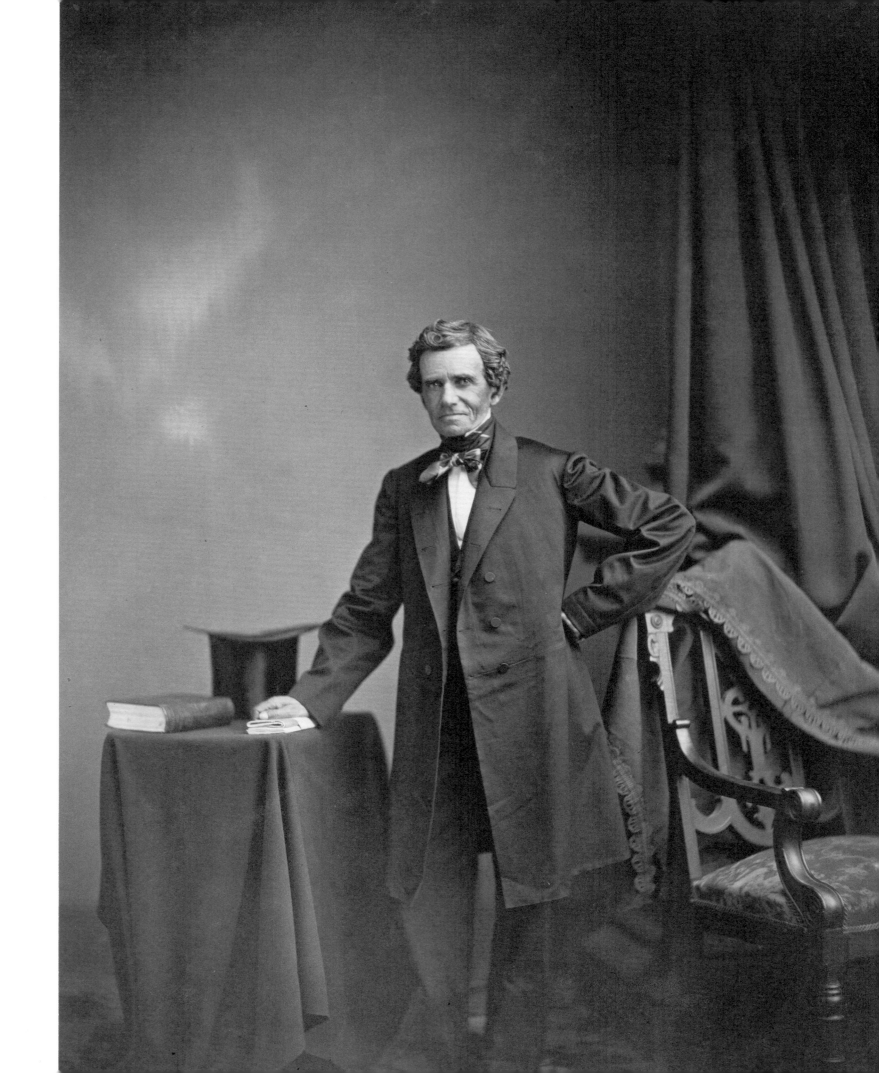

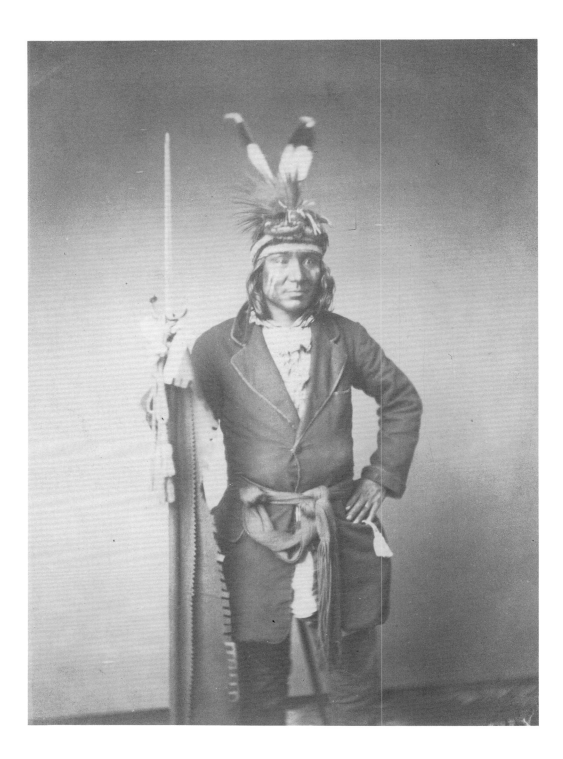

PLATE 13 **JULIAN VANNERSON**
Shining Metal, 1858,
salted paper print, 22.2 x 16.5 cm (8 ¾ x 6 ½ in.)

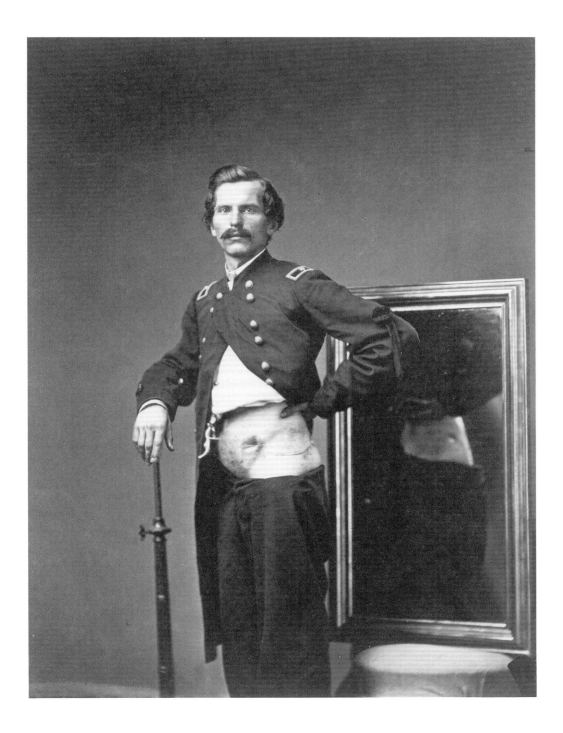

PLATE 14 **WILLIAM BELL**
General H. A. Barnum, Recovery After a Penetrating Gunshot Wound..., 1865,
albumen print, 21.6 x 16.8 cm (8 ½ x 6 ⅝ in.)

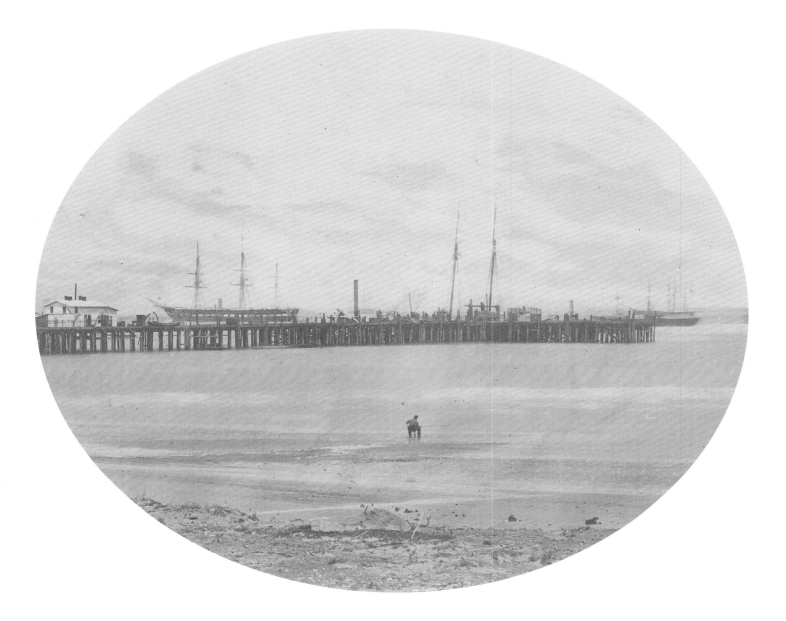

PLATE 15 **HENRY P. MOORE** (attributed to)
Long Dock at Hilton Head, Port Royal, South Carolina, 1862,
salted paper print, 18.1 x 22.9 cm (7 ⅛ x 9 in.)

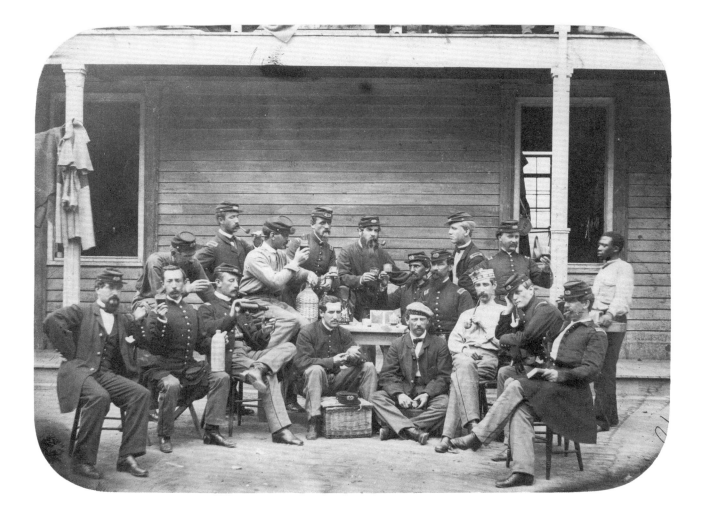

PLATE 16 **EGBERT GUY FOWX**
New York 7th Regiment Officers, ca. 1863,
salted paper print, 14.3 x 19.1 cm (5 ⅝ x 7 ½ in.)

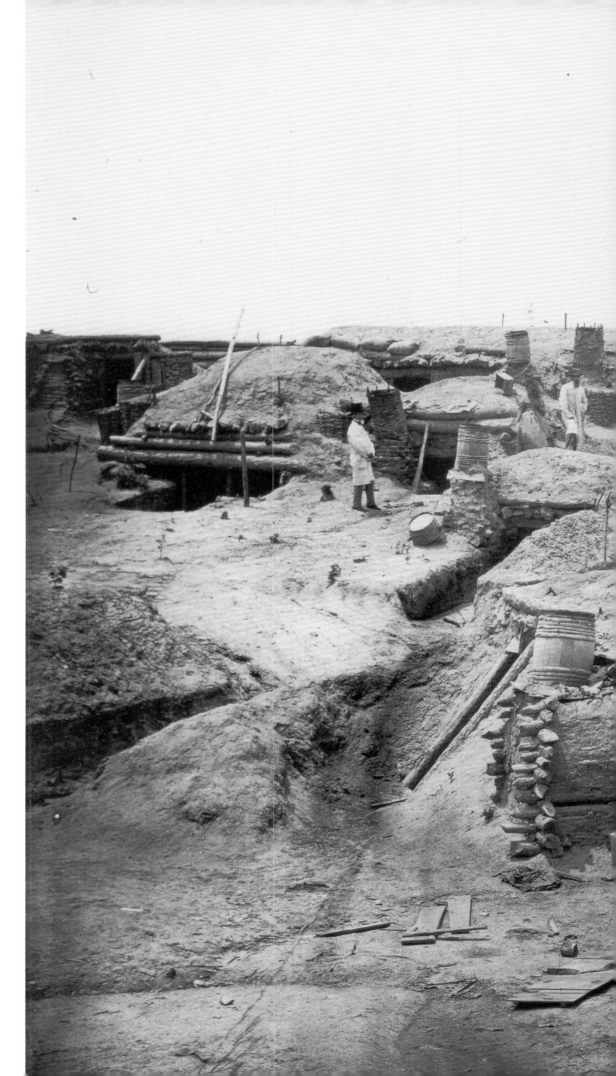

PLATE 17 **TIMOTHY O'SULLIVAN**
Quarters of Men in Fort Sedgwick,
Known as Fort Hell, 1865, albumen
print, 19.4 x 25.4 cm (7 ⅝ x 10 in.)

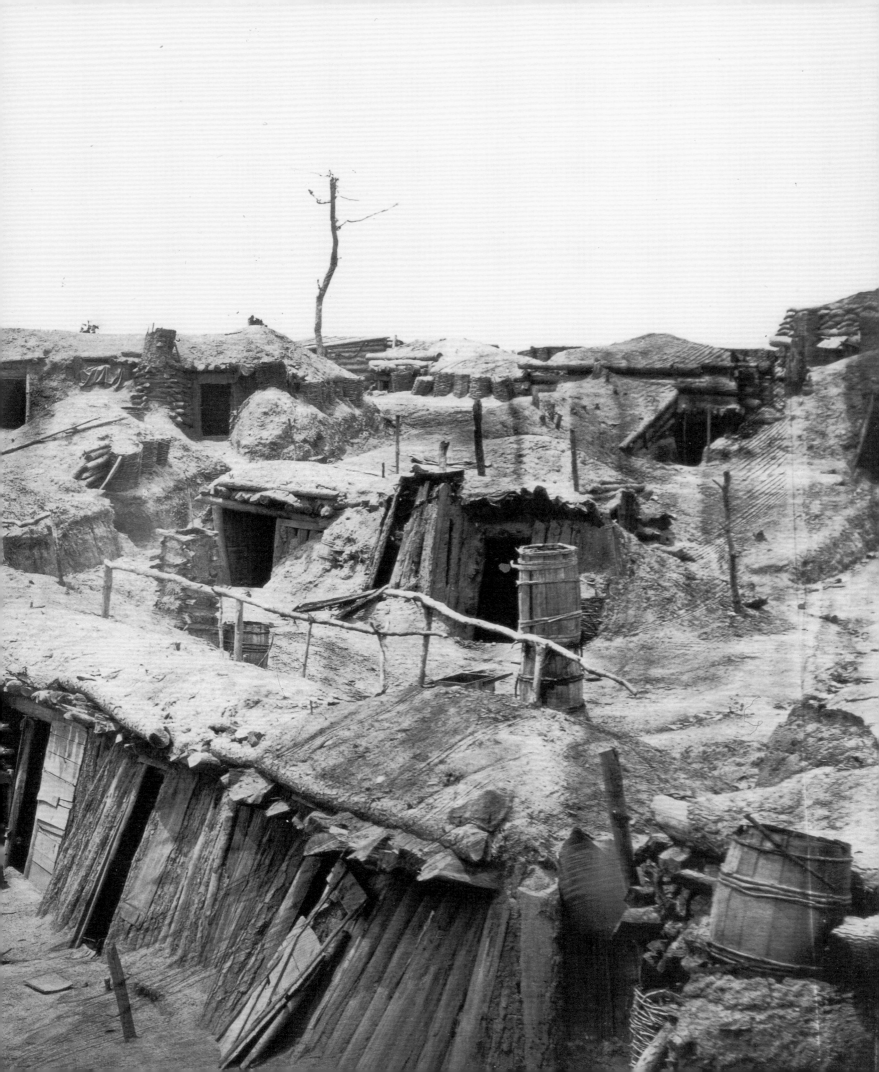

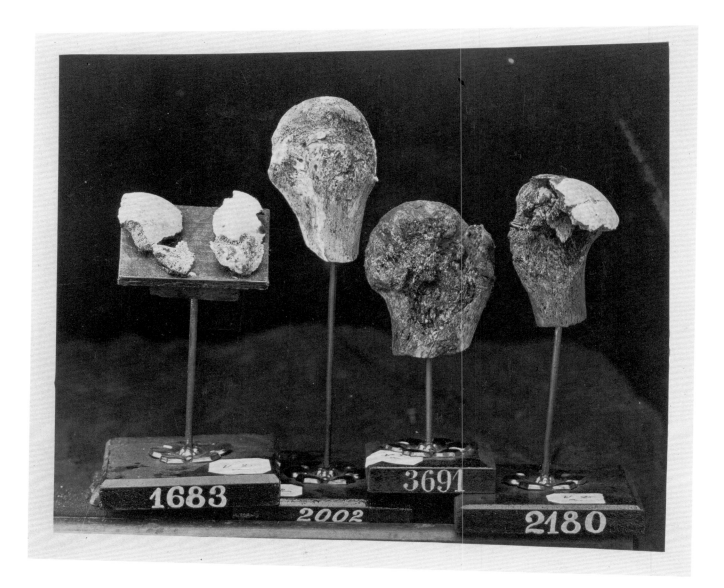

PLATE 18 **WILLIAM BELL**
Heads and Fragments of Heads of Humeri..., 1865,
albumen print, 18.4 x 22.2 cm (7 ¼ x 8 ¾ in.)

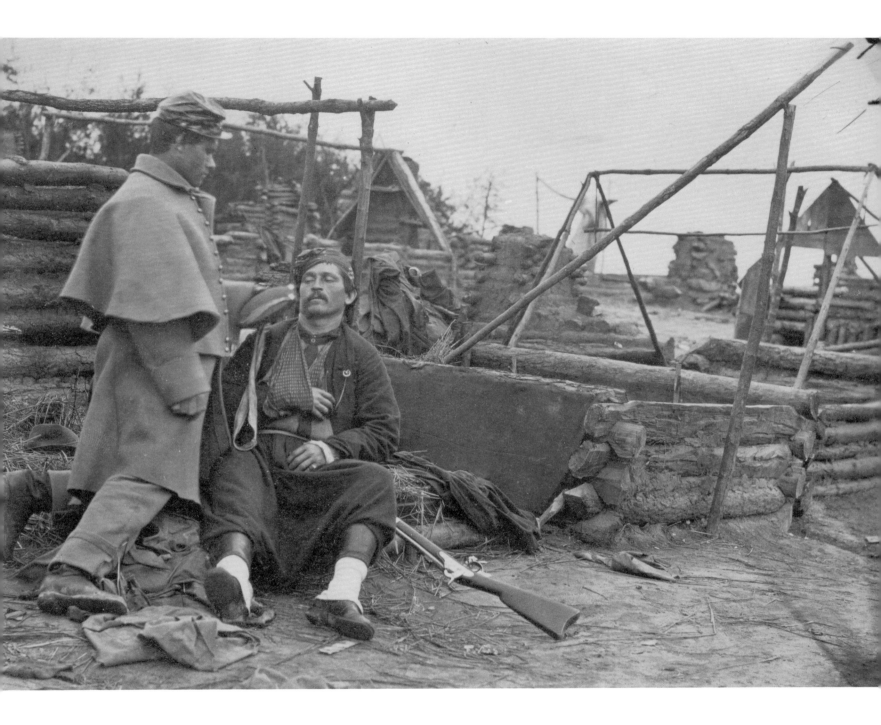

PLATE 19 **BRADY STUDIO**
The Sick Soldier, ca. 1863,
albumen print, 14.3 x 20 cm (5 ⅝ x 7 ⅞ in.)

PLATE 20 **CHURCHILL AND DENISON STUDIO** (attributed to)
Group at the Sanitary Commission Fair, Albany, 1864,
salted paper print, 15.2 x 20.3 cm (6 x 8 in.)

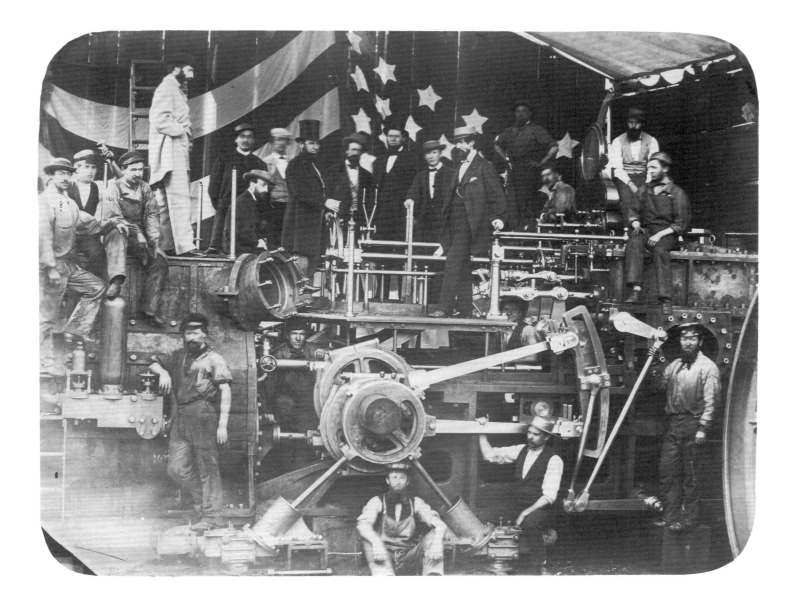

PLATE 21 **KELLOGG BROTHERS**
Engine of the USS Kearsarge, ca. 1861,
salted paper print, 25.4 x 33.6 cm (10 x 13 ¼ in.)

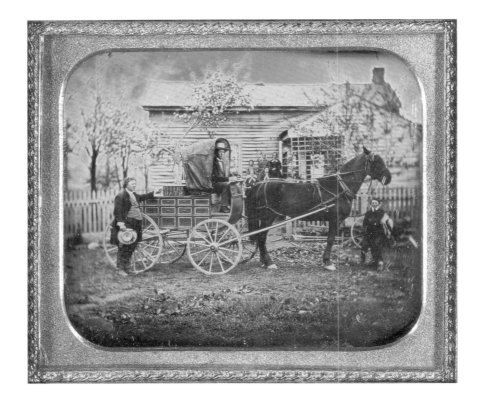

PLATE 22 **UNIDENTIFIED ARTIST**
The Ohio Star *Buggy*, ca. 1850,
daguerreotype, sixth plate

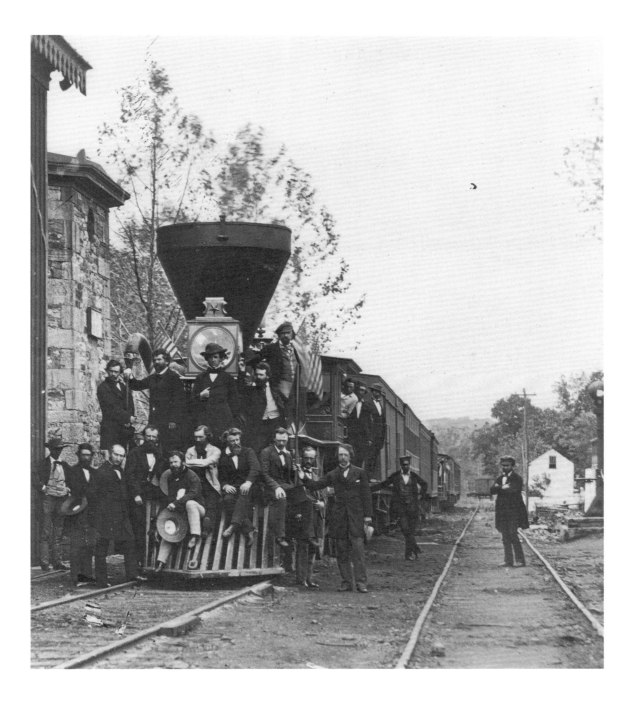

PLATE 23 **UNIDENTIFIED ARTIST**
Artists' Excursion, Sir John's Run, Berkeley Springs, 1858,
salted paper print, 17.2 x 15.6 cm (6 ¾ x 6 ⅛ in.)

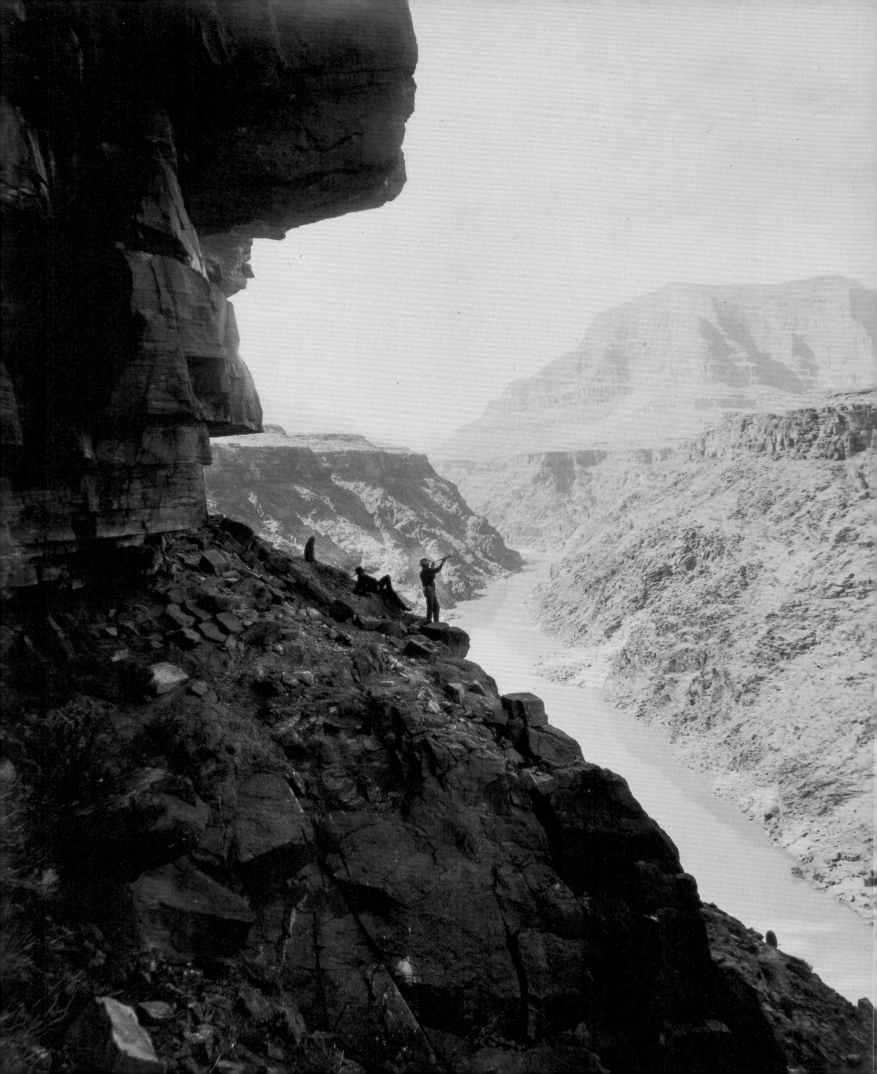

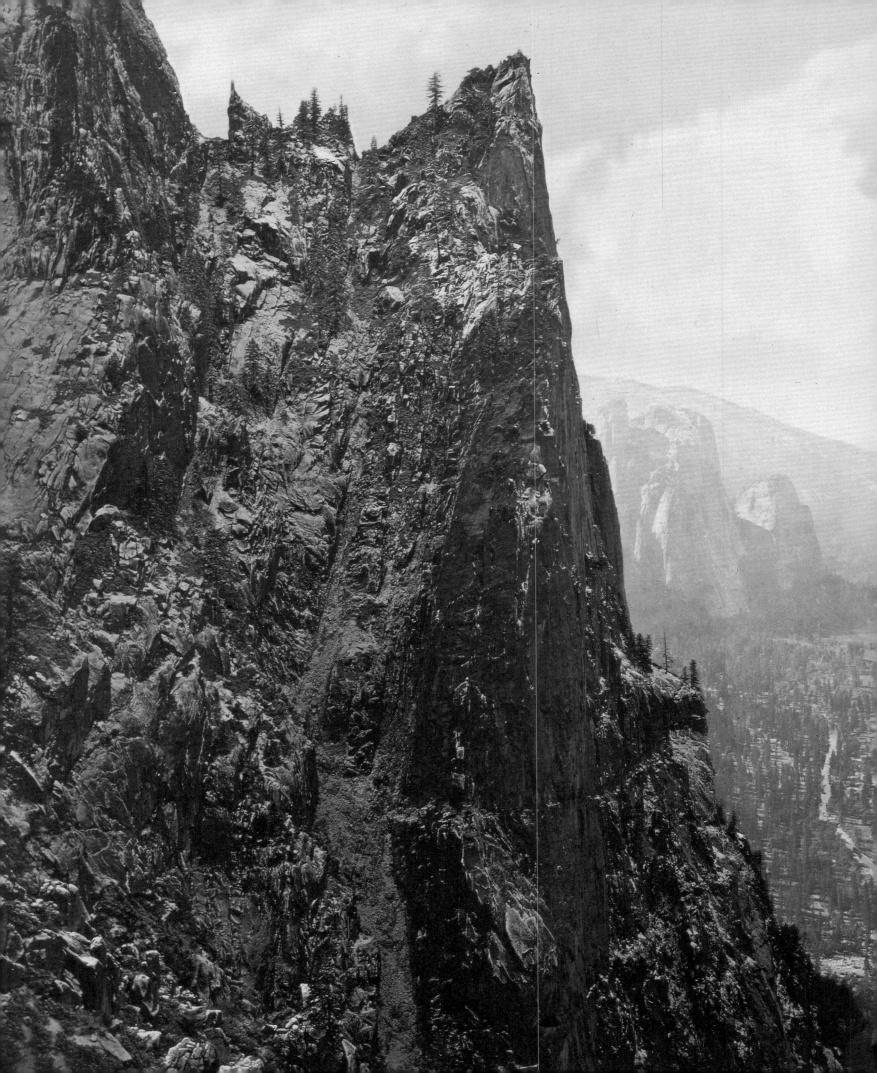

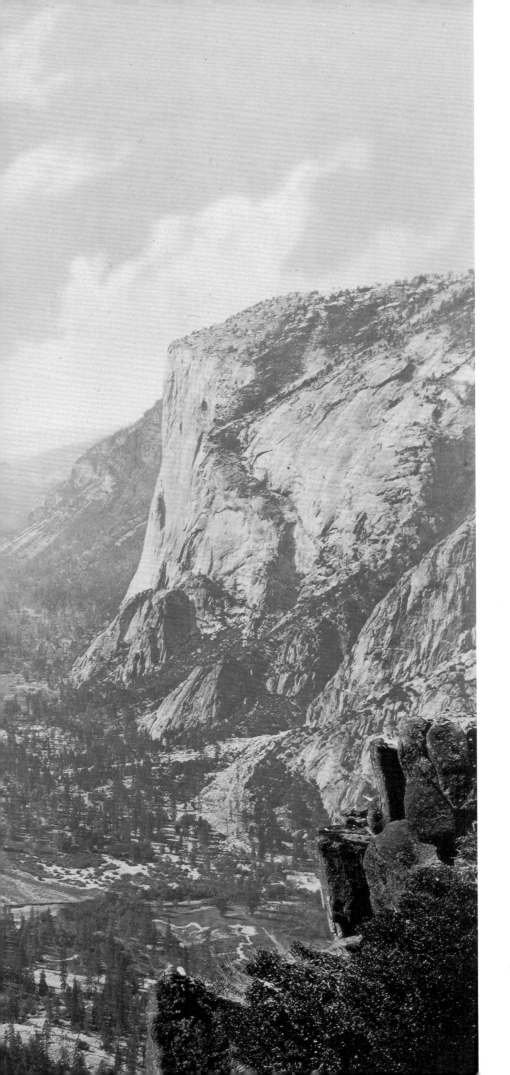

PLATE 25 EADWEARD MUYBRIDGE
Valley of the Yosemite from Union Point, 1872,
albumen print, 43.2 x 54.6 cm (17 x 21 ½ in.).
Gift of Dr. and Mrs. Charles T. Isaacs

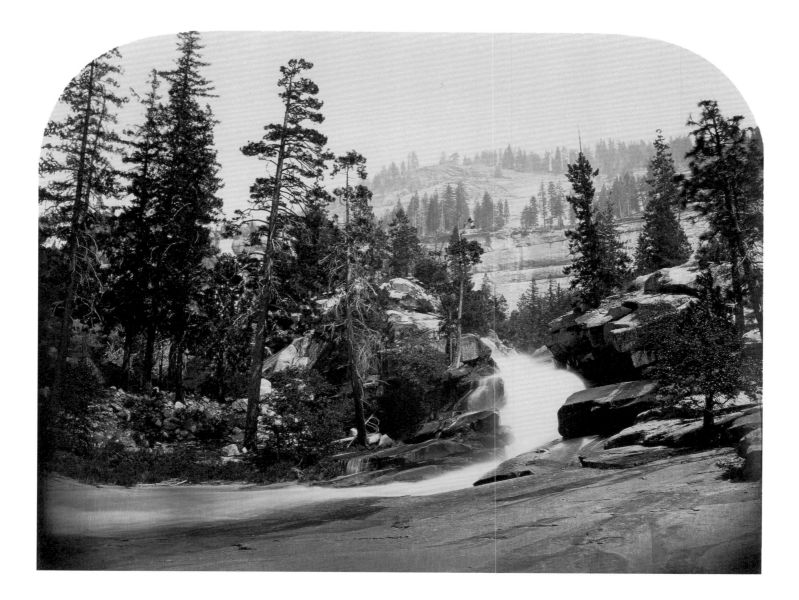

PLATE 26 **CARLETON E. WATKINS**
Cascade, Nevada Falls, Yosemite, California, ca. 1861,
albumen print, 39.6 x 53 cm (15 ⅝ x 20 ⅞ in.)

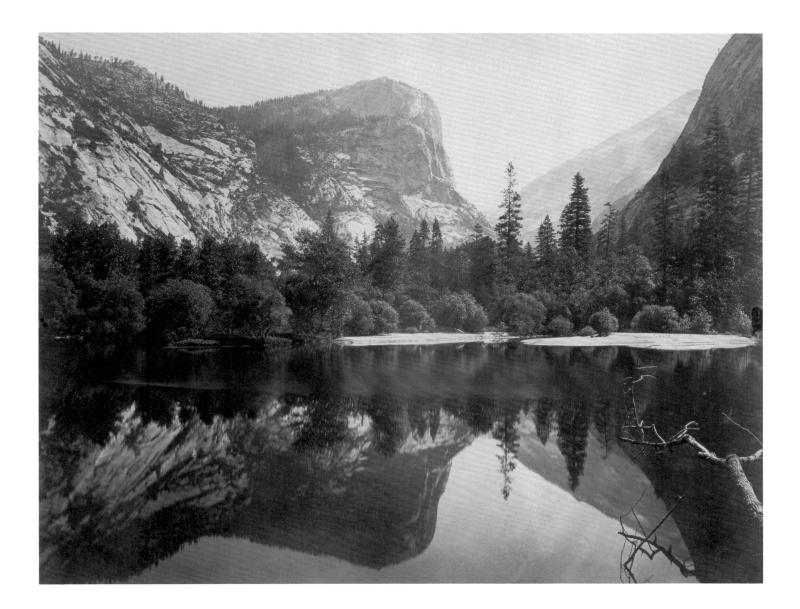

PLATE 27 **CHARLES LEANDER WEED**
Mirror Lake and Reflections, Yosemite Valley, Mariposa County, California, 1865,
albumen print, 39.4 x 51.4 cm (15 ½ x 20 ¼ in.).
Gift of Dr. and Mrs. Charles T. Isaacs

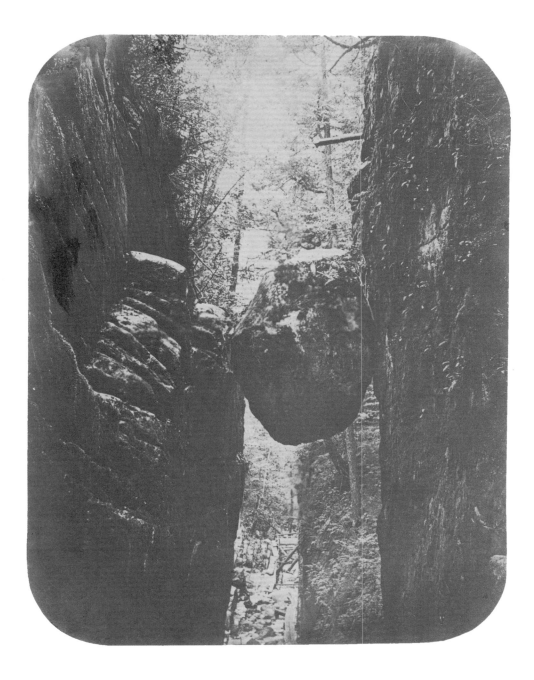

PLATE 28 **FRANKLIN WHITE** *(above)*
Trapped Boulder, White Mountains, 1859,
salted paper print, 16.5 x 13 cm (6 ½ x 5 ⅛ in.)

PLATE 29 **WILLIAM BELL** *(opposite)*
Perched Rock, Rocker Creek, Arizona, 1872,
albumen print, 27.3 x 20.3 cm (10 ¾ x 8 in.)

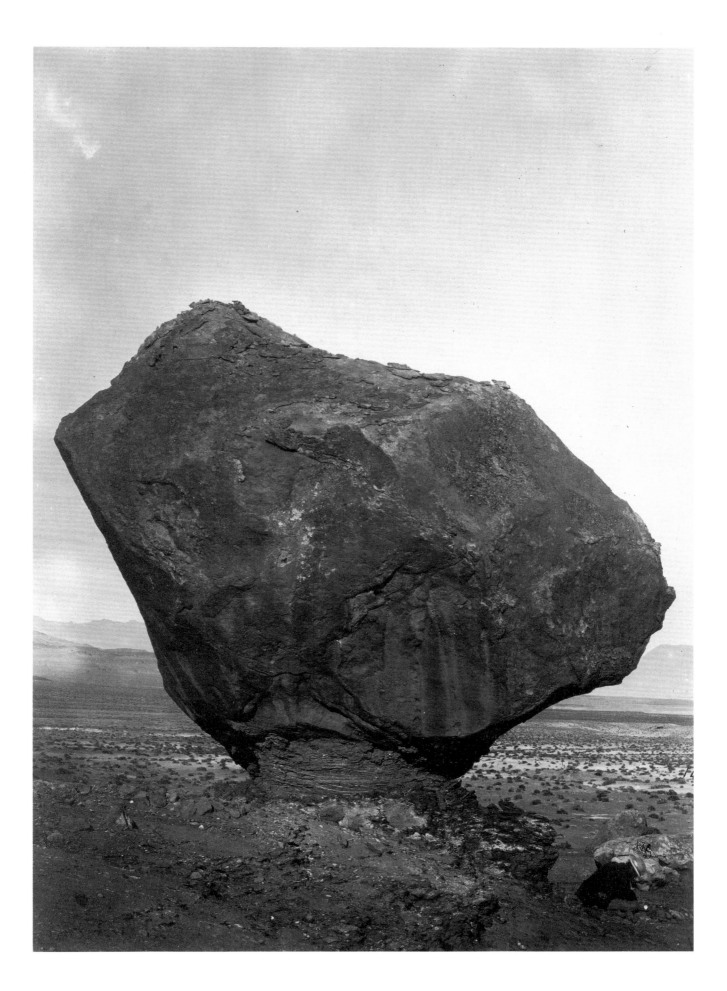

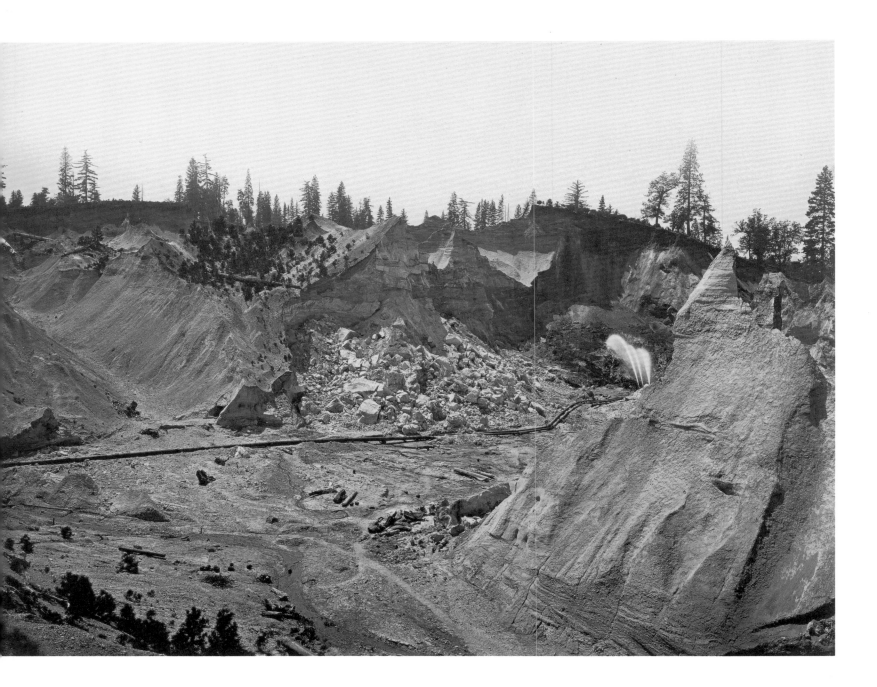

PLATE 30 **CARLETON E. WATKINS** (*above*)
Union Diggings, Columbia Hill, Nevada, ca. 1871,
albumen print, 40.3 x 54.9 cm (15 ⅞ x 21 ⅝ in.)

PLATE 31 **JOHN K. HILLERS** (*opposite*)
Hopi Mesa, ca. 1879,
albumen print, 25.1 x 32.7 cm (9 ⅞ x 12 ⅞ in.)

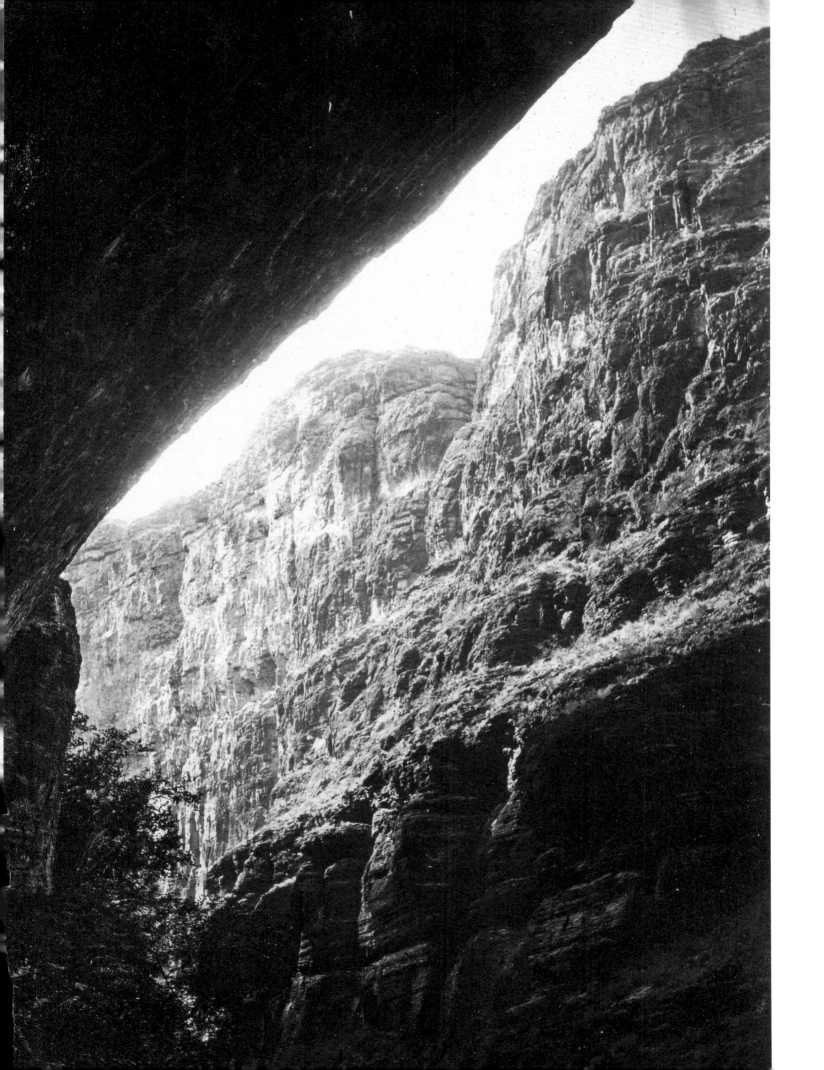

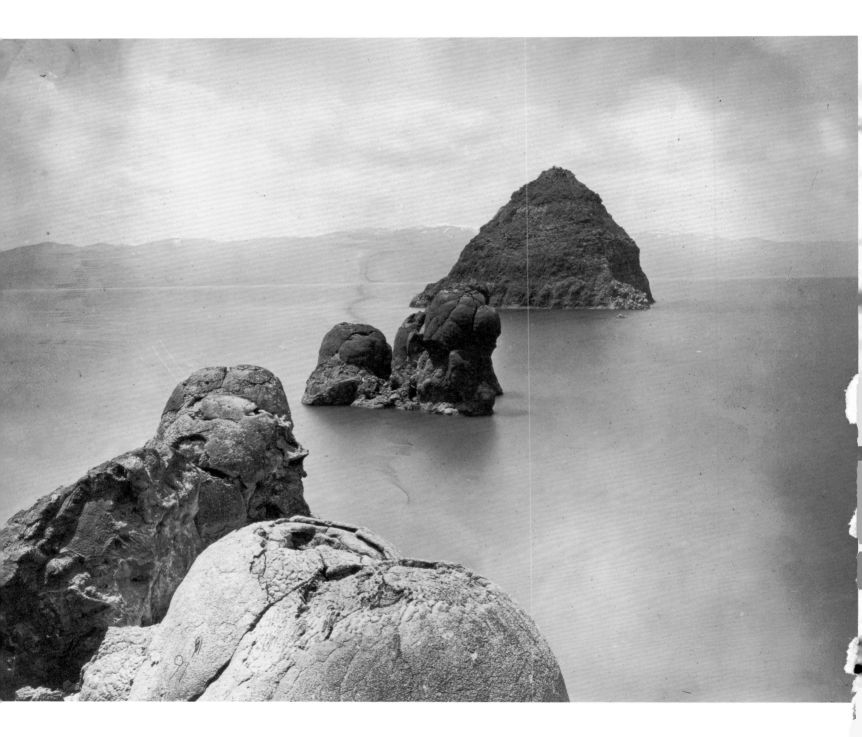

PLATE 34 **TIMOTHY O'SULLIVAN**
Tufa Domes, Pyramid Lake, Nevada, 1867,
albumen print, 20 x 27 cm (7 ⅞ x 10 ⅝ in.)

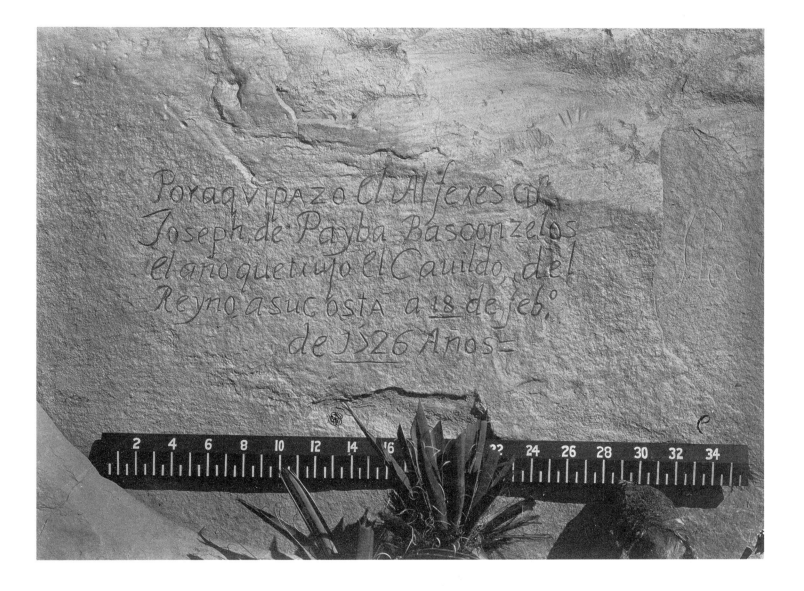

PLATE 35 **TIMOTHY O'SULLIVAN**
Historic Spanish Record of the Conquest, South Side of Inscription Rock, New Mexico, No. 3,
1873, albumen print, 20.3 x 27.6 cm (8 x 10 ⅞ in.)

69

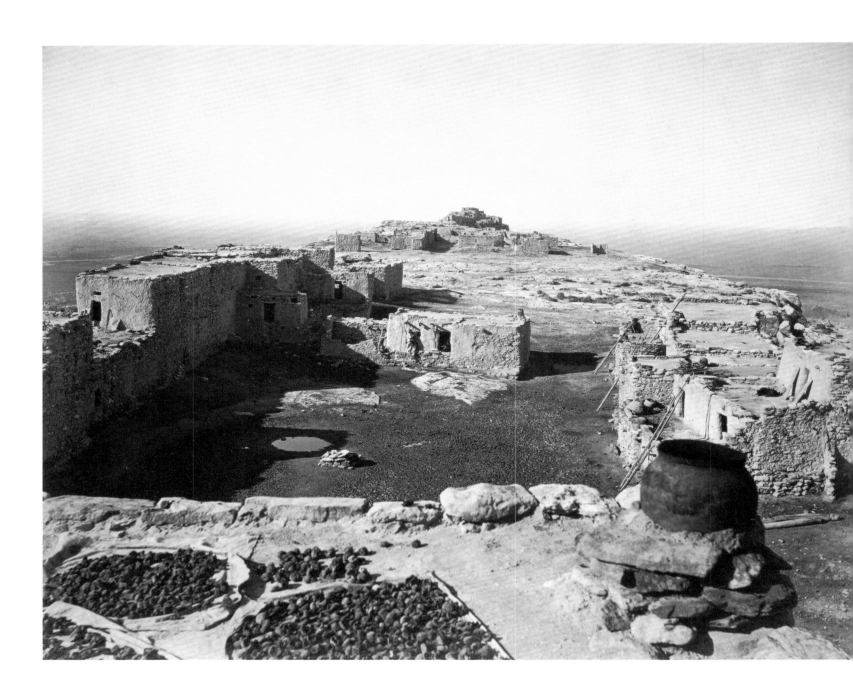

PLATE 32 **WILLIAM BELL** *(overleaf, left)*
Cañon of Kanab Wash, Colorado River, Looking South, 1872,
albumen print, 27.6 x 20 cm (10 ⅞ x 7 ⅞ in.)

PLATE 33 **WILLIAM BELL** *(overleaf, right)*
Looking South into the Grand Cañon, Colorado River, Sheavwitz Crossing, 1872,
albumen print, 20.3 x 27.6 cm (8 x 10 ⅞ in.)

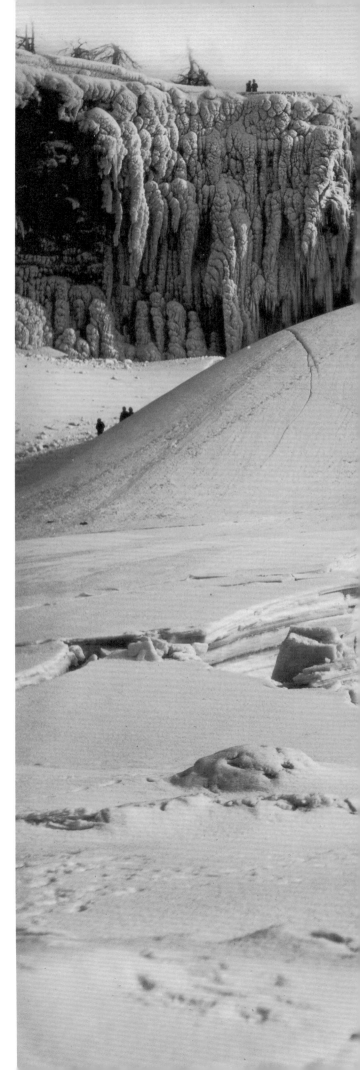

PLATE 38 **GEORGE BARKER**
The Falls in Winter, ca. 1888,
albumen print, 41.3 x 48.2 cm (16 ¼ x 19 in.)

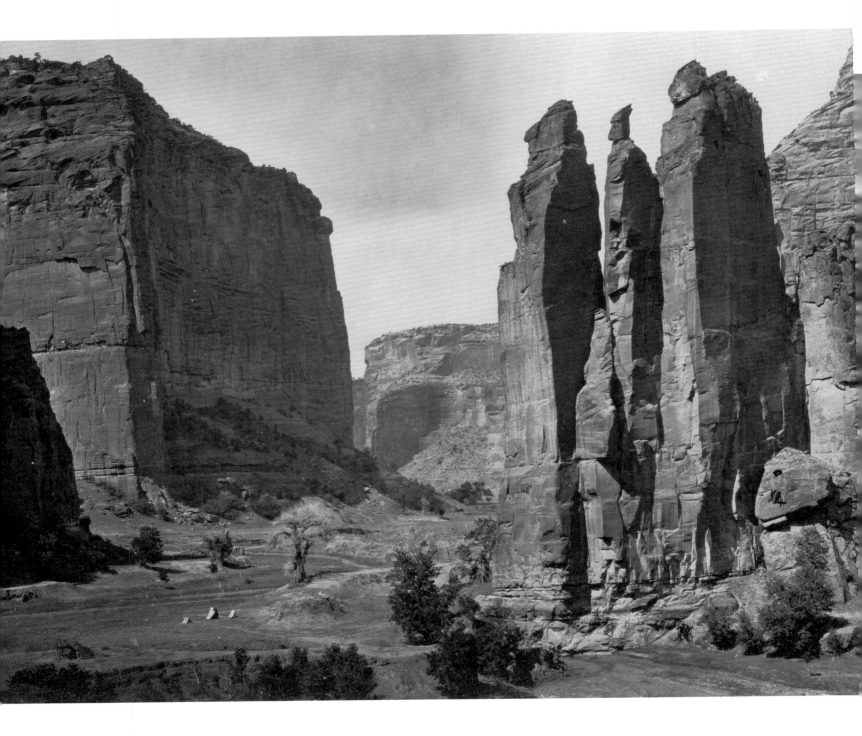

PLATE 36 **TIMOTHY O'SULLIVAN**
Cañon de Chelle, Walls of the Grand Cañon About 1200 Feet in Height, 1873,
albumen print, 20.3 x 27.6 cm (8 x 10 ⅞ in.)

70

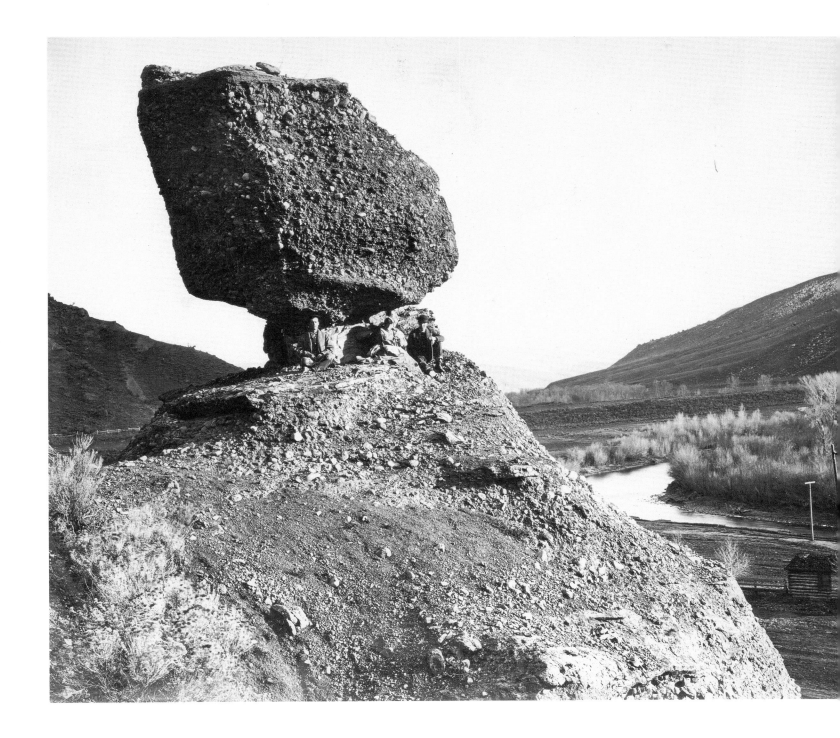

PLATE 37 **ANDREW JOSEPH RUSSELL**
Sphinx of the Valley, 1869,
albumen print, 23.2 x 31.4 cm (9 ⅛ x 12 ⅜ in.)

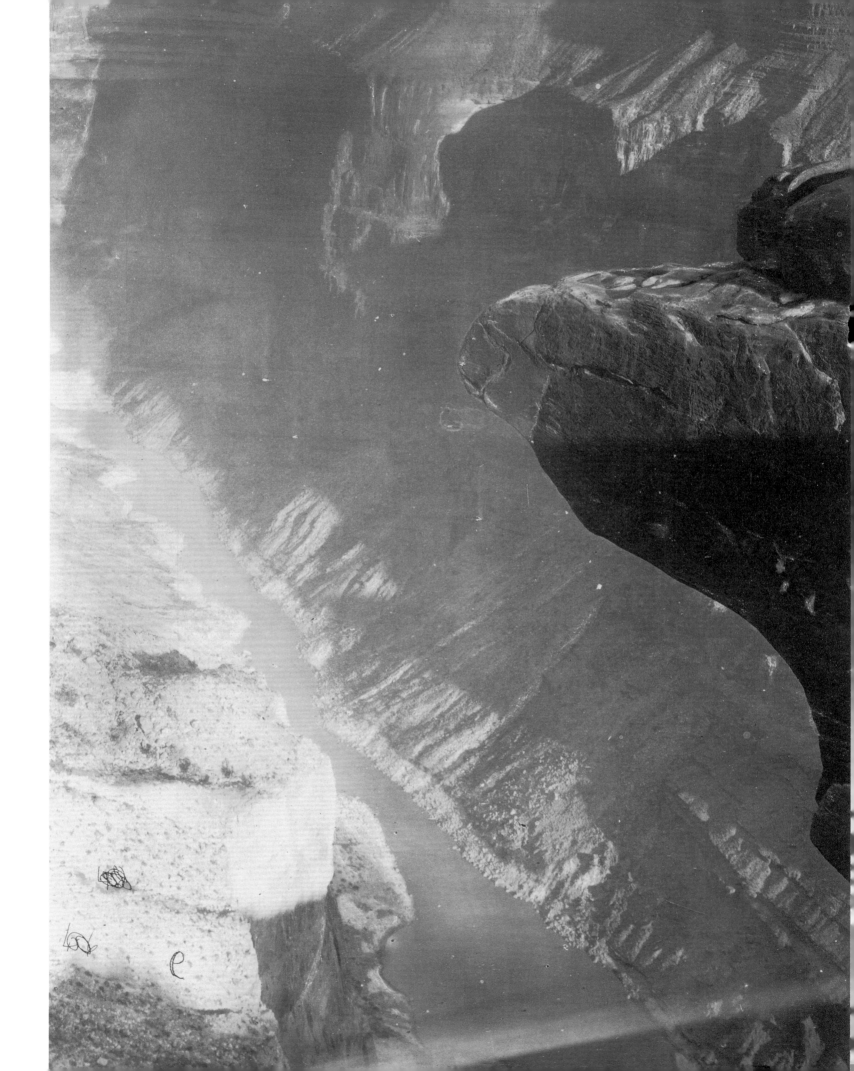

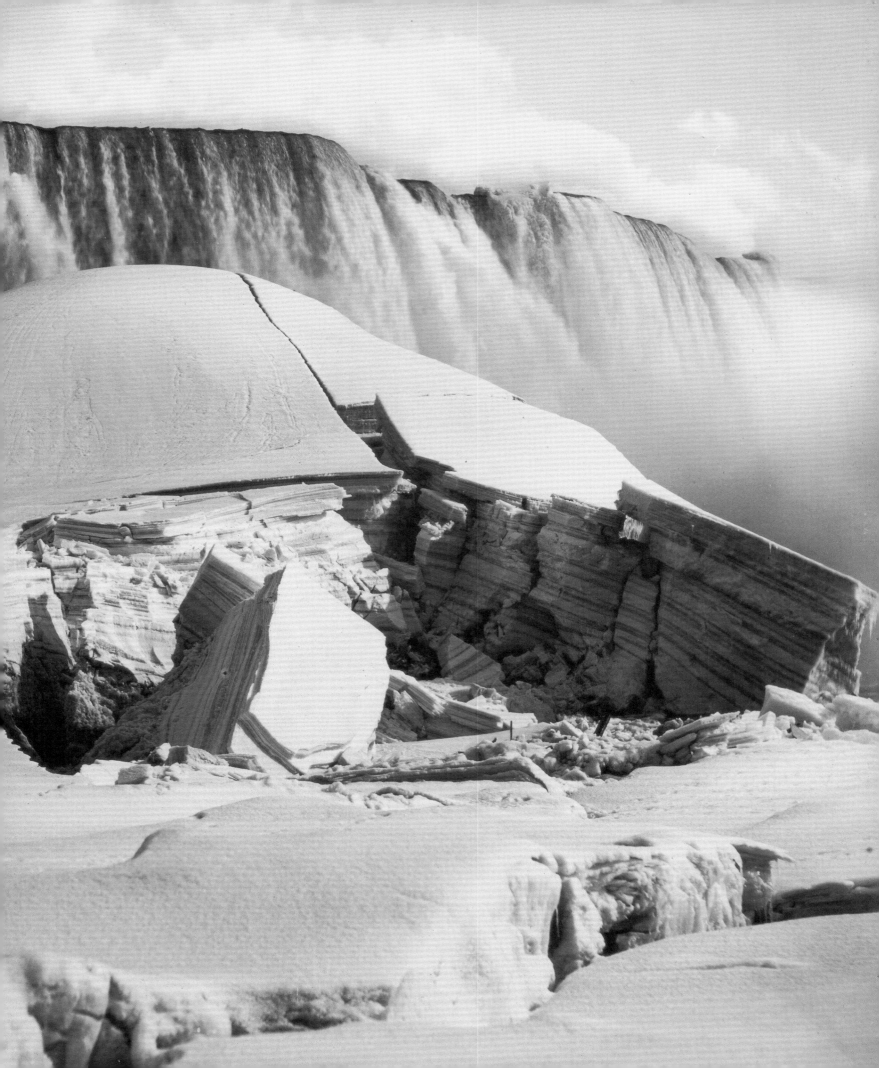

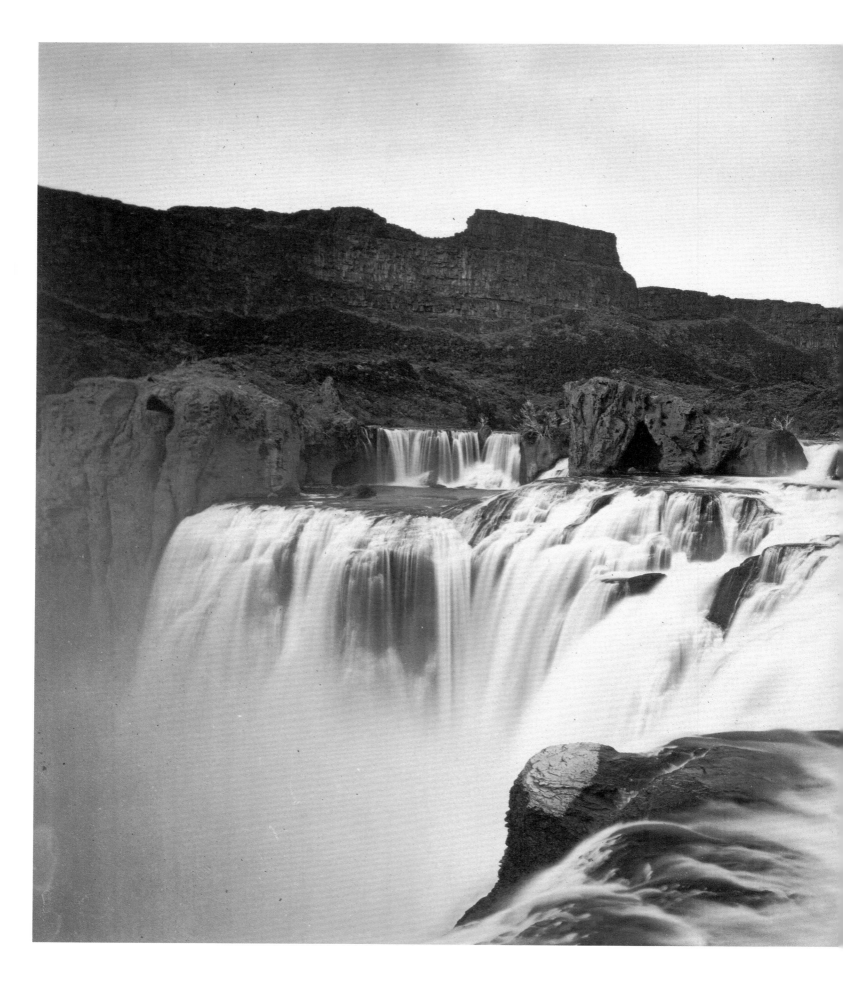

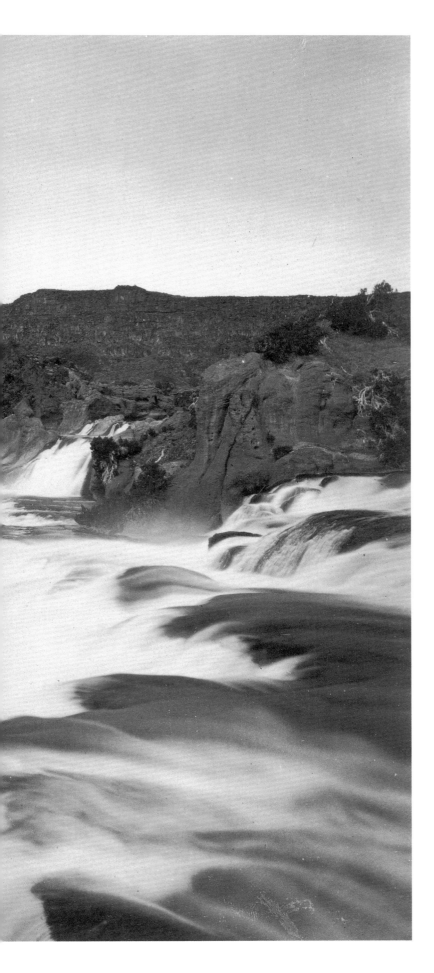

PLATE 39 **TIMOTHY O'SULLIVAN**
Shoshone Falls, Snake River, Idaho, View Across the Top of the Falls, 1874,
albumen print, 20.4 x 27.3 cm (8 x 10 ¾ in.)

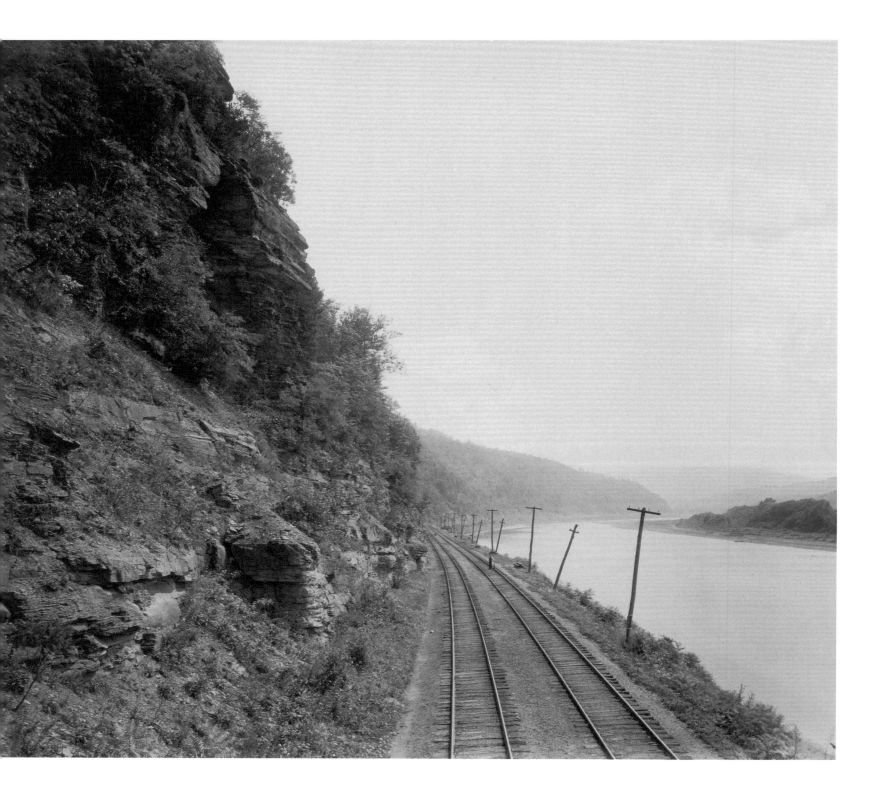

PLATE 40 **WILLIAM H. RAU**
Cathedral Rocks, Susquehanna River near Meghoppen, 1899,
albumen print, 43.8 x 51.8 cm (17 ¼ x 20 ⅜ in.).
Gift of Dr. and Mrs. Charles T. Isaacs

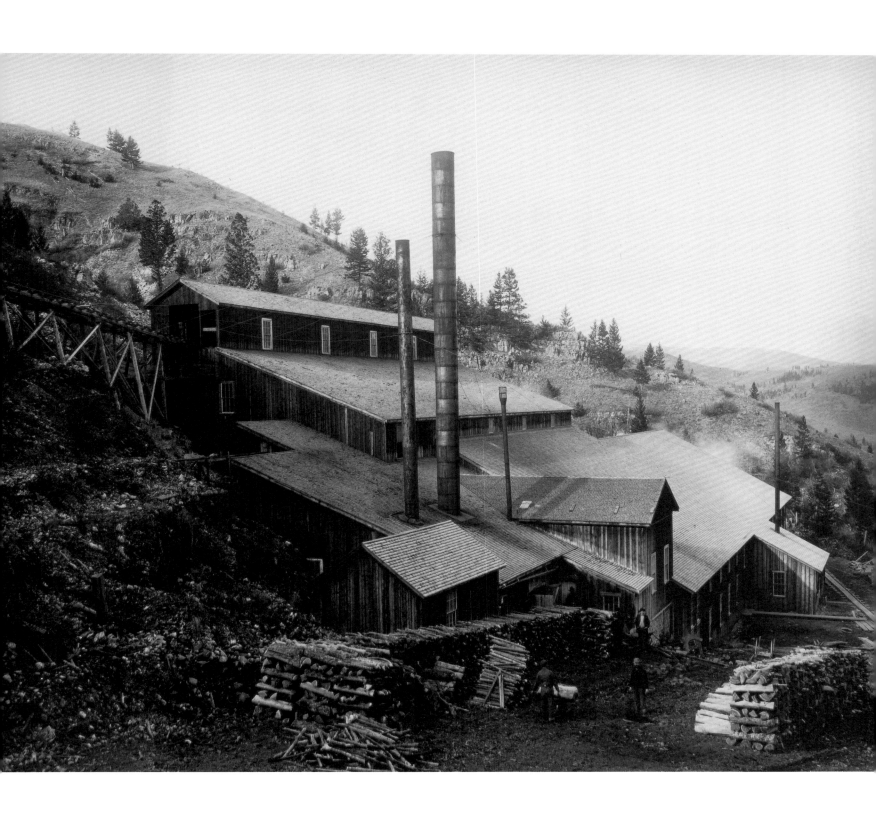

PLATE 41 **FRANK JAY HAYNES**
Gloster Mill, 60 Stamps, 24 Pans, 12 Settlers, ca. 1885,
albumen print, 43.2 x 55.2 cm (17 x 21 ¾ in.)

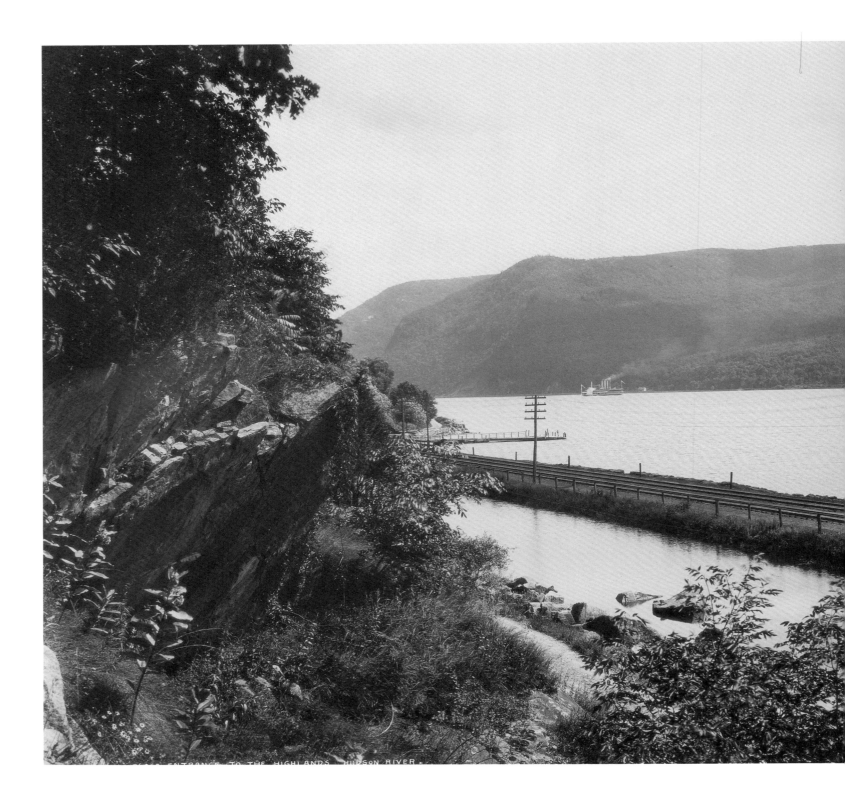

ENTRANCE TO THE HIGHLANDS, HUDSON RIVER.

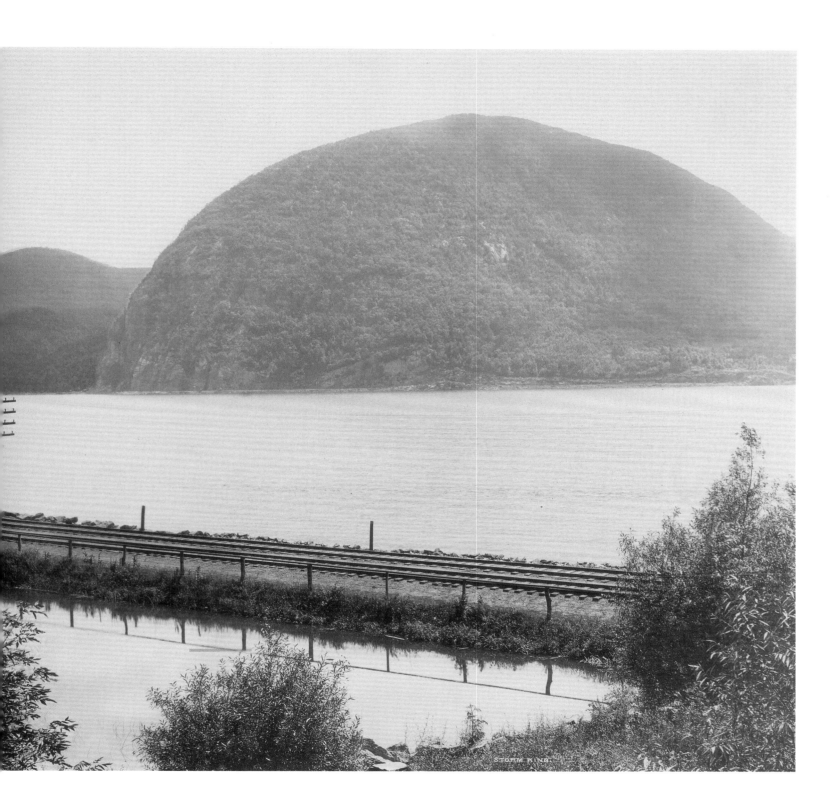

PLATE 42 **WILLIAM H. JACKSON** (attributed to)
for the Detroit Photo Co., *Entrance to the Highlands, Hudson River*, ca. 1898,
silver print, 43.8 x 98.4 cm (17 ¼ x 38 ¾ in.)

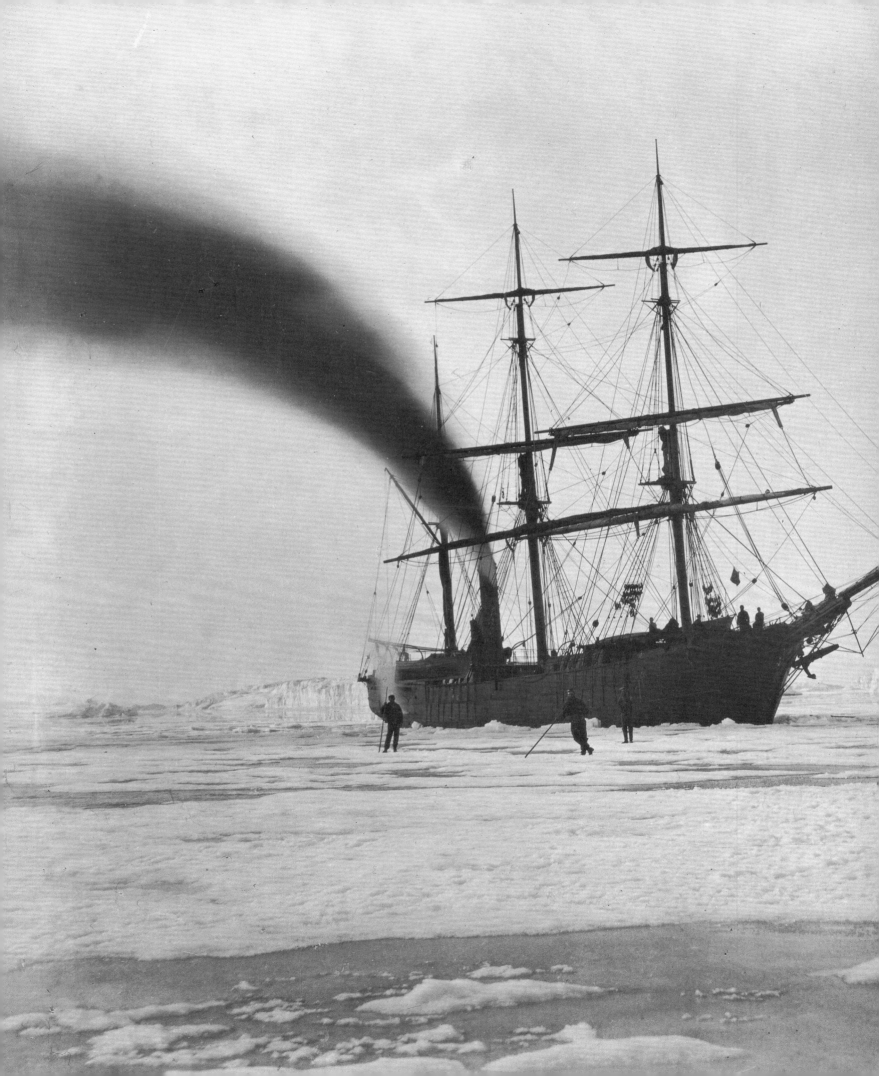

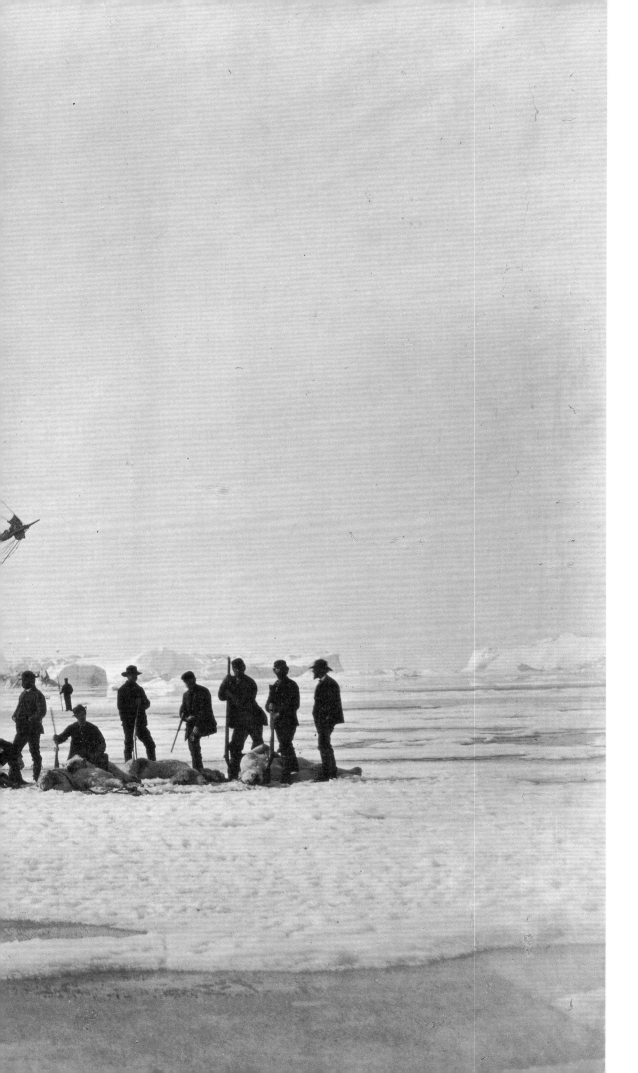

PLATE 43 **JOHN L. DUNMORE**
AND GEORGE CRITCHERSON
Hunting by Steam in Melville Bay...,
1869, albumen print,
27.7 x 38.8 cm (10 ⅞ x 15 ¼ in.).
Gift of Charles Isaacs

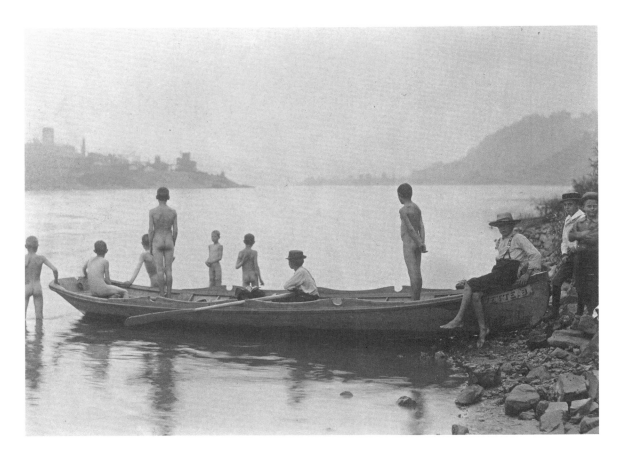

PLATE 44
THOMAS ANSHUTZ
Boys with a Boat, Ohio River,
Near Wheeling, West Virginia,
1880, cyanotype,
14.6 x 22.2 cm
(5 ¾ x 8 ¾ in.)

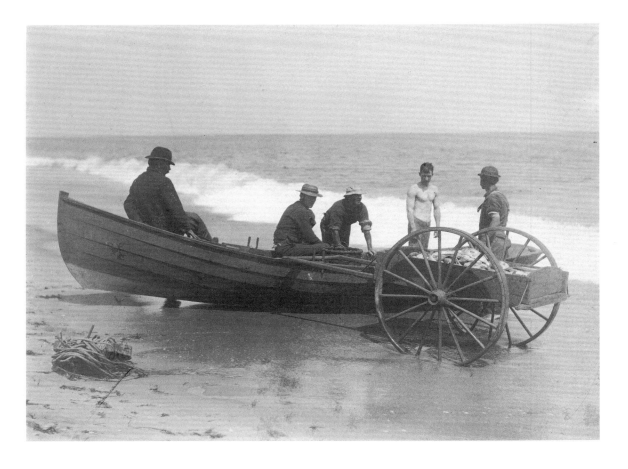

PLATE 45
LOUIS COMFORT TIFFANY
Fishermen Unloading a Boat,
Sea Bright, New Jersey, 1887,
albumen print,
15 x 20.7 cm
(5 ⅞ x 8 ⅛ in.)

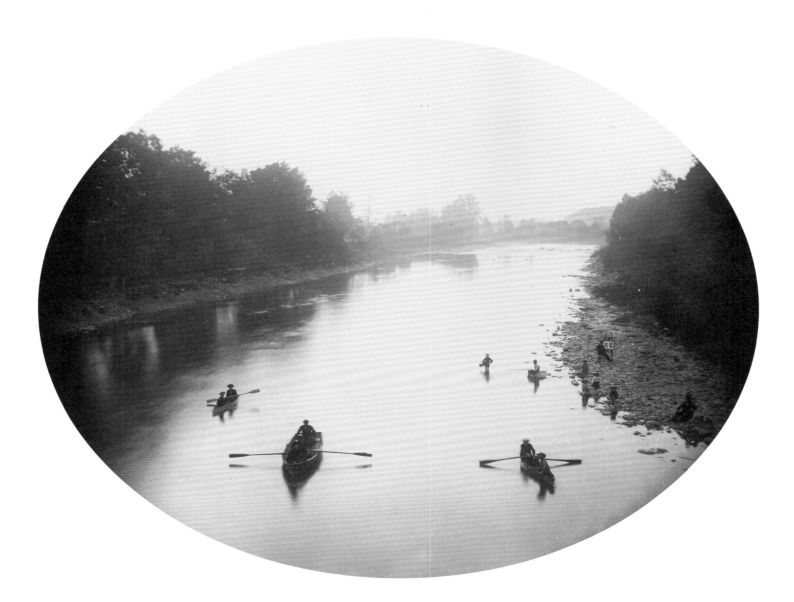

PLATE 46 **UNIDENTIFIED ARTIST**
View at Gervanda Looking Downstream from the Bridge, ca. 1880,
albumen print,
22.2 x 29.8 cm (8 ¾ x 11 ¾ in.)

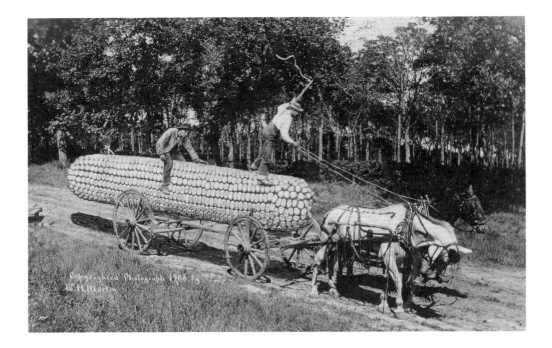

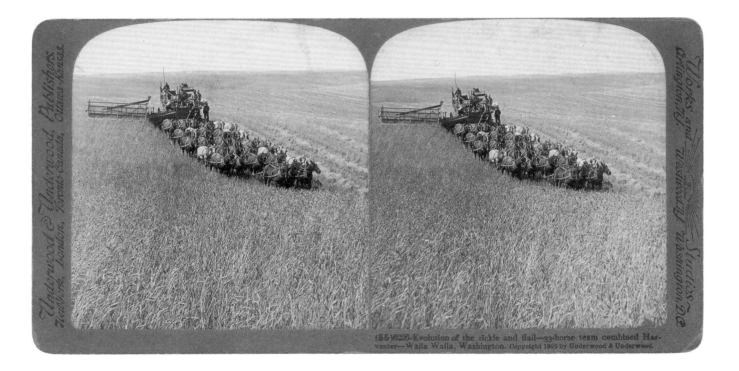

PLATE 47 **WILLIAM H. MARTIN**
Riding a Giant Corncob to Market, 1908, silver print (postcard),
8.9 x 13.4 cm (3 ½ x 5 ½ in.)

PLATE 48 **UNDERWOOD & UNDERWOOD**
Publisher: Underwood & Underwood, *Evolution of the sickle and flail—33-horse team
combined Harvester—Walla Walla, Washington,* 1902,
mounted albumen prints (stereograph card), each 8.3 x 7.9 cm (3 ¼ x 3 ⅛ in.)

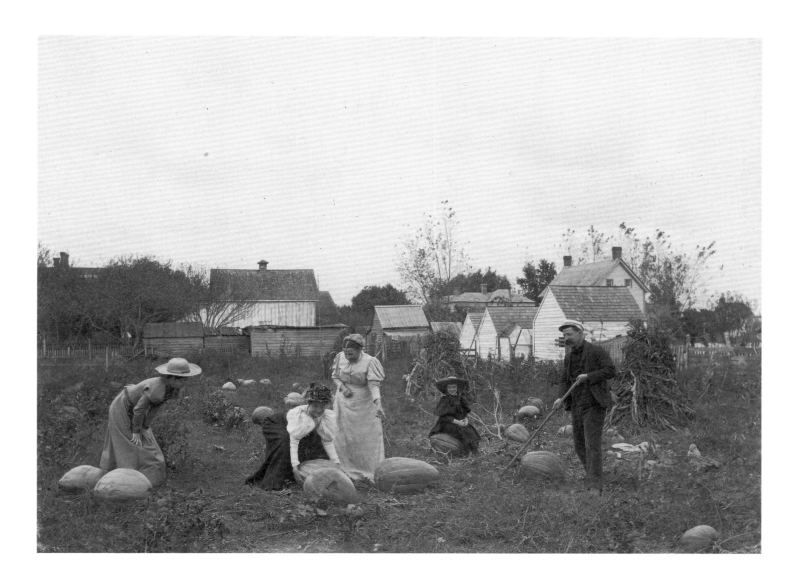

PLATE 49 **JAMES BARTLETT RICH**
In the Pumpkin Field at Lewes (The Photographer's Wife, His Daughter, and Friends), 1898,
silver print, 12.1 x 16.5 cm (4 ¾ x 6 ½ in.)

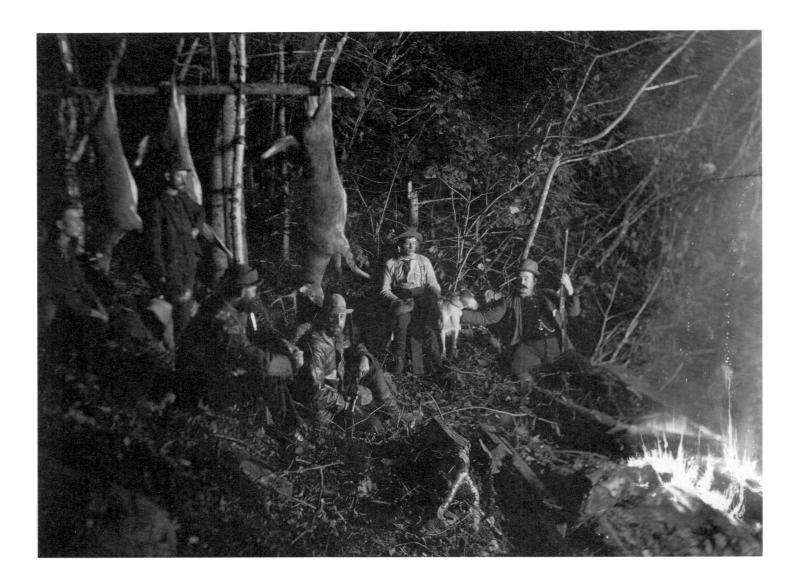

PLATE 50 **SENECA RAY STODDARD**
The Antlers, Open Camp, Raquette Lake, ca. 1889,
silver print, 15.6 x 20.7 cm (6 ⅛ x 8 ⅛ in.)

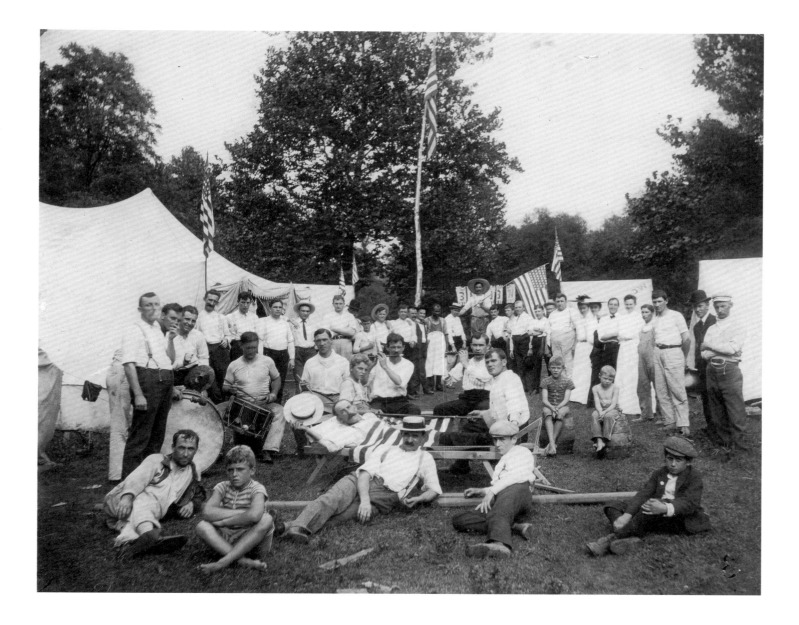

PLATE 51 **E. E. DICKINSON**
Group Portrait at a Patriotic Celebration, ca. 1915,
silver print, 19.4 x 24.8 cm (7 ⅝ x 9 ¾ in.)

87

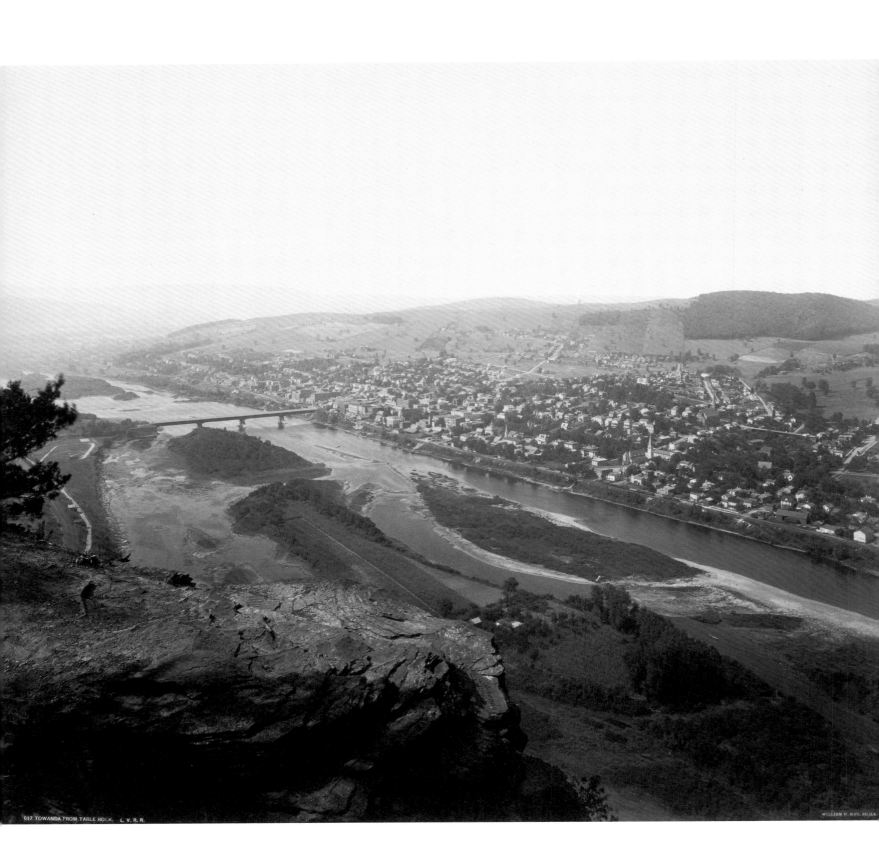

617 TOWANDA FROM TABLE ROCK. L. V. R. R.

WILLIAM H. RAU, PHILA.

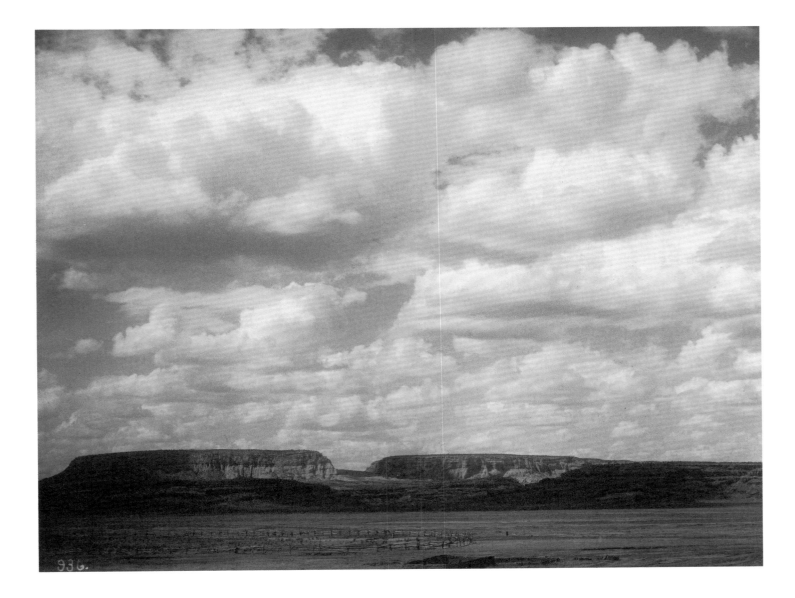

Plate 52 **WILLIAM H. RAU** (*opposite*)
Towanda from Table Rock, 1899,
albumen print, 43.8 x 52 cm (17 ¼ x 20 ½ in.)

Plate 53 **ADAM CLARK VROMAN** (*above*)
Around Zuni, From Northeast of Pueblo "99," 1899,
platinum print, 16.5 x 21.6 cm (6 ½ x 8 ½ in.)

PLATE 54 **UNIDENTIFIED ARTIST** (*opposite*)
"Forty-niner" Street Advertiser in Studio, San Francisco, 1890,
albumen print, 18.7 x 12.4 cm (7 ⅜ x 4 ⅞ in.)

PLATE 55 **WILLIAMS STUDIO** (*above*)
A Group of Chairs, Haverhill, Massachusetts, ca. 1924,
silver print, 15.9 x 20.6 cm (6 ¼ x 8 ⅛ in.)

PLATE 56 **BERTHA JAQUES**
Dandelion Seeds, Taraxacium Officinale, ca. 1910,
cyanotype photogram, 34.6 x 7.3 cm (13 ⅝ x 2 ⅞ in.)

PLATE 57 **ANNA K. WEAVER**
No Cross, No Crown, 1874,
albumen print of a photogram, 26.3 x 21.5 cm (10 ⅜ x 8 ½ in.)

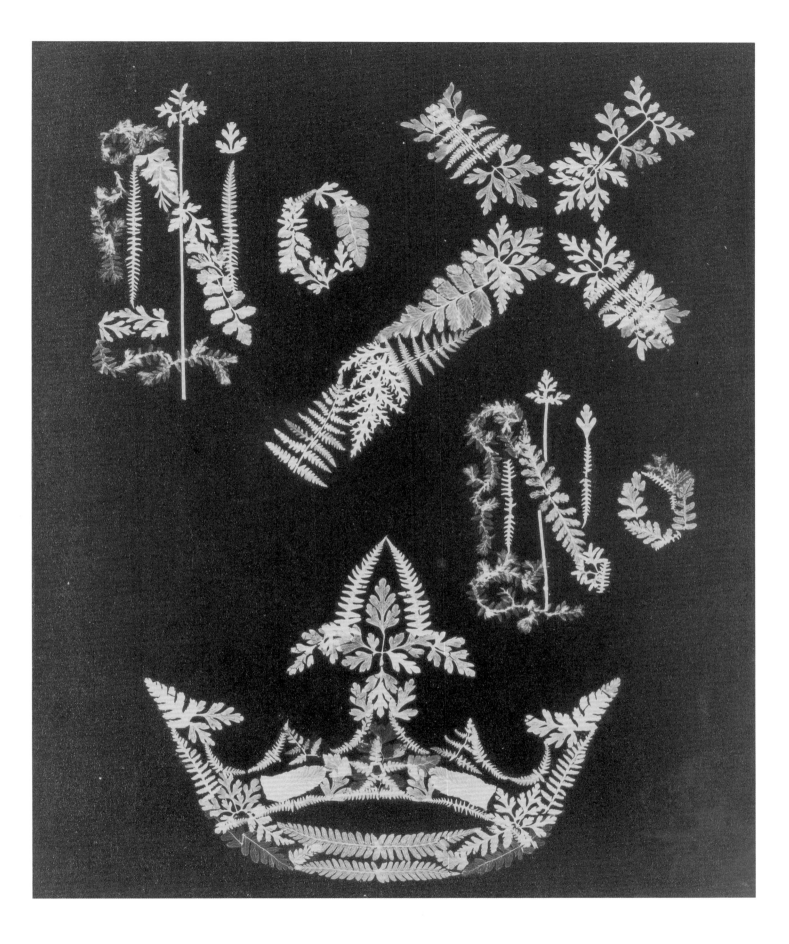

PLATE 58 **WILLIAM B. POST**
Apple Trees in Blossom, ca. 1897,
platinum print, 19.1 x 23.8 cm (7 ½ x 9 ⅜ in.)

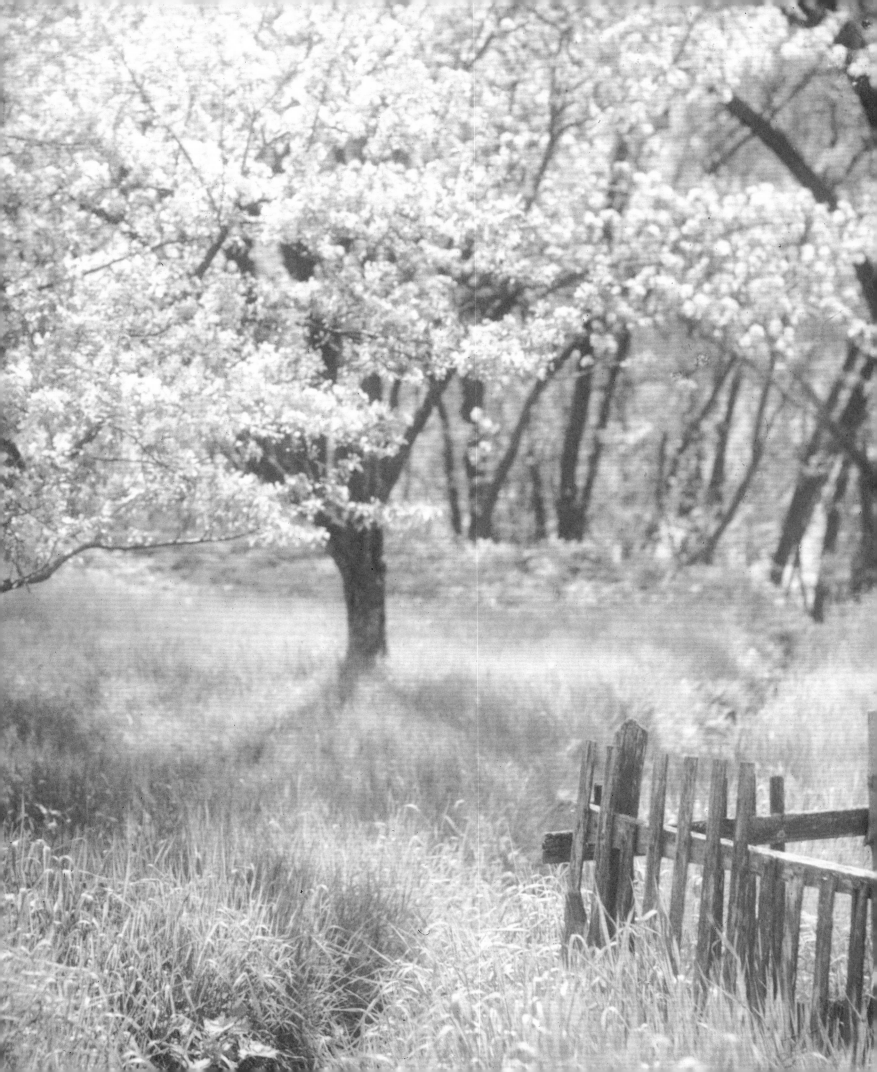

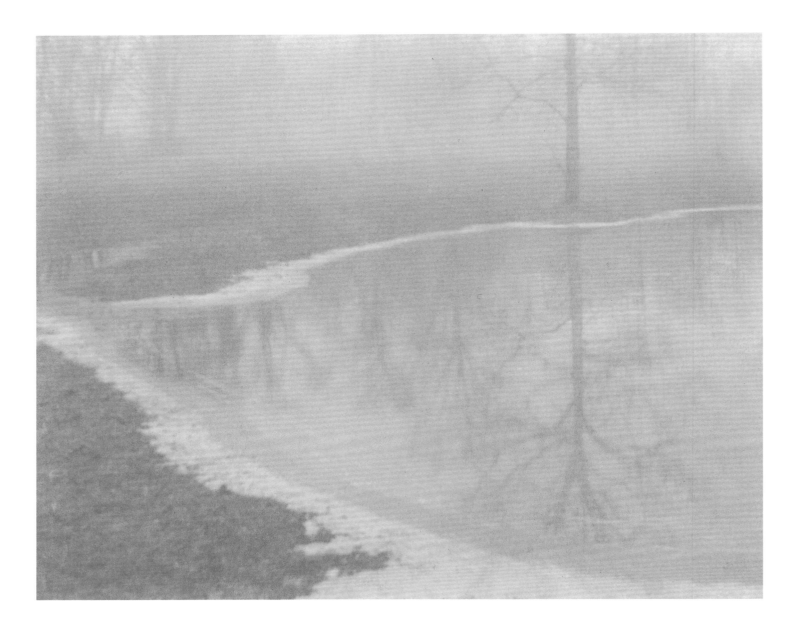

PLATE 59 **JOHN CHISLETT** *(above)*
Pond in the Fog, ca. 1900,
platinum print, 19 x 24.4 cm (7 ½ x 9 ⅝ in.)

PLATE 60 **DWIGHT A. DAVIS** *(opposite)*
A Quiet Pool (Early Evening), ca. 1905,
platinum print, 31.1 x 23.8 cm (12 ¼ x 9 ⅜ in.)

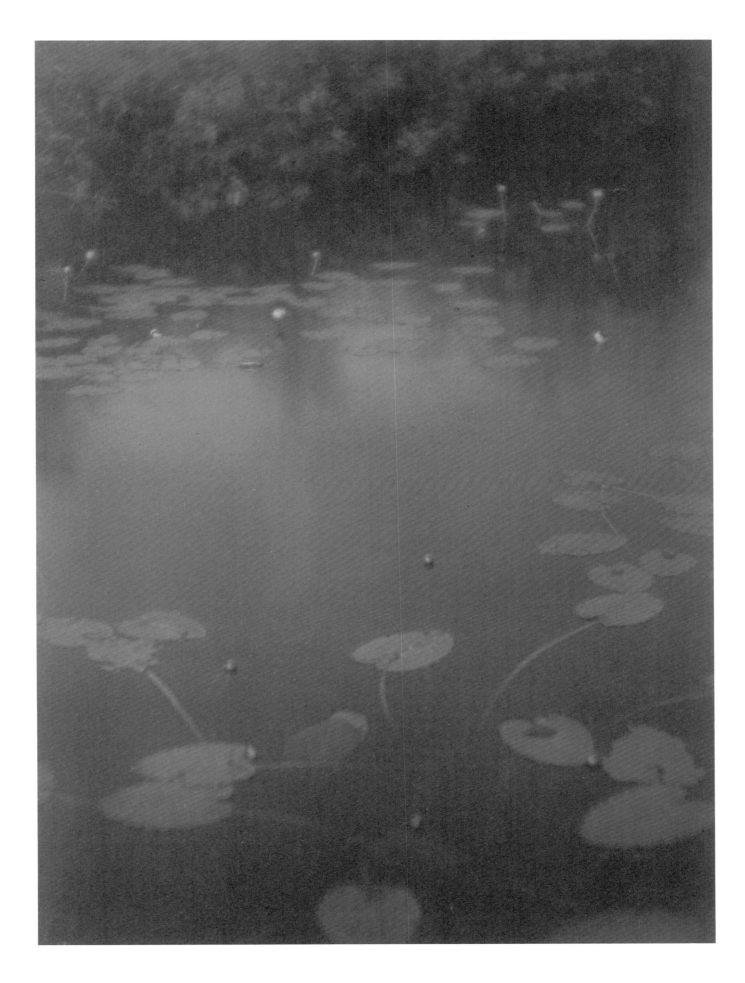

PLATE 61 **WILLIAM JAMES MULLINS**
Ploughman in Landscape, ca. 1900,
platinum print, 6.3 x 9.5 cm (2 ½ x 3 ¾ in.)

98

PLATE 62 **DORIS ULMANN**
Corn Shocks and Sky, ca. 1925,
platinum print, 18.4 x 15.3 cm (7 ¼ x 6 in.).
Gift of Dr. and Mrs. Charles T. Isaacs

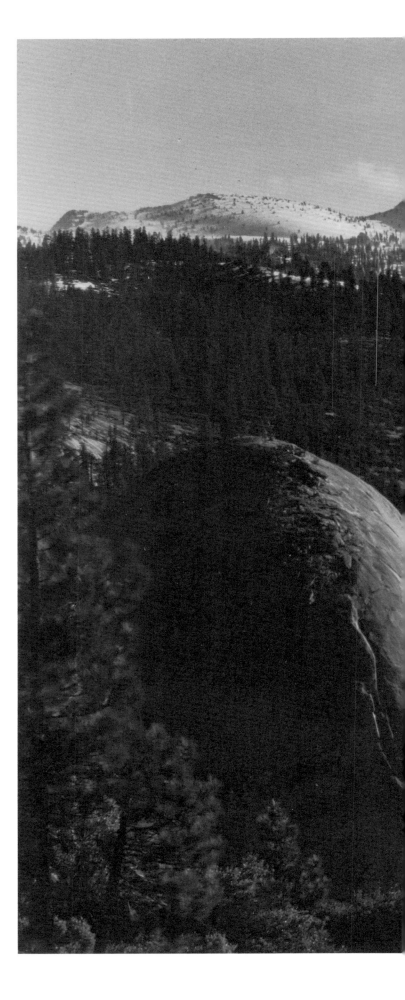

PLATE 63 **ANSEL ADAMS**
North Dome, Basket Dome, Mount Hoffman, Yosemite, ca. 1935,
silver print, 16.5 x 21.9 cm (6 ½ x 8 ⅝ in.)

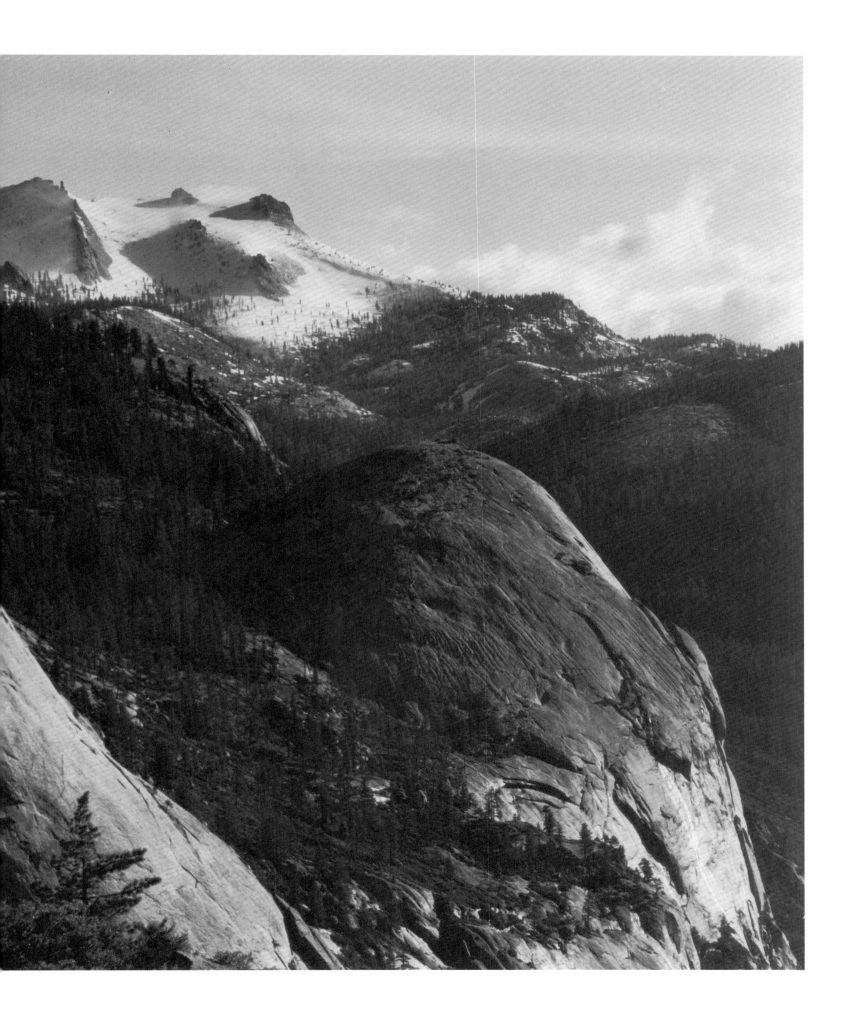

PLATE 64 **FORMAN HANNA** *(above)*
Cloud Study, ca. 1925,
silver print, 23.5 x 30.1 cm (9 ¼ x 11 ⅞ in.)

PLATE 65 **LAURA GILPIN** *(opposite)*
Pikes Peak and Colorado Springs, ca. 1926,
platinum print, 30.2 x 24.5 cm (11 ⅞ x 9 ⅝ in.)
Promised gift of Charles Isaacs

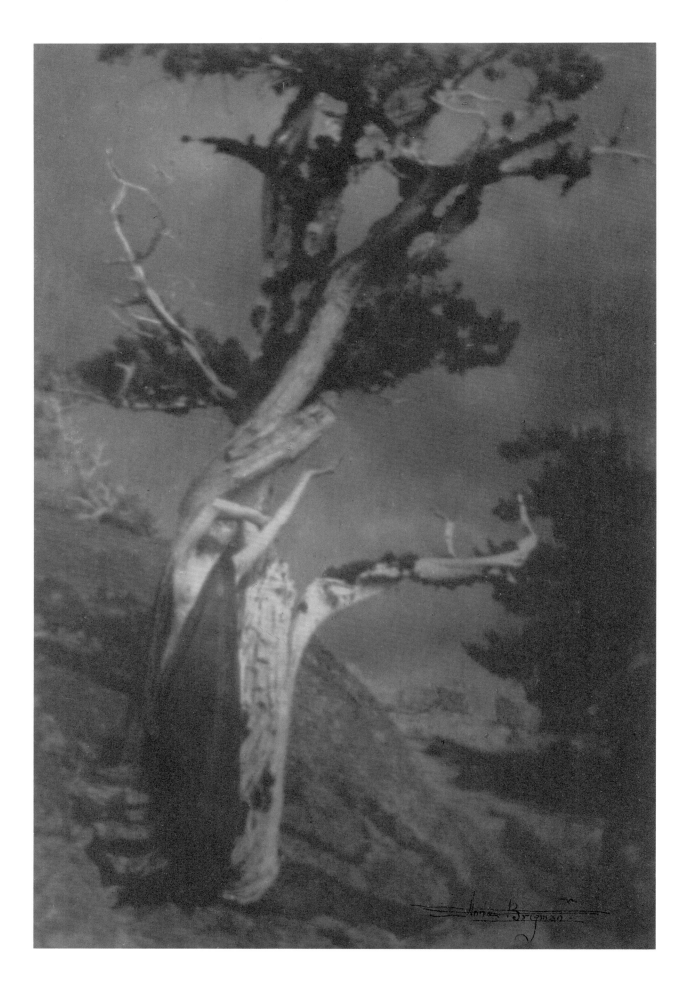

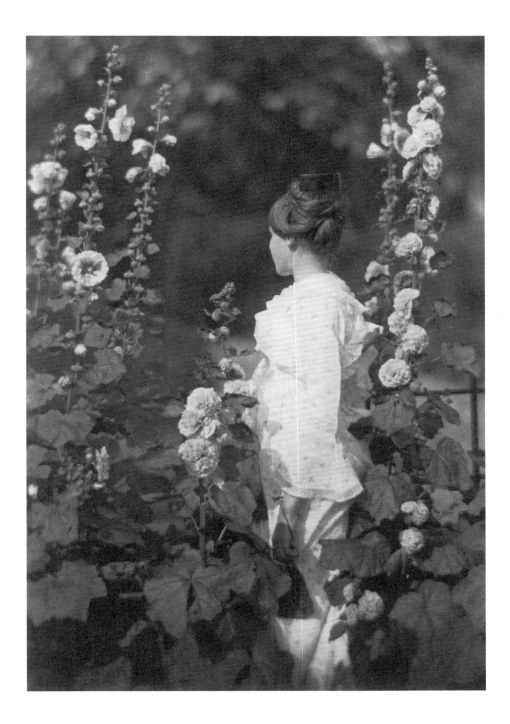

PLATE 66 **ANNE W. BRIGMAN** (*opposite*)
The Dying Cedar, 1906,
platinum print, 23.5 x 16.2 cm (9 ¼ x 6 ⅜ in.)

PLATE 67 **JOHN G. BULLOCK** (*above*)
Marjorie in the Garden, ca. 1903,
platinum print, 19.1 x 13.3 cm (7 ½ x 5 ¼ in.)

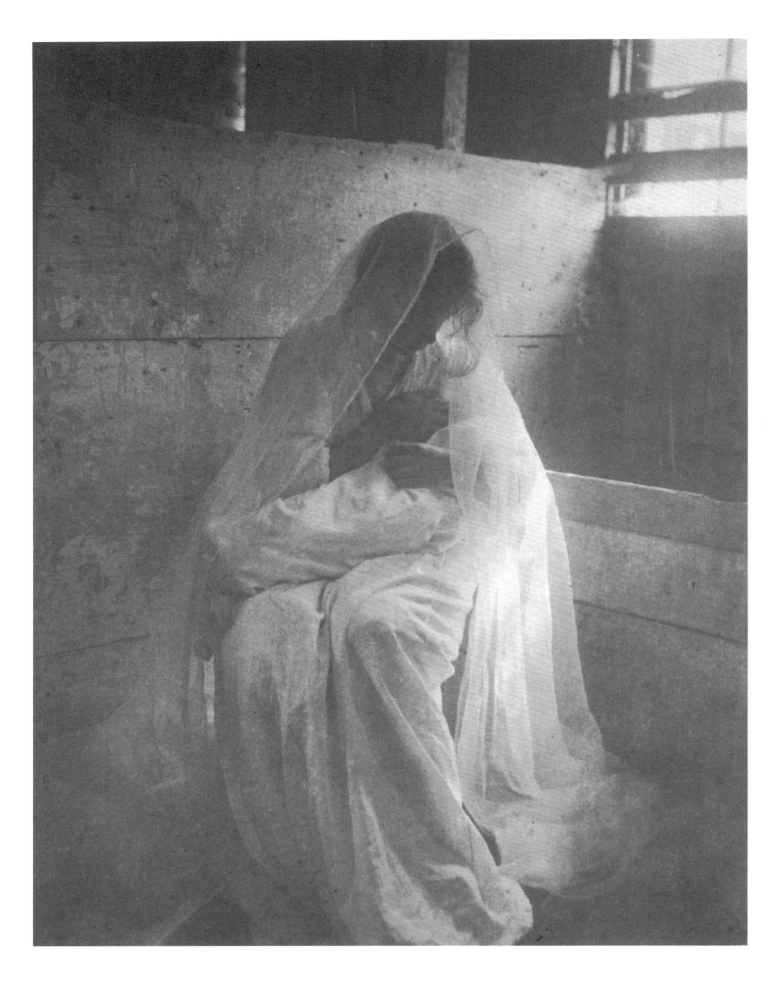

Plate 68 **Gertrude Käsebier** (*opposite*)
The Manger, 1899,
platinum print, 31.8 x 25.4 cm (12 ½ x 10 in.).
Gift of Charles Isaacs

Plate 69 **Imogen Cunningham**, possibly with **Roi Partridge** (*above*)
Self-Portrait, 1915,
platinum print, 9.5 x 11.5 cm (3 ¾ x 4 ½ in.)

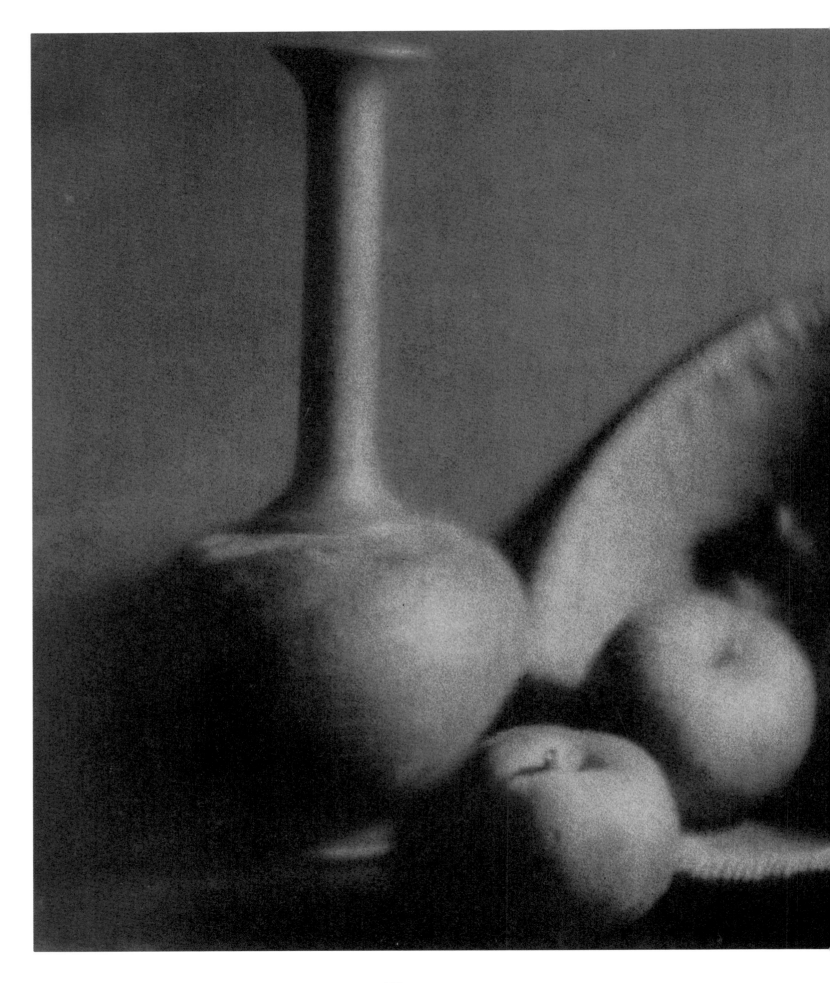

PLATE 70 **GEORGE SEELEY**
Still Life with Vase and Apples, 1916,
gum print, 38.1 x 50.2 cm (15 x 19 ¾ in.)

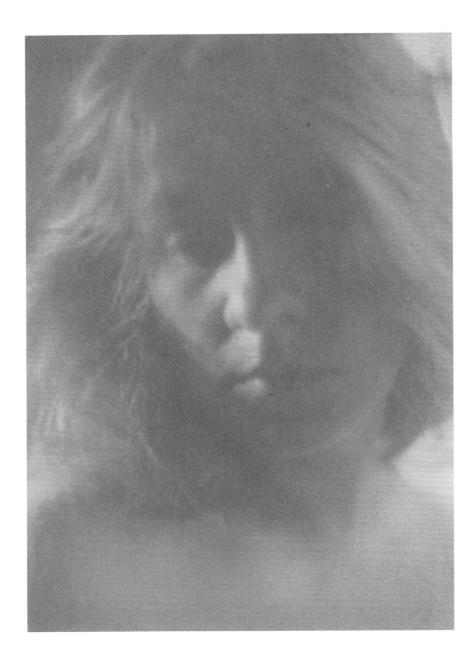

PLATE 71 **CLARA ESTELLE SIPPRELL**
Lucy Sipprell, ca. 1913,
platinum print, 15.9 x 11.4 cm (6 ¼ x 4 ½ in.)

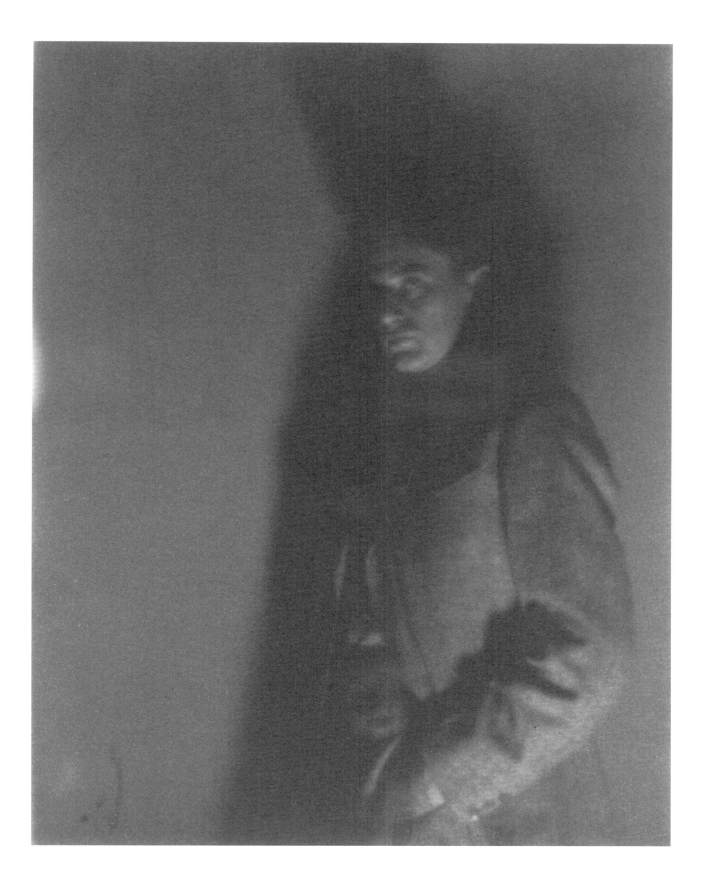

PLATE 72 **PAUL BURTY HAVILAND**
Portrait of a Man, ca. 1908,
platinum print, 25 x 20.3 cm (9 ⅞ x 8 in.)

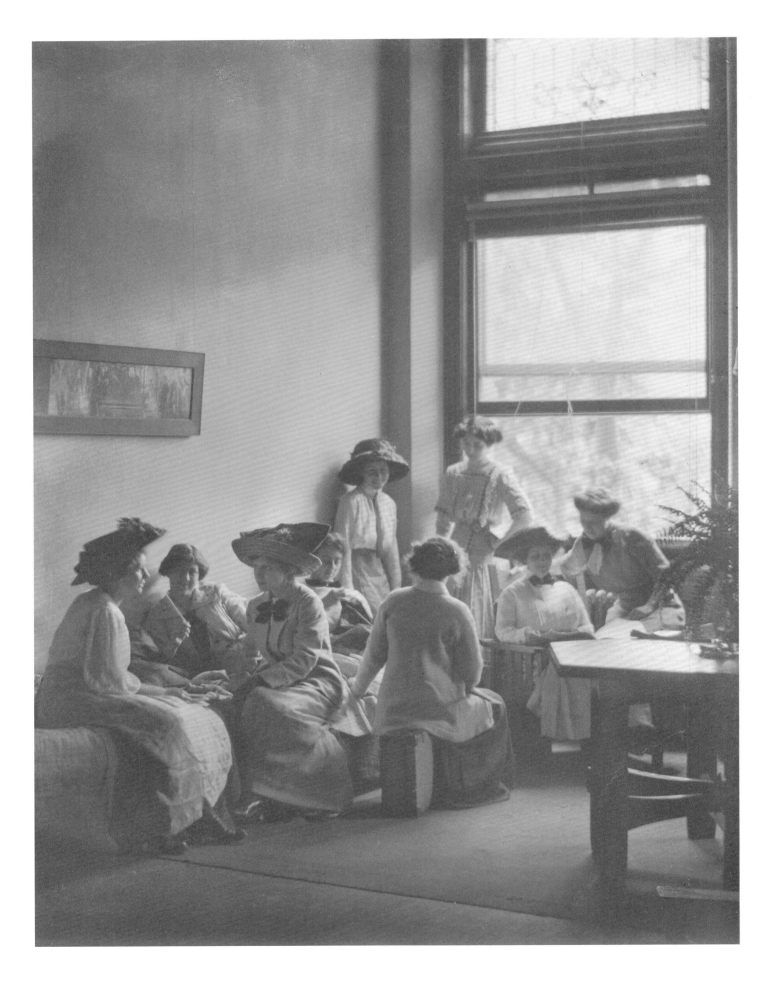

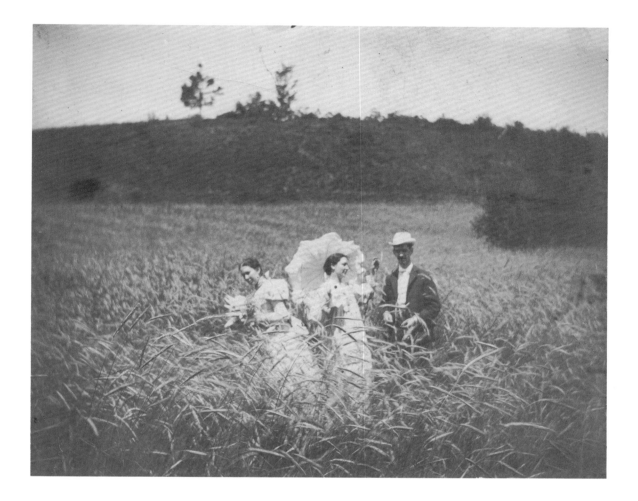

PLATE 73 **CLARENCE H. WHITE** (*opposite*)
Rest Hour (Columbia Teachers College), 1912,
silver print, 24.8 x 19.7 cm (9 ¾ x 7 ¾ in.)

PLATE 74 **UNIDENTIFIED ARTIST** (*above*)
Three Friends in a Field, ca. 1900,
silver print, 9.5 x 12.1 cm (3 ¾ x 4 ¾ in.)

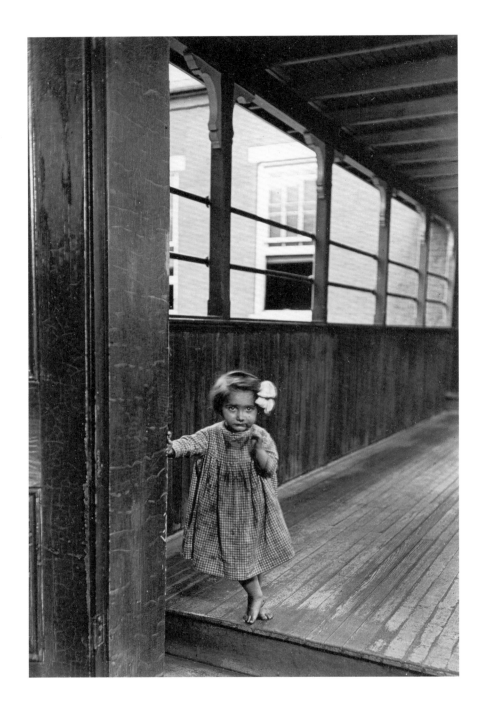

PLATE 75 **LEWIS HINE**
Little Orphan Annie in a Pittsburgh Institution, 1909/printed later,
silver print, 16.5 x 11.5 cm (6 ½ x 4 ½ in.)

PLATE 76 **JOHN FRANK KEITH**
Two Girls on a Stoop, Kensington, Philadelphia, ca. 1925,
silver print, 13.7 x 8.6 cm (5 ⅜ x 3 ⅜ in.)

115

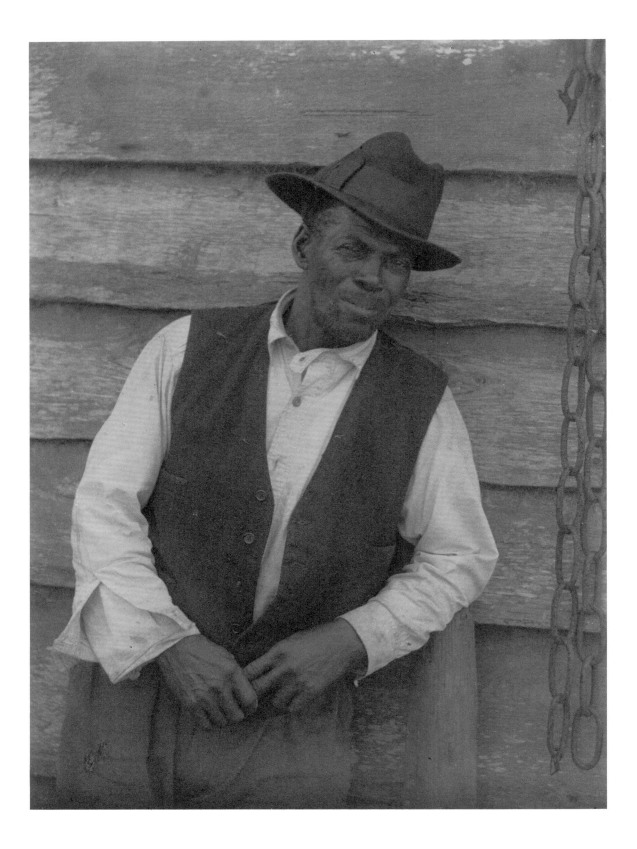

PLATE 77 **DORIS ULMANN**
Man Leaning against a Wall, ca. 1930,
platinum print, 20.3 x 15.3 cm (8 x 6 in.)

116

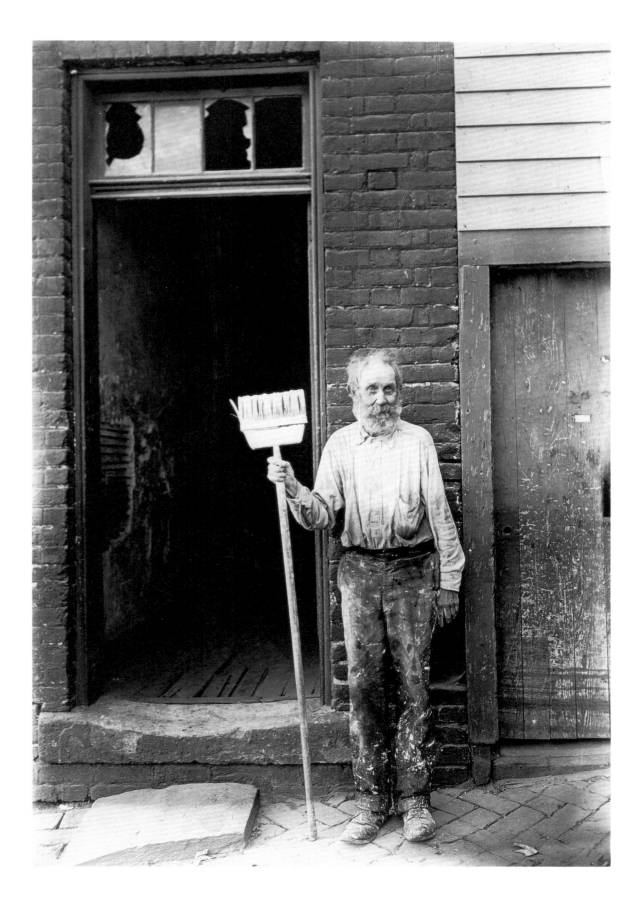

PLATE 78 **LEWIS HINE**
Handyman in Washington, DC, 1909,
silver print, 17.2 x 12.1 cm (6 ¾ x 4 ¾ in.)

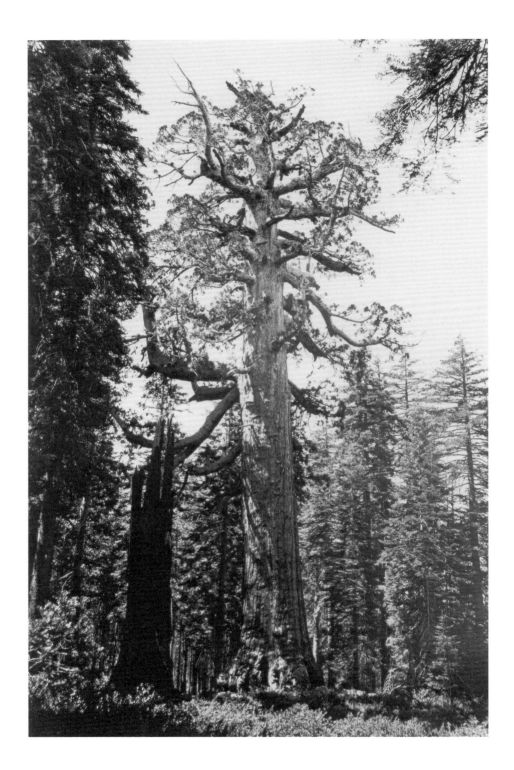

PLATE 79 **CARLETON E. WATKINS/I. W. TABER & CO.**
The Grizzly Giant, Mariposa Grove, Yosemite, 1861/printed ca. 1875
albumen print, 30.5 x 20 cm (12 x 7 ⅞ in.)

Catalogue of the Exhibition

ANSEL ADAMS 1902–1984

North Dome, Basket Dome, Mount Hoffman, Yosemite
ca. 1935, silver print
16.5 x 21.9 cm (6 ½ x 8 ⅝ in.) PLATE 63

One of the most influential photographers of the twentieth century, Adams spent a significant part of his adult life in Yosemite National Park. Born in San Francisco and trained as a musician, by 1920 he had begun making trips into the High Sierra; in 1924 he made his first important photographs there and began to publish both images and writings. Adams's work in both media contributed greatly to the American conservationist movement.

By the mid-1930s, when this photograph was taken, Adams had abandoned an earlier Pictorialist style in favor of the clean, sharp-focus vision of Group f/64. Along with Edward Weston, Imogen Cunningham, and Willard Van Dyke, Adams was a founding member of this group, dedicated to "a simple and direct presentation [of] purely photographic means." Adams's work, in particular, is characterized by meticulous technique and a dramatic celebration of the natural world.

Unlike his habit of returning over time to the same Yosemite vista, Adams seldom photographed Basket Dome, and never again from this vantage point. Because the negative does not exist in the Ansel Adams Archive, now housed at the Center for Creative Photography in Tucson, Arizona, we may assume that it was destroyed in a 1937 darkroom fire that consumed 5,000 of his Yosemite negatives.

THOMAS ANSHUTZ 1851–1912

Boys with a Boat, Ohio River, Near Wheeling, West Virginia, 1880
cyanotype
14.6 x 22.2 cm (5 ¾ x 8 ¾ in.) PLATE 44

As early as 1880, Anshutz was using his photographs as preparatory studies for paintings. Like Thomas Eakins, his teacher and colleague at the Pennsylvania Academy of the Fine Arts, Anshutz made photographs that served as compositional experiments or reminders of details of landscape or figures. As a painter committed to direct observation, Anshutz was intrigued by Eadweard Muybridge's sequential photographs of moving human figures and occasionally assisted him at the Academy.

Anshutz posed his models to capture body movements and gestures and provide outdoor compositional arrangements. The figures from another cyanotype, *Bathers*, as well as figures and compositional motifs from other photo sketches, were used for Anshutz's 1896 painting *Steamboat on the Ohio*.

Introduced in the 1840s and easy to process, cyanotypes were originally used by mapmakers and scientists. In the late nineteenth century the cyanotype found renewed interest among artists and amateur photographers.

GEORGE BARKER 1844 CANADA–1894 USA

Niagara in Summer, from Below, ca. 1888
combination print
50.2 x 41.9 cm (19 ¾ x 16 ½ in.)

The Falls in Winter, ca. 1888
albumen print
41.3 x 48.2 cm (16 ¼ x 19 in.) PLATE 38

Though his original aim was to be a landscape painter, Barker worked his entire career as a photographer. Settling in Niagara, New York, in 1862, he opened Barker's Stereoscopic View Manufactory and Photograph Rooms, marketing views, as well as curios and souvenirs, of a natural wonder that embodied the power and optimism associated with America.

By the mid-1880s spectacular images of the Falls were his trademark. They were composed for dramatic effect: a darkened sky, the contrast of churning white water with dark rocks, and an emphasis on tremendous scale. When appropriate, he retouched or added details with pen or pencil, such as the rock in the foreground of *Niagara in Summer, from Below*. Displayed in his variety-store gallery and purchased as art or memento, the photographs were shipped to all parts of the world.

GEORGE N. BARNARD 1819–1902

Bonaventure, Savannah, Georgia, ca. 1866
albumen print
25.4 x 35.9 cm (10 x 14 ⅛ in.)

The "Hell Hole," New Hope Church, Georgia, 1866
albumen print
25.7 x 35.9 cm (10 ⅛ x 14 ⅛ in.)

A well-known daguerrean artist in Oswego, New York, George N. Barnard had opened a photography studio in Syracuse by 1854. He subsequently became affiliated with Mathew Brady's gallery in Washington, D.C., and photographed Lincoln's inauguration in 1861. As an official Union Army photographer during the Civil War, he was given two mules, a covered wagon, and an African-American driver to follow several military campaigns, most notably General William Tecumseh Sherman's famous march in 1864 from Chattanooga to Atlanta. His reminiscences of Generals Sherman, Ulysses S. Grant, and Joseph Hooker made interesting reading for patrons of *Harper's Weekly*, *Leslie's*, and other contemporary periodicals and were illustrated by line engravings of his photographs. Prompted by the success of Alexander Gardner's *Photographic Sketch Book of the War*, Barnard published *Photographic Views of Sherman's Campaign* in 1866. Including sixty-one photographs, a small volume of historical text, and several official campaign maps, the album weighed twenty pounds and sold for one hundred dollars.

Barnard made at least three photographs of the area around New Hope, Georgia, after the week-long battle in May 1864 between General Joseph Johnston's southern forces and Sherman's troops. He often focused on broken trees and ravaged ground, as

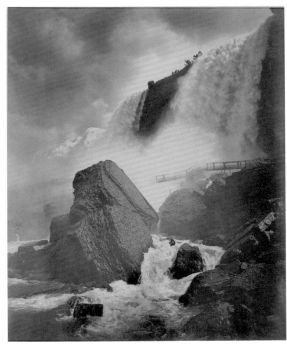

GEORGE BARKER, *Niagara in Summer, from Below*

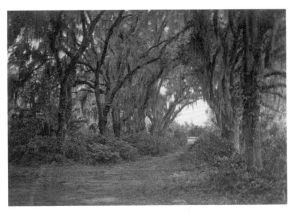

GEORGE N. BARNARD, *Bonaventure, Savannah, Georgia*

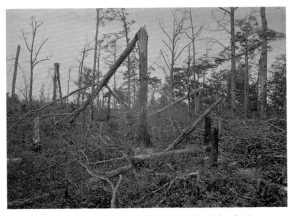

GEORGE N. BARNARD, *The "Hell Hole," New Hope Church, Georgia,*

well as other melancholy views, such as the Jones Memorial on the grounds of Bonaventure Plantation near Savannah. Barnard's album presents a complex symbolic picture of the appalling losses suffered in this national conflict.

WILLIAM BELL 1830 ENGLAND–1910 USA

General H. A. Barnum, Recovery After a Penetrating Gunshot Wound..., 1865
albumen print
21.6 x 16.8 cm (8 ½ x 6 ⅝ in.) PLATE 14

Heads and Fragments of Heads of Humeri..., 1865
albumen print
18.4 x 22.2 cm (7 ¼ x 8 ¾ in.) PLATE 18

Pvt. Charles Myer, Amputation of the Right Thigh, 1865
albumen print
21.6 x 18.1 cm (8 ½ x 7 ⅛ in.)

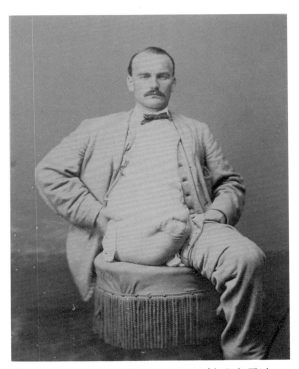

WILLIAM BELL, *Pvt. Charles Myer, Amputation of the Right Thigh*

After serving in the war between the United States and Mexico in 1846–48, Bell went to work for his brother-in-law, Philadelphia daguerreotypist John A. Keenan, and opened his own studio there in 1860. During the Civil War, Bell served with the First Regiment of Pennsylvania Volunteers; after the war, he became head of the photographic department at the newly created Army Medical Museum in Washington, D.C.

The museum collected and commissioned photographs to study "all specimens of morbid anatomy, surgical or medical, which may be regarded as valuable...to the study of military medicine or

surgery." According to a report written by the editor of the *Philadelphia Photographer*, "The principal work of the photographer is to photograph shattered bones, broken skulls, and living subjects, before and after surgical operations. Of course, all these subjects were created by the war." Besides forming an in-house archive, the photographs were used to aid the engraver in making woodcuts to illustrate medical books.

Cañon of Kanab Wash, Colorado River, Looking South, 1872
albumen print
27.6 x 20 cm (10 ⅞ x 7 ⅞ in.) PLATE 32

Grand Cañon, Colorado River, near Paria Creek, Looking West, 1872
albumen print
27.3 x 20 cm (10 ¾ x 7 ⅞ in.)

Looking South into the Grand Cañon, Colorado River, Sheavwitz Crossing, 1872
albumen print
20.3 x 27.6 cm (8 x 10 ⅞ in.) PLATE 33

Perched Rock, Rocker Creek, Arizona, 1872
albumen print
27.3 x 20.3 cm (10 ¾ x 8 in.) PLATE 29

Bell left Washington in 1872 to accompany Lieutenant George Wheeler's Geographical Explorations and Surveys west of the 100th meridian.

CHARLES BIERSTADT 1819 GERMANY–1903 USA

The Rapids, Below the Suspension Bridge, ca. 1870
albumen print
17.8 x 23.5 cm (7 x 9 ¼ in.)

Charles Bierstadt was the brother of Albert, a renowned landscape painter, and Edward, a photographer and publisher who had the American rights to the albertype printing process. All three of them had been initially drawn to photography, trading their established New Bedford, Massachusetts, woodworking shop for cameras and a stereo photography business. In 1867 Charles moved to Niagara. He later published books of stereo views with Edward, and in 1882 he was one of three photographers selected by the commercial stereo photography business of Underwood & Underwood to supply them with popular and historic views.

Located two miles below the Falls, the Niagara suspension bridge, spanning more than eight hundred feet over one of the wildest parts of the Niagara River, was considered a marvel of modern technology. Designed by John Augustus Roebling and completed in 1855, the bridge was built primarily to link the trunk line of the New York Central Railroad to the Great Western Railway of Canada. The railway was on the upper level, a road on the lower. Juxtaposing the wildness of nature and this manmade marvel, Bierstadt produced a dramatic picture. The bridge appears solid and safe in contrast to the chaos of the unruly river. Photographed at river level, the waters seem even more threatening,

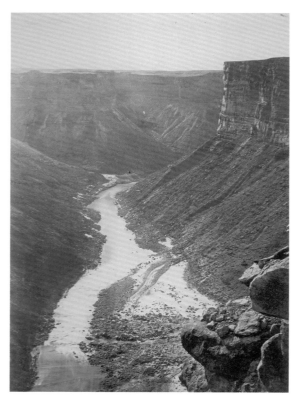

WILLIAM BELL, *Grand Cañon, Colorado River, near Paria Creek, Looking West*

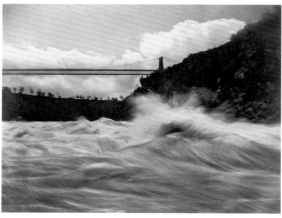

CHARLES BIERSTADT, *The Rapids, Below the Suspension Bridge*

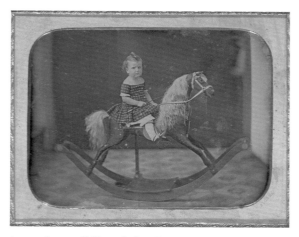

ALBERT BISBEE, *Child on a Rocking Horse*

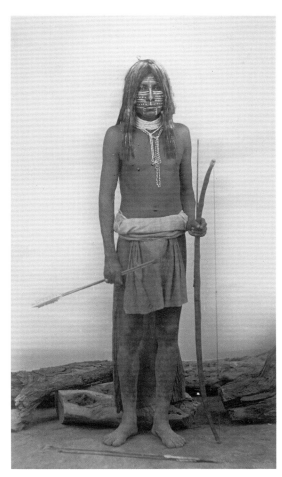

Elias A. Bonine 1843–1916

Maricopa Indian, Arizona, ca. 1875
albumen print
19 x 11.1 cm (7 ½ x 4 ⅜ in.)

Born in Lancaster, Pennsylvania, Elias Bonine was one of three brothers, all of whom were photographers. Moving to California in 1876, he traveled throughout the state and photographed in remote areas, using his tent as both home and darkroom. He subsequently settled in Lamanda Park, near Pasadena.

Bonine was one of the most prolific photographers of Native American portraits in the carte-de-visite format. Unlike the earlier work of government-survey photographers or of early anthropologists who used photography as field research, Bonine's images were made for a public audience increasingly enthralled by native subjects. His several trips to Arizona in the 1870s and 1880s produced hundreds of portraits of members of the Yuman tribes, including the Maricopas. Photographing his subjects in a temporary studio, Bonine attempted to add "natural" touches such as rocks or logs rather than the usual props of chair or curtain. Bonine's photographs were staged, calculated for a buying public who preferred the romance of the disappearing Indian to a more truthful and authentic presentation.

Henry Bosse 1844 Prussia–1903 usa

Mouth of the St. Croix River
from the series *Upper Mississippi River*, 1885
cyanotype
37.5 x 43.5 cm (14 ¾ x 17 ⅛ in.)

adding energy to the scene. In order to achieve all of these effects in a single balanced image, Bierstadt probably used several negatives: one for the river, another for the bridge, a third for the dramatic, billowing clouds.

Albert Bisbee active 1850s

Child on a Rocking Horse, ca. 1855
daguerreotype
half plate

Bisbee was a daguerreotypist, photographer, inventor, and author. His *History and Practice of Daguerreotyping* was published in 1853, the same year he opened a photography studio in partnership with James Robertson on Main Street in Dayton, Ohio. He later operated portrait studios in Cleveland, Columbus, and Zanesville. The rocking horse was a popular prop for photographers, who were often called upon to take portraits of children. The toy's presence in so many pictures suggests that clients of city studio photographers were often members of the rising middle class, who could afford not only a rocking horse but the relative luxury of portraits of their children.

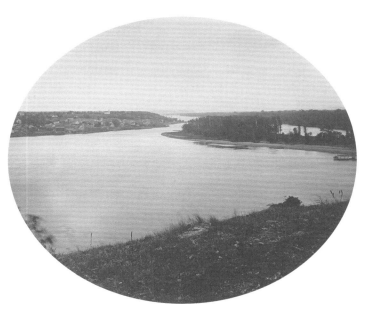

Born in Prussia in 1844, Bosse immigrated to America about 1870. Entering the service of the U.S. Corps of Engineers as a draftsman in 1874, he was chief draftsman by 1887. During his tenure he produced photographs, maps, and drawings of engineering projects along the Upper Mississippi River. Many of the photographs were printed as cyanotypes, a process that provided easy and economical proofs for study, and were later bound into albums with elaborately hand-decorated and lettered title pages. Presented to various dignitaries of the Corps of Engineers, the prints were also exhibited at the World's Columbian Exposition in 1893.

BRADY STUDIO, PHOTOGRAPHER: ALEXANDER GARDNER
1821 SCOTLAND–1882 USA

Mr. Wilkeson, ca. 1859
salted paper print
47 x 36.2 cm (18 ½ x 14 ¼ in.) PLATE 12

Having learned the daguerreotype process from Samuel F. B. Morse and John William Draper, Mathew Brady (1823–1896) opened a daguerreotype studio in New York City ca. 1842. He soon became one of the city's leading portrait photographers. The Brady Studio—Brady usually took credit but, in fact, executed few of the portraits himself—took pictures of the nation's most prominent figures, including the president, military leaders, businessmen, artists, and writers. Among the latter was Samuel Wilkeson (1817–1889), a journalist who worked for Horace Greeley's *New York Tribune* at the time he was photographed. Later, Wilkeson, like Brady, followed the events of the Civil War, traveling with the Army of the Potomac as a reporter for the *New York Times*. He arrived at Gettysburg on the last day of the battle, only to discover his oldest son's body among the fallen. His dispatch was written July 4, 1863, soon after the battle: "My pen is heavy. Oh! You dead at Gettysburg have baptized with your blood the second birth of freedom in this country."

The introduction of glass negatives made it possible to produce larger and more impressive images such as this salted paper print of Mr. Wilkeson. It was meticulously retouched with india ink to sharpen and darken the shadows around the folds of drapery and suit fabric.

BRADY STUDIO

The Sick Soldier, ca. 1863
albumen print
14.3 x 20 cm (5 ⅝ x 7 ⅞ in.) PLATE 19

When the Civil War began, Brady obtained permission for himself and his staff (which at various times included Alexander Gardner, George Barnard, John Reekie, and Timothy O'Sullivan, among others) to travel with the troops. He published all photographs, both by himself and others, under the name Brady & Co. Like most photographers during the war, Brady rarely photographed actual battles. Cumbersome camera equipment and slow exposure times made it difficult to capture action. Instead, they focused on

the aftermath of battle, military portraits, and scenes of camp life. Brady's expertise as a studio photographer may have suggested the posed drama of *The Sick Soldier*. His picture of a Northern soldier being aided by another played to the collective trauma of mid-nineteenth-century American households, most of whom, like Samuel Wilkeson, had suffered the loss of a relative or friend.

ANNE W. BRIGMAN 1869–1950

The Dying Cedar, 1906
platinum print
23.5 x 16.2 cm (9 ¼ x 6 ⅜ in.) PLATE 66

Anne W. Brigman (born Anne Wardrope Nott and married in 1894 to Martin Brigman, a San Francisco sea captain) was known for her photographs of female nudes in landscape settings. Enjoying early success as a Pictorialist, she was a member of the Camera Club of San Francisco and the Photo-Secession group. The January 1909 issue of *Camera Work* published five of Brigman's photographs, including *The Dying Cedar*, accompanied by this statement: "Mrs. Annie W. Brigman, of Oakland, California, has during the past few years gained a prominent position amongst American camera workers." Because critics unfamiliar with California and the Sierra Nevada sometimes accused Brigman of staging photographs in her studio, the editors added: "These negatives are not produced in a studio 'fitted up with papier-maché trees and painted backgrounds,' but have been taken in the open, in the heart of the wilds of California."

Nature was paramount in Brigman's life and work. Often using herself or friends as models for her photographs of nudes she usually juxtaposed the figures with trees or rocks, reflecting her celebration of woman and nature as parallel sources of energy. Brigman also wrote expressive poetry, and in 1929 she published a book of poems titled *Songs of a Pagan*. These lines from the poem *Cry* describe her photograph of *The Dying Cedar*:

Beloved Earth...I am weary of your mighty clasp.
Life Crowds...I am exhausted with the stern decree
Of your relentless, aging binding, bending grasp...
Beloved Earth...

JOHN G. BULLOCK 1854–1939

Marjorie in the Garden, ca. 1903
platinum print
19.1 x 13.3 cm (7 ½ x 5 ¼ in.) PLATE 67

Like American painters who were converts to Impressionism, Pictorialist photographers such as John Bullock were open to using their medium in a new way. Bullock's work, usually printed in the delicate tones of platinum, represents the refined expression of the American naturalistic aesthetic. Many of his pastoral views evoke nostalgia for a past without the complexities of modern life.

Marjorie in the Garden has a more restricted viewpoint than Bullock's earlier photographs, suggesting the influence of members

of the Stieglitz circle, such as Clarence White and Gertrude Käsebier, with whom Bullock was associated. In this image the camera's shallow focus transforms the background into a visual screen of soft tones, directing attention to the woman's white dress and the flowers.

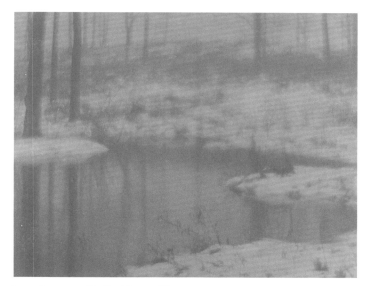

JOHN CHISLETT, *Woodland Stream, Winter*

JOHN CHISLETT 1856–1938

Pond in the Fog, ca. 1900
platinum print
19 x 24.4 cm (7 ½ x 9 ⅝ in.) PLATE 59

Woodland Stream, Winter, ca. 1900
platinum print
18.7 x 24.1 cm (7 ⅜ x 9 ½ in.)

John Chislett, like other members of the Salon Club of America, was devoted to the creative rather than the mimetic possibilities of photography. His soft-focus images and use of the tonally rich platinum printing process demonstrate his interest in the suggestive effects of light. Like other Salon photographers at the turn of the century who aspired to art, Chislett believed the medium's true aim was to record the impression of facts, not the facts themselves.

CHURCHILL AND DENISON STUDIO (ATTRIBUTED TO) ACTIVE CA. 1850s–60s

Group at the Sanitary Commission Fair, Albany, 1864
salted paper print
15.2 x 20.3 cm (6 x 8 in.) PLATE 20

Remmett E. Churchill and his partner, D. Denison, began their careers as daguerreotypists in Albany during the 1850s. By the following decade they had opened a studio specializing in school and public-event commissions.

The U.S. Sanitary Commission was established by Mary Aston Livermore in 1863 as a civilian auxiliary organization dedicated to reform and raising funds to improve health conditions in military facilities. Fairs were held in many cities, featuring exhibition halls for the display of art and commercial products. The first fair, held in Chicago in November 1863, raised $80,000. The enterprise was unique in its day, offering the opportunity to sell goods while also promoting a national cause. More than a dozen fairs were held and eventually inspired the founding of the American Red Cross.

Both amateur and professional photographers exhibited their work, and many were also employed by the fairs. The sale of souvenir photographs, stereographs, books, and photo albums was lucrative. As mementos, these products presumably sustained the public's interest in the cause. As the "official photographer" of the Albany fair, the local studio of Churchill and Denison was probably responsible for this elegant, though unsigned, portrait of four young members of the Sanitary Commission.

WILLIAM L. CULLEN ACTIVE 1900s

Four Portraits of a Man in Different Headgear, 1905
silver print
3.2 x 14 cm (1 ¼ x 5 ½ in.)

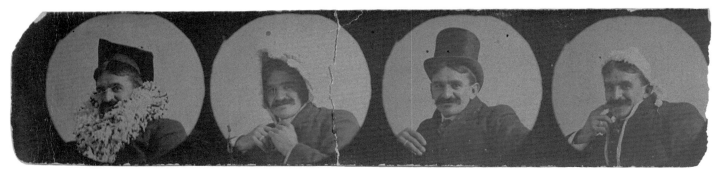

WILLIAM L. CULLEN, *Four Portraits of a Man in Different Headgear*, 1905

IMOGEN CUNNINGHAM 1883–1976
possibly with **ROI PARTRIDGE** 1888–1984

Self-Portrait, 1915
platinum print
9.5 x 11.5 cm (3 ¾ x 4 ½ in.) PLATE 69

Cunningham posed for this portrait at the age of thirty-two, with her new husband, Roi Partridge, tripping the camera's shutter. Two years before composing this image, Cunningham wrote: "Photography, when employed to its highest potential, should not create abstractions and fantastic images, but should examine beauty as it already exists in nature.... There are plenty of subtleties of life right on the earth, which need a delicate interpretation." In this darkly toned platinum print, she has the appearance of a character from an ancient Celtic myth, but, in fact, Cunningham had less fanciful concerns as a photographer. Using a photographic style considered artistic in the early years of the twentieth century, she presented a portrait of the artist, determined in demeanor and confident of her talent. By the time of World War I, Pictorialism had run its course. Cunningham went on to become a member of the California-based Group f/64, known for its dedication to the sharp-focus rendition of simple subjects.

DWIGHT A. DAVIS 1852–1944

A Quiet Pool (Early Evening), ca. 1905
platinum print
31.1 x 23.8 cm (12 ¼ x 9 ⅜ in.) PLATE 60

A Worcester, Massachusetts, member of the Pictorial Photographers of America, Davis exhibited his work in the controversial First American Salon in December 1905. Signaling a break between rival factions of American Pictorialism and Stieglitz's Photo-Secession, this Salon introduced work of regional photographers such as Davis while omitting work by major figures such as George Seeley.

Along with John Chislett, Davis was singled out for his handling of light. Taken in the crepuscular light of early evening, Davis's photograph exemplifies the impressionistic aesthetic of American Pictorialism.

E. E. DICKINSON ACTIVE 1915

Group Portrait at a Patriotic Celebration, ca. 1915
silver print
19.4 x 24.8 cm (7 ⅝ x 9 ¾ in.) PLATE 51

JOHN L. DUNMORE AND GEORGE CRITCHERSON
ACTIVE 1865–75

The Glacier as Seen Flowing, 1869
albumen print
28 x 38.1 cm (11 x 15 in.)

Hunting by Steam in Melville Bay..., 1869
albumen print
27.7 x 38.8 cm (10 ⅞ x 15 ¼ in.) PLATE 43

In 1869 Dunmore and Critcherson accompanied the marine painter William Bradford (1823–1892) on an expedition to the Arctic. Using the photographs as reference, Bradford later painted scenes of the Arctic wilderness that won great acclaim in America and England.

Like the landscapes of the post-Civil War geological-survey photographers, the Dunmore and Critcherson images are compelling in their description of human activity against the backdrop of an awesome and beautiful nature. The polar-bear kill in *Hunting by Steam* would also have piqued the Victorian passion for adventure.

Carrying unwieldy equipment (large 14-x-18-inch plates and a troublesome wet-plate process that required on-site preparation) and combating climatic problems (the strong reflecting light on ice and snow created difficulties in photographing), Dunmore and Critcherson still managed to expose nearly two hundred plates. In 1873 *The Arctic Region*, an album of 139 images, including both full-plate images and smaller illustrations, was published in London.

RUDOLF EICKEMEYER, JR. 1862–1932

Under the Greenwood Tree, 1901/printed 1906
platinum print
23.2 x 18.1 cm (9 ⅛ x 7 ⅛ in.)

Describing his method of working, Rudolf Eickemeyer, Jr. wrote: "The art lies in the man, not in the medium, and the photographer who loves the poetical, dreamy, sometimes melancholy...moods of nature, will show these qualities in his work." As an avid outdoorsman and amateur photographer, Eickemeyer made good use of weekend travels to focus his camera on the landscapes and domestic scenes of Westchester County, New York, and his native Hoboken, New Jersey. His photographs of local environs combine the sense of discovery of survey photographs and the artistic concerns of Pictorialist composition. During the 1890s Eickemeyer achieved great success, winning many awards and medals in exhibitions. He was the second American (Stieglitz was the first) invited to join the elite London photography group, The Linked Ring. Unlike Stieglitz, who labored to win a place for photography in museums and galleries alongside other fine arts, Eickemeyer endeavored to make it more accessible to a wider audience. He had no qualms about using his art for commercial means, producing advertisements for Kodak's foolproof cameras and opening a studio to take society portraits. Perhaps Eickemeyer's most important contribution to promoting the medium was his development of the first photographic picture books. Printed inexpensively to make them more easily available, they sold for $1.50 to $2.00 per copy.

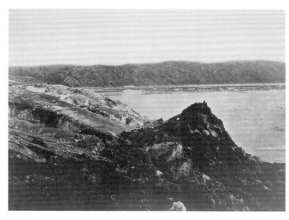

JOHN L. DUNMORE AND GEORGE CRITCHERSON,
The Glacier as Seen Flowing

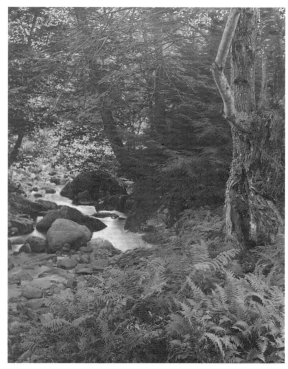

RUDOLF EICKEMEYER, JR., *Under the Greenwood Tree*

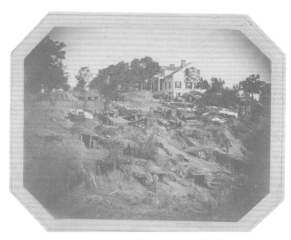

O. D. FINCH, *Bivouac of the 45th Illinois near the Shirley House*

O. D. FINCH ACTIVE 1860S

Bivouac of the 45th Illinois near the Shirley House, 1863
salted paper print
16.5 x 21.6 cm (6 ½ x 8 ½ in.)

During the siege of Vicksburg, Mississippi, the Shirley House, residence of Unionist "Judge" James Shirley and his family, was caught in the crossfire of Union troops led by Ulysses S. Grant and Confederate troops under John C. Pemberton. Surrendering to Union forces, the family was removed from their home to protect them from cannon fire and housed in a manmade cave, like the ones (called sheebangs) in this photograph. The siege ended after six weeks when Pemberton, who was responsible for the city's residents and more than 200,000 Confederate soldiers (many ill with disease and starvation), surrendered Vicksburg to the Union Army. The Union thereby gained complete control of the Mississippi River. The Shirleys retained their estate until 1902, when it was given to the National Park Service and became the Vicksburg National Military Park.

The photographer O. D. Finch has drifted into obscurity. Although this work brings to light the living conditions of soldiers, it raises technical questions regarding methods of photography during the Civil War. As a salt print, this image represents one of the earliest photographic technologies. It soon fell out of favor as more advanced techniques were invented. It is possible that during the siege Finch lacked access to the supplies needed for the more conventional silver print preferred by his contemporaries. Probably taken toward the end of the long siege—judging by the poor state of the encampment—this has become one of the most famous images of the Shirley House during the Vicksburg battle.

JAMES FORD 1827–CA. 1877
possibly **CARLETON E. WATKINS** 1829–1916

San Francisco, Corner of California and Montgomery Streets,
ca. 1857
coated salted paper print
25.4 x 32.1 cm (10 x 12 ⅝ in.) PLATE 9

Leaving New York on the bark *Salem*, James Ford arrived in California in 1849. He opened a series of photographic businesses, first in Sacramento, where he remained until at least 1854, advertising his "stereoscopic daguerreotypes" in the city newspaper. He also established a gallery in San Francisco on Clay Street, where, according to the September 19, 1854, edition of the San Francisco *Herald*, "he...fitted up one of the MOST ELEGANT ESTABLISHMENTS OF THIS KIND IN THE WORLD!" Even so, the business failed, forcing him to sell. After subsequent failed ventures in San Jose, he opened another studio in San Francisco, hiring Carleton Watkins in 1865. In addition to being a daguerreotypist, Ford was among the first photographers in California to perfect the technique of making salted paper prints. Presumably he taught Watkins how to print such photographs.

This image of the Pacific Express building was probably a commission from the newly established San Francisco telegraph

company housed there. As Watkins often worked in the field for Ford, this picture could be attributed to either man. The photograph alludes to the new utility company in such details as the name of the building, telegraph pole, and rooftop dovecotes, which would have housed the carrier pigeons that were displaced by the wire telegraph.

J. R. FOSTER ACTIVE 1860s

Ruins of the Charleston Lighthouse, Morris Island,
South Carolina, ca. 1863
albumen print
13.3 x 20.7 cm (5 ¼ x 8 ⅛ in.)

Very little is known about J. R. Foster. Active as a photographer in the 1860s and 1870s in New Hampshire (according to a New Hampshire business directory), he may have followed local regiments to war in hopes of making salable views or portraits of soldiers for an interested local audience. In several instances, soldiers who had worked as photographers in civilian life set up shop temporarily in their camps. Because this image depicts Morris Island, it is possible that Foster was a relative of Charleston photographer Henry C. Foster, who was based on Morris Island during the Civil War.

Covered bodies in the foreground and what looks like a group of men claiming victory at the top of a mound of rubble suggest that this photograph may have been taken at the conclusion of the battle for control of Morris Island. Perhaps the photographer who seems to be taking a picture at the base of the lighthouse is Henry Foster.

EGBERT GUY FOWX 1821–DIED AFTER 1883

New York 7th Regiment Officers, ca. 1863
salted paper print
14.3 x 19.1 cm (5 ⅝ x 7 ½ in.) PLATE 16

The New York 7th Regiment was a popular subject for photographers who set up studios in the camps. George N. Barnard's stereo photographs of the regiment were published by E. and H. T. Anthony and Company. Many members of the 7th also came to Mathew Brady's gallery in Washington. Encampments provided an ideal opportunity for enterprising photographers, and Fowx may have hoped to sell copies of his pictures of the dashing members of the "Gallant 7th." In 1863 Baltimore photographer Fowx was working as an assistant to Andrew J. Russell, who was then employed as a photographer for the Bureau of the U.S. Military Railroads.

ALEXANDER GARDNER 1821 SCOTLAND–1882 USA

Burnside Bridge, Across Antietam Creek, Maryland, 1862
albumen print
17.8 x 22.9 cm (7 x 9 in.)

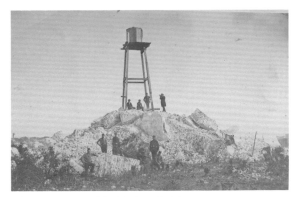

J. R. FOSTER, *Ruins of the Charleston Lighthouse,*
Morris Island, South Carolina

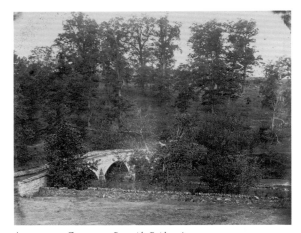

ALEXANDER GARDNER, *Burnside Bridge, Across*
Antietam Creek, Maryland

FORMAN HANNA, *Pueblo Scene*

128

By the time Alexander Gardner emigrated from Scotland to the United Stated in 1856, he was already an accomplished photographer, with an interest in optics, astronomy, and chemistry. He introduced himself to Mathew Brady, whose work Gardner had seen at the Crystal Palace exhibition in London. Brady was impressed by Gardner's expertise with the difficult wet-plate negative/paper-print process, which was rapidly displacing the daguerreotype in America. In 1858 Gardner moved to Washington, D.C., to manage Brady's gallery there. For a short time he was part of Brady's team of Civil War photographers, but in a disagreement over attribution of his work (Brady published all pictures taken by his staff as the work of Brady & Co.), Gardner left to establish his own business photographing the war. In 1866 he published *Gardner's Photographic Sketch Book of the War*, a two-volume work with text and one hundred images taken by himself and several other photographers, including Timothy O'Sullivan and John Reekie, whose images are meticulously credited.

Burnside Bridge, Across Antietam Creek, Maryland shows the site of some of the most desperate fighting during the Battle of Antietam. The accompanying caption in the *Sketch Book* describes a battle scene in which "the dead and wounded on the field...seemed countless," and an aftermath in which "the Confederates were buried where they fell, and our own dead carefully interred in groups, which were enclosed with the material of fences overthrown in the struggle." In fact, the picture was taken sometime after the battle. Documenting a landscape that hides a cemetery, the photographer shows a bridge—"the only monument of many gallant men who sleep in the meadow at its side."

Laura Gilpin 1891–1979

Pikes Peak and Colorado Springs, ca. 1926
platinum print
30.2 x 24.5 cm (11 ⅞ x 9 ⅝ in.) PLATE 65

Gilpin studied at the Clarence White School between 1916 and 1918 and was strongly influenced by a range of teachers: White, Paul Anderson, Max Weber, Bernard Horne, and Anton Bruehl. Returning to her native Colorado, Gilpin focused on many of the most spectacular sites in the Southwest, including the archaeological ruins of the Navajo and Pueblo Indians.

Gilpin's view of Colorado's famous Pikes Peak documented a western landscape that increasingly faced modern-day intrusions. Employing the delicate tones of platinum and a shallow plane of focus, with the military airplanes given emphasis as three tiny black specks in the sky, she created a dreamlike landscape in which nature no longer reigned in solitude.

Forman Hanna 1882–1950

Cloud Study, ca. 1925
silver print
23.5 x 30.1 cm (9 ¼ x 11 ⅞ in.) PLATE 64

Pueblo Scene, ca. 1920
silver print
20.3 x 25.4 cm (8 x 10 in.)

Raised in a small Texas town, Hanna had his first encounters with photography and most of his art training through camera-club magazines. Emulating the Pictorialist style, he used his western surroundings as subject matter.

While working as a pharmacist in Globe, Arizona, Hanna made frequent trips to nearby canyons and Pueblo villages to photograph what he believed was a lost way of life. Recognized for his Arizona landscapes, he often exhibited in the juried shows of camera clubs. In the years just following World War I, these organizations provided an important forum for many of the nation's artistic photographers like Hanna. Although they lived in different parts of the country, these photographers attained a collective identity.

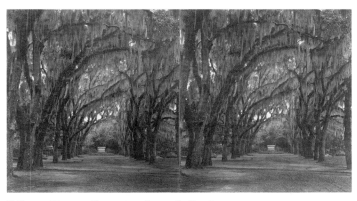

O. Pierre Havens, *Bonaventure, Savannah, Georgia*

O. Pierre Havens 1838–1912

Bonaventure, Savannah, Georgia, after 1869
mounted albumen prints (stereograph card)
each 8.9 x 8.3 cm (3 ½ x 3 ¼ in.)

Born in Ossining, New York, Havens moved to Savannah, Georgia, in 1872 and opened a photography studio in partnership with J. N. Wilson. In 1888 he relocated to Jacksonville, Florida, where he maintained a studio until his death. Like many commercial photographers in America during the late nineteenth century, Havens was as occupied with publishing and marketing his photographs as he was in making them. Stereographs—the most popular photographic form of the period—were in greatest demand.

Bonaventure Cemetery's beautiful grounds are the burial site of many famous Georgians, including George Wimberly Jones (1766–1838), a judge, senator, and mayor of Savannah, whose memorial can be seen in the distance in this picture. In the late 1860s the grounds were well known by tourists as well as Savannah locals, who enjoyed family picnics there. Havens's stereograph was therefore a well-calculated choice of subject in terms of potential sales.

PAUL BURTY HAVILAND 1880 FRANCE–1950 FRANCE

Portrait of a Man, ca. 1908
platinum print
25 x 20.3 cm (9 ⅞ x 8 in.) PLATE 72

Two Sisters, ca. 1908
platinum print
19 x 24.1 cm (7 ½ x 9 ½ in.)

Haviland's middle name was that of his maternal grandfather, a photography critic in France in the 1850s. Haviland also explored the arts while working in New York as a representative for his father's porcelain factory. His interest in writing and photography eventually led him to the Little Galleries of the Photo-Secession, where Alfred Stieglitz and his circle of photographers strove to have the medium recognized as a fine art. In 1910 Haviland was made associate editor of Stieglitz's publication *Camera Work*.

Haviland's *Portrait of a Man*, made about the same time he met Stieglitz, is an impressionistic study rather than a conventional likeness. Although Haviland continued making portraits upon returning to France after World War I, they lacked the engaging inventiveness of his work in New York.

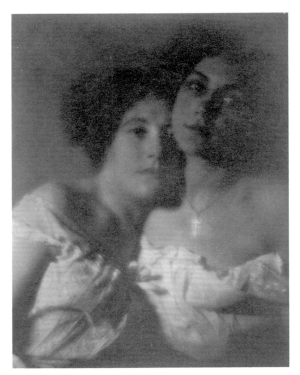

PAUL BURTY HAVILAND, *Two Sisters*

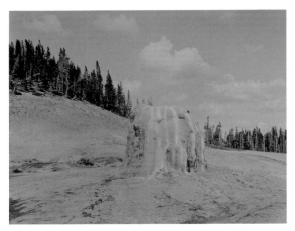

FRANK JAY HAYNES, *Lone Star Geyser Cone,*
Yellowstone National Park

FRANK JAY HAYNES 1853–1921

Lone Star Geyser Cone, Yellowstone National Park, 1884
albumen print
43.2 x 55.2 cm (17 x 21 ¾ in.)

Gloster Mill, 60 Stamps, 24 Pans, 12 Settlers, ca. 1885
albumen print
43.2 x 55.2 cm (17 x 21 ¾ in.) PLATE 41

East Entrance, Jefferson Canyon, 1890
albumen print
43.5 x 54.9 cm (17 ⅛ x 21 ⅝ in.)

Originally a studio photographer from the North Dakota Territory, Haynes spent most of his career documenting in pictures the development of the western territories. Commissioned in 1876 to make views along the route of the Northern Pacific Railroad, he traveled through the West until 1905, working in a railroad car equipped as both gallery and darkroom. Besides photographing spectacular views of natural scenery, Haynes produced an extensive record of the modification of the landscape by railroad and industry.

On an 1881 trip to the newly created Yellowstone Park, via the new line of his railroad company employer, Haynes decided to pursue a commercial concession as park photographer. In 1884 he opened a studio and photography gallery in Yellowstone, selling to tourists prints of the park's natural wonders, such as the Lone Star Geyser Cone. For more than thirty years Haynes served as the official photographer of Yellowstone National Park.

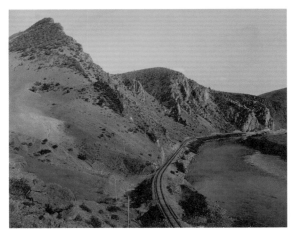

FRANK JAY HAYNES, *East Entrance, Jefferson Canyon*

ALEX HESLER 1823 CANADA–1895 USA
Falls of Minnehaha, Minnesota, ca. 1855
salted paper print
20.3 x 15.3 cm (8 x 6 in.) PLATE 7

Hesler's most famous image was made while he was employed by
Harper's Traveller's Guide to daguerreotype views of the Mississippi
River from St. Paul to Galena, Illinois. On a single day in
August 1851, Hesler and his assistant, Joel E. Whitney, reportedly
made eighty-five daguerreotype views in Minnesota, including a
view of Minnehaha Falls. While on display in Hesler's Chicago
studio, one of these views was purchased in 1854 by George
Sumner as a gift for his brother, Senator Charles Sumner of Mas-
sachusetts. The senator in turn presented it to his friend Henry
Wadsworth Longfellow, who reportedly used the image to draw
inspiration for his narrative poem "The Song of Hiawatha." Both
poem and view were wildly popular, attracting other photogra-
phers to the Falls (see Whitney and Zimmerman) and leading
Hesler to make copies of his original.

 In the mid-1850s the introduction in America of collodion-on-
glass negatives, or wet plates provided a way to reproduce da-
guerreotypes. Hesler made many salted paper print copies of his
daguerreotypes, notably a portrait of Abraham Lincoln for his
1860 presidential campaign, which was printed in the thousands.

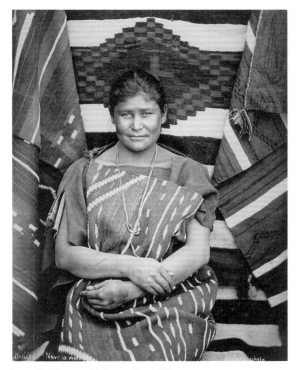

JOHN K. HILLERS, *Hedipa, a Navajo Woman*

JOHN K. HILLERS 1843 GERMANY–1925 USA

Hopi Mesa, ca. 1879
albumen print
25.1 x 32.7 cm (9 ⅞ x 12 ⅞ in.) PLATE 31

Hedipa, a Navajo Woman, ca. 1880
albumen print
23.2 x 18.4 cm (9 ⅛ x 7 ¼ in.)

In 1879 the Bureau of Ethnology (later changed to the Bureau of
American Ethnology) was created under the Department of the
Interior. With the Smithsonian Institution appointed as adminis-
trator, John Wesley Powell became the first director, and Hillers,
who had previously worked for Powell, was hired as staff photog-
rapher. In 1871 Hillers signed on as a boatman for the second
Powell expedition down the Colorado River. Assisting the expedi-
tion photographers Edward O. Beaman and Walter Powell, he sub-
sequently became Powell's expedition photographer in 1872. Hill-
ers continued the work of the surveys, but his emphasis shifted
from geography and geology to archaeology and ethnology. His
portraits of the Hopi (Moki) and Navajo, as well as photographs
of architecture, domestic life, and rituals, were used by the bureau
to record traditional ways of life and supplement material collec-
tions. Often he contrasts the details of a site with the more ab-
stract and spacious idea of history. In his photograph of Hopi
Mesa (or the First Mesa, as it was named by the Spaniards on their
trek north from Mexico in the sixteenth century), domestic details
such as the drying of peaches, as well as a chimney funnel made
from an old pot, crowd the near foreground. Taken from Hano
pueblo, the photograph shows Sichomovi pueblo in the middle

distance. At the most distant point is Walpi pueblo, site of the
sacred Antelope-Snake Ceremony.

LEWIS HINE 1874–1940

Little Orphan Annie in a Pittsburgh Institution, 1909/printed later
silver print
16.5 x 11.5 cm (6 ½ x 4 ½ in.) PLATE 75

Educated as a sociologist at the University of Chicago, Hine
became involved with social welfare issues while pursuing studies
at the Columbia University School of Social Philosophy. As a
teacher at the Ethical Culture School in New York City, he orga-
nized photographic excursions through New York's commercial
and tenement areas in order to heighten his students' awareness of
the world around them. By 1904 Hine had begun to photograph
immigrants, the poor, and the exploited as a means of studying and
describing the social conditions faced by these people. He is best
known, however, for his systematic and comprehensive documen-
tation of child workers for the National Child Labor Committee.
Hine spoke about his work on extensive lecture tours, and his pho-
tographs were widely disseminated through newspapers, socially
concerned publications, and posters.

 Many of Hine's photographs of children, such as this image of a
girl at the door of an orphanage, describe the relationship between
an individual and an institution. Here, Hine calls our attention to
the austere space beyond the child, emphasizing the extent to
which her home already seems like a factory. The title given to the
photograph—possibly when it was included in a portfolio of
Hine's work organized by the New York Photo League in the late

1940s—refers to the Dickensian comic-strip character "Little Orphan Annie," created in 1924, who was forced to labor for her keep at an orphanage.

Biloxi, Mississippi, 1911/printed later
silver print
19.1 x 24.1 cm (7 ½ x 9 ½ in.)

Along with his photographs, Hine often sent the Child Labor Committee detailed reports of his conversations with children and their parents. Providing revelant details about their lives, his comments supplemented the emotional content of the photographs. This picture was part of a series documenting southern delta shrimp pickers and oyster shuckers. Hine wrote: *"Olga Schubert. The little 5-year-old after a day's work helping her mother in the Biloxi Canning factory, began at about 5:00 A.M., was tired out and refused to be photographed. The mother said, 'Oh, she's ugly.' Both she and other persons said picking shrimp was very hard on the fingers."*

When used for publication, Hine's photographs were usually printed directly from a 5-x-7-inch negative. Occasionally he made enlargements for exhibitions or copy photographs that he cut up, collaged with other images, and rephotographed. Just barely visible in the upper right-hand corner of this copy is the tack that was used to hold the original in place.

Handyman in Washington, DC, 1909
silver print
17.2 x 12.1 cm (6 ¾ x 4 ¾ in.) PLATE 78

Hine was interested in photographing urban workers of all kinds. Like painters George Luks, William Glackens, and Robert Henri, he found a modern nobility in working-class subjects. The bold, simple composition of this portrait of a Washington handyman gives the picture its forcefulness and dignity. The photograph was possibly made just after Hine completed work for Charles F. Weller's 1908 Washington slum study.

Throughout his career Hine used a Graflex, a camera introduced in the first decade of the twentieth century, which made it easier for the photographer to see the picture just as the camera would record it. Unlike earlier cameras that required the photographer to compose and focus before putting in the sensitive plate, the Graflex allowed Hine to frame his subject to the very edges of the plate and postpone decisions about focus and angle of view until the instant he clicked the shutter.

WILLIAM H. JACKSON 1843–1942

Grand Cañon of the Colorado, ca. 1880
albumen print
53.7x 42.8 cm (21 ⅛ x 16 ⅞ in.) PLATE 24

Currecanti Needle, Black Cañon of the Gunnison, ca. 1880
albumen print
54 x 42.5 cm (21 ¼ x 16 ¾ in.)

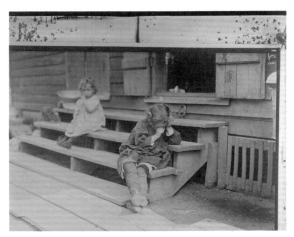

LEWIS HINE, *Biloxi, Mississippi*

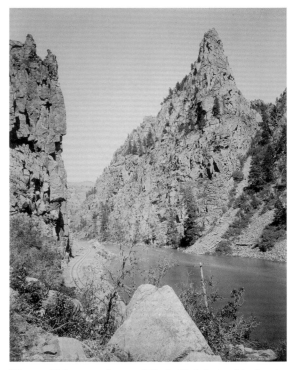

WILLIAM H. JACKSON, *Currecanti Needle, Black Cañon of the Gunnison*

Leaving his native New York in 1863, Jackson made his first trip west as a driver for a wagon train. As he had previously earned his living painting theatrical backdrops and political posters and working in a photographic gallery as a retoucher and colorist, it is not surprising that within a year he had opened a photography studio in Omaha, Nebraska. From 1870 to 1878 he was the official photographer for Ferdinand V. Hayden's U.S. Geological and Geographical Survey of the Territories.

Jackson made his first photographs of the Yellowstone area in 1871, returning there many times in subsequent years. These images became extremely popular and also played an important part in convincing Congress to pass the bill in 1872 that established Yellowstone as the first national park. Working with fellow survey artists Sanford R. Gifford and Thomas Moran, Jackson developed

a style of photography that was both descriptive and broadly pictorial. In turn, many artists drew upon Jackson's images as source material for their paintings.

In 1879 he opened the Jackson Photographic Company in Denver to promote his pictures of western subjects. Jackson was often commissioned by the railroad companies to take photographs along new or already popular western routes, such as the Gunnison River in western Colorado. Competing with the scenery in many of these images are signs of commercial progress such as telegraph lines and railroad tracks. These published photographs stimulated interest in the region among business people and tourists.

WILLIAM H. JACKSON (ATTRIBUTED TO) 1843–1942 for the DETROIT PHOTO COMPANY

Entrance to the Highlands, Hudson River, ca. 1898
silver print
43.8 x 98.4 cm (17 ¼ x 38 ¾ in.) PLATE 42

In 1897 Jackson acquired part interest in the Detroit Publishing Company, later called the Detroit Photo Company, which published and distributed his photographs. It is often difficult to determine an exact date or attribution for these works because he employed numerous assistants and sometimes published the work of other photographers.

During the 1880s and 1890s Jackson's chief business was making large-scale panoramas commissioned by railroad companies throughout the United States. In many cases he printed his mammoth-plate negatives on collodion paper, which had a denser weave than albumen coated paper. Collodion not only hid the edge of the abutting negatives but also produced a glossy, non-yellowing image, undoubtedly more suitable for framing. At least two negatives were used to make this panorama of the Hudson River, which documents competing forms of transportation: the railroad and the steamboat.

BERTHA JAQUES 1863–1941

Dandelion Seeds, Taraxacium Officinale, ca. 1910
cyanotype photogram
34.6 x 7.3 cm (13 ⅝ x 2 ⅞ in.) PLATE 56

Lavender, Lavendula Labiatae, ca. 1910
cyanotype photogram
35.6 x 15.9 cm (14 x 6 ¼ in.)

Milkweed Pods, Asclepias Cornuti, ca. 1910
cyanotype photogram
32.4 x 20.3 cm (12 ¾ x 8 in.)

Jaques was already a respected printmaker when she began making cyanotype photograms of wildflowers. An active member of the Wild Flower Preservation Society, she created over a thousand of these botanical images. Made without a camera by placing

BERTHA JAQUES,
Lavender, Lavendula Labiatae

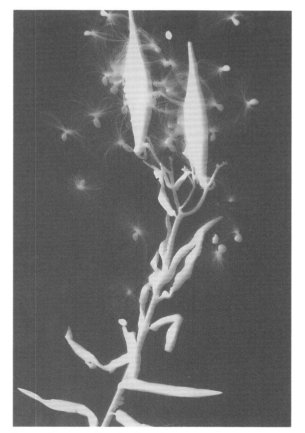

BERTHA JAQUES, *Milkweed Pods, Asclepias Cornuti*

objects directly on sensitized paper and exposing it to light, the photogram is the least industrialized type of photography. Because prints were easy to produce by this method, it achieved wide popularity. Graphic artists often chose this form of print because of its rich Prussian blue color. Aligned with the antimodernist views of the late Victorian Arts and Crafts movement, Jaques's work reflects a reverence for commonplace elements of nature and the beautifully crafted object.

JONES AND BROTHER ACTIVE 1860s

A Baby, ca. 1860
salted paper print with applied color
18.8 x 13.7 cm (7 ⅜ x 5 ⅜ in.)

During the late 1850s the beginning of widespread use of the negative-positive process, which allowed the efficient production of a large number of prints from a single negative, marked the end of the daguerrean era in America. Many commercial photographers whose business had been built on the popularity of the daguerreotype portrait converted their darkrooms to accommodate a variety of new photographic processes. In many places, however, studios still employed painters to hand-color the finished image, as they had done with daguerreotypes. Photographers increasingly took advantage of the rich tonality and matte surface offered by the salted-paper process. Prepared by coating the paper with a solution of sodium chloride (common table salt) and then brushing it with a solution of silver nitrate, salted paper prints range in color from warm chocolate brown to slate gray.

Though signed with the studio stamp "Jones and Brother," this image is possibly the work of William H. Jones, whose advertisement promoted his ability to photograph children and gave his business address as Exchange Place, Waterbury, Connecticut.

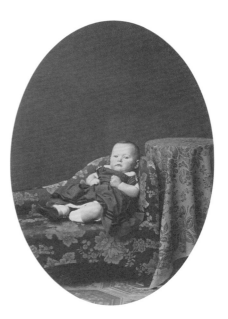

JONES AND BROTHER, *A Baby*

GERTRUDE KÄSEBIER 1852–1934

The Manger, 1899
platinum print
31.8 x 25.4 cm (12 ½ x 10 in.) PLATE 68

Gertrude Käsebier began her artistic studies at the age of thirty-seven after her children had grown up. While studing painting at Pratt Institute in New York, she began to explore photography. In 1897 she opened a photography studio in New York, specializing in portraits of women and children. Käsebier was a founding member of both the Photo-Secession group and the Pictorial Photographers of America. A favorite of Alfred Stieglitz, she was the featured artist in the premier issue of *Camera Work*. *The Manger* was one of the principal illustrations. Describing *The Manger*, art critic Charles Caffin wrote that Käsebier's use of light in the simple setting "fills the place with heaven and surrounds the figures with divinity." However, Käsebier did not explicitly support a religious interpretation of this image. She encouraged friends and critics to regard it as an artistic exercise in the effects of light in a composition of white on white. As in much of her other work, form and pattern are emphasized here. Writing in 1899, critic Arthur Wesley Dow stated that Käsebier combined two functions in a photograph—one "as a record of truth, the other as a work of fine art."

The Garden Party, ca. 1905
platinum print
24.5 x 19.4 cm (9 ⅝ x 7 ⅝ in.)

The setting for this photograph is possibly the Käsebier residence on Long Island, which was purchased in 1904 or 1905 and sold in 1910 after the death of Käsebier's husband, Eduard. The woman is probably one of Käsebier's daughters, either Gertrude or Hermine; the other figures are Käsebier's grandchildren. Unlike her studio portraits, this record of a family gathering contains a degree of spontaneity. Her control of the image is evident, however, in the careful grouping, selective focusing, and effects of light and shadow. The striped patterns of the boys' smocks, for example, are matched by the patterns of light on the white dresses of mother and daughter.

JOSEPH T. KEILEY 1869–1914

Scene in a Garden, ca. 1899
platinum print
10.8 x 7.6 cm (4 ½ x 3 in.)

Although Keiley was a Wall Street lawyer, his photographic activities were various and influential. In addition to writing art criticism and experimenting with various photographic processes, he collaborated with Alfred Stieglitz on the invention of the glycerine process, which permitted the partial development of platinum prints to facilitate obtaining the soft-focus tones they favored.

Keiley was an editor of both *Camera Notes* and *Camera Work*—so admired by his colleagues that his name remained on the mast-

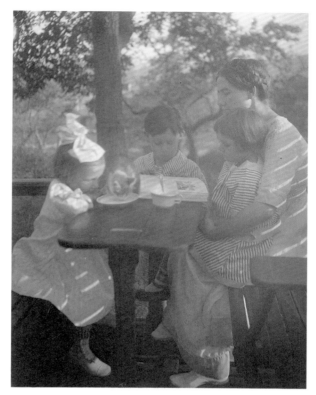

GERTRUDE KÄSEBIER, *The Garden Party*

head of *Camera Work* even after his death. One of the founding members of the Photo-Secession, Keiley sought to align great photographers with great painters and other artists. He wrote: "Only the shamelessly vain and tasteless aspire to be original. The truly great artist alone fears not to be compared to the old masters."

Mercedes de Cordoba, 1902
platinum print
16.5 x 11.5 cm (6 ½ x 4 ½ in.)

The beautiful wife of the prominent modernist painter Arthur Carles, Mercedes de Cordoba was photographed by Keiley on several occasions. In this photograph, he created a painterly portrait, contrasting the soft-focus texture of the platinum print with the subject's candid, nearly impertinent gaze.

JOSEPH T. KEILEY, *Scene in a Garden*

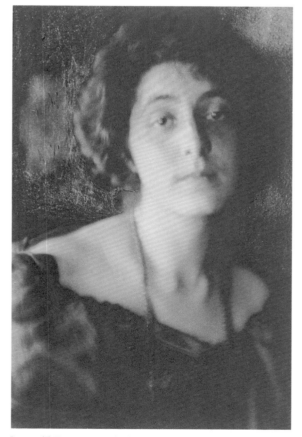

JOSEPH T. KEILEY, *Mercedes de Cordoba*

JOHN FRANK KEITH 1883–1947

Two Girls on a Stoop, Kensington, Philadelphia, ca. 1925
silver print
13.7 x 8.6 cm (5 ⅜ x 3 ⅜ in.) PLATE 76

Boys on Steps, Kensington, Philadelphia, ca. 1925
silver print
14 x 8.9 cm (5 ½ x 3 ½ in.)

Baby on a Stoop, Kensington, Philadelphia, ca. 1925
silver print
14 x 8.9 cm. (5 ½ x 3 ½ in.)

Keith worked as a bookkeeper in a fish market but spent weekends making photographs. His subjects were invariably the working-class families of Philadelphia's Kensington area. Never asking payment for his pictures, he gave them to the people he photographed.

Keith's informal archive is more than a collection of individuals: it is an intimate portrait of a neighborhood in the 1920s. Working in a documentary style reminiscent of Lewis Hine, but without Hine's social activism, Keith posed members of the community—usually children—on the front stoops of their urban row houses. His inexpensive camera dictated a consistent distance from the subjects, and his amateur-quality lens was responsible for the slightly unfocused distortion at the edge of the picture. Had he stood farther away, the camera's blur would have been too great; standing closer, he would have lost all reference to the neighborhood. Like itinerant photographers of the nineteenth century who counted on the similarities of circumstance and dress to compose a picture, Keith rarely changed the major elements of his photographs. Instead, he focused on the small details that did change: the difference in a door frame or the contrasting colors of shoes worn by two almost identical sisters.

KELLOGG BROTHERS ACTIVE 1860s

Engine of the USS Kearsarge, ca. 1861
salted paper print
25.4 x 33.6 cm (10 x 13 ¼ in.) PLATE 21

William K. and Edwin P. Kellogg operated a studio at various addresses on Main Street in Hartford, Connecticut, for more than three decades. Just as their portraits of the town's leading citizens describe the public character of an economically successful area, their photographs of machinery and new industry communicate a reverence for the power of mechanical invention. Photographs such as the one made at the Hartford factory of Woodruff & Beach upon completion of the engine for the USS *Kearsarge*—launched at Portsmouth, New Hampshire, on September 11, 1861—were advertisements for local business as well as patriotic symbols of Union naval prowess in the first months of the Civil War.

A "Screw Steamer," or "Sloop-of-War," the *Kearsarge* went on to glory, sinking the Confederate cruiser *Alabama* in the harbor of Cherbourg, France, on June 19, 1864. A significant and inspiring

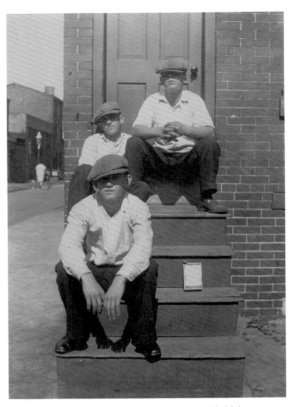

JOHN FRANK KEITH, *Boys on Steps, Kensington, Philadelphia*

JOHN FRANK KEITH, *Baby on a Stoop, Kensington, Philadelphia*

victory for the Union Navy, the event won even greater fame after Edouard Manet completed his 1864 painting that depicts the burning *Alabama* and the triumphant *Kearsarge*.

LANGILL & DARLING ACTIVE 1880s

Johnstown Flood, General View Looking South, 1889
albumen print
18.4 x 24.4 cm (7 ¼ x 9 ⅝ in.)

On May 31, 1889, during a period of very heavy rainfall, the South Fork Dam collapsed near the town of Johnstown, Pennsylvania, a center of iron and steel manufacturing. As a result, a wall of water inundated the valley, causing the deaths of more than 2,000 people and extensive property damage.

Hundreds of photographers, including the little-known team of Langill & Darling, descended on the area to record the event and sell pictures to a public eager for details of the calamity. Many of the photographers chose to restage the more gruesome aspects of the event, even placing corpses among the debris. Langill & Darling, however, documented the disaster by selecting a view that dramatically contrasted the chaotic foreground of destroyed buildings with the distant, ghostlike town.

WILLIAM H. MARTIN 1865–1940

Riding a Giant Corncob to Market, 1908
silver print (postcard)
8.9 x 13.4 cm (3 ½ x 5 ½ in.) PLATE 47

The comic phenomenon of tall-tale postcards developed around the turn of the century. They served as a relief from the harsh realities of midwestern agricultural life—from grasshopper plagues to drought and floods—while also satirizing the idealized pictures that had lured people west a generation earlier. The variety of tongue-in-cheek images was enormous, including fish so big that three men were needed to catch them, wheat fields so lush that a farmer could be lost in them forever, and corncobs so huge that only one would fit on a wagon.

William H. "Dad" Martin of Kansas perfected the technique of photomontage. Cutting and pasting together pieces from different photographs, he composed an out-of-scale scene in which tiny people were juxtaposed with immense images of produce or game. He then rephotographed this altered picture and printed it on postcard stock. Western settlers often sent Martin's popular images back east to friends and relatives, who collected them in albums for family entertainment.

SAMUEL MASURY 1818–1874

Looking Outward from the Barn, Loring Estate, Beverly Farms, Massachusetts, ca. 1858
coated salted paper print
26.7 x 34.6 cm (10 ½ x 13 ⅝ in.) PLATE 8

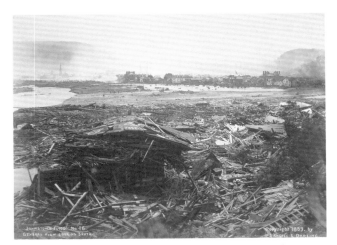

LANGILL & DARLING, *Johnstown Flood, General View Looking South*

A well-known Boston daguerreotypist and photographer, Masury was commissioned by Charles Greely Loring, a prominent lawyer and the first director of the Museum of Fine Arts, Boston, to photograph his estate at Beverly, Massachusetts. Although genre paintings of the period often included farm workers or stable hands resting by a barn door, Masury's view from inside the barn is unusual. He has used the doorway as a framing device, and the view of a rocky hillside presents a variation on the compositional elements found in most mid-nineteenth-century genre and landscape paintings.

JAMES McCLEES 1821–1887

Jefferson's House, Philadelphia, 1855
coated salted paper print
23.2 x 19.1 cm (9 ⅛ x 7 ½ in.)

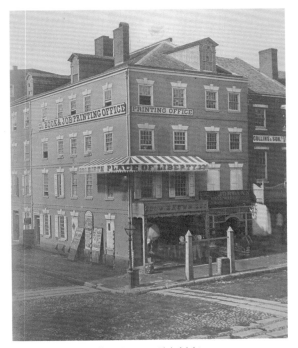

JAMES McCLEES, *Jefferson's House, Philadelphia*

The Waterworks, Fairmount, Philadelphia, 1855
salted paper print
15.9 x 22.5 cm (6 ¼ x 8 ⅞ in.) PLATE 10

Trained in Philadelphia as a daguerreotypist, McClees was among the first to experiment with the art of paper photography. In partnership with Lafayette Germon (1823–1878), he improved greatly on what was known as the "Whipple" process, named after the Boston photographer John A. Whipple, who originally owned the American patent for making paper prints from glass negatives (crystalotypes).

Announcing the departure of McClees from Philadelphia, on September 1, 1857, the editors of the *Photographic & Fine Arts Journal* predicted success for his new Washington, D.C., gallery and concluded that "the most striking photos of places in mid-19th century Philadelphia are those...by James McClees." His photographs commemorated already historic sites, such as the house at the southwest corner of Seventh and Market Streets where Thomas Jefferson composed the Declaration of Independence, as well as new monuments to civic pride. At mid-century, the view from the hill above the Fairmount waterworks was considered the best in Philadelphia. McClees, however, turned away from this site, commemorating a view that presented an image of the city as progressive yet upholding classical ideals.

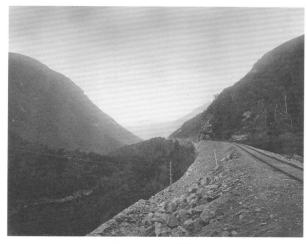

CHARLES L. MITCHELL, *Crawford Notch, White Mountains*

CHARLES L. MITCHELL, *Walkway through a Gorge, White Mountains*

CHARLES L. MITCHELL ACTIVE 1890–1905

The Pool, White Mountains, ca. 1890
salted paper print
24.2 x 19.4 cm (9 ½ x 7 ⅝ in.)

Crawford Notch, White Mountains, ca. 1890
silver print
18.4 x 23.3 cm (7 ¼ x 9 ¼ in.)

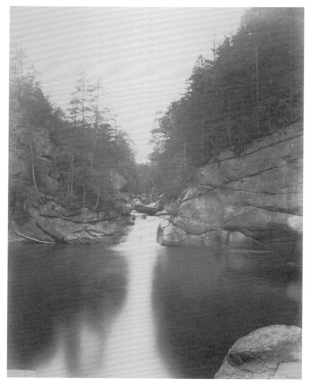

CHARLES L. MITCHELL, *The Pool, White Mountains*

Walkway through a Gorge, White Mountains, ca. 1890
salted paper print
24.2 x 19.4 cm (9 ½ x 7 ⅝ in.)

An avid amateur photographer and a leading spokesman for the conservative faction of the Photographic Society of Philadelphia, Dr. Charles L. Mitchell saw little originality in the Pictorialist photographs that were increasingly exhibited in the society's annual Salon. He criticized Gertrude Käsebier's works as "foggy" and described those of Clarence H. White as portraying "the ugliness cult."

In keeping with his scientific training, Mitchell preferred straightforward representational photography. Using his camera to record the beauty he found in nature, he made no attempt to alter his view through manipulation of the negative or print. Mitchell often traveled to the White Mountains of New Hampshire to photograph at Crawford Notch and other scenic areas in New England.

HENRY P. MOORE (ATTRIBUTED TO) 1833–1911

Long Dock at Hilton Head, Port Royal, South Carolina, 1862
salted paper print
18.1 x 22.9 cm (7 ⅛ x 9 in.) PLATE 15

Though unsigned or stamped with a maker's name, there are reasons to believe that this photograph was taken by Henry P. Moore. Leaving his home in Concord, New Hampshire, Moore traveled during the Civil War in search of business, as did many photographers of his day. In 1862–63 he operated a portable gallery and studio at Hilton Head, where a regiment of New Hampshire troops was stationed. Though perhaps best known for his portraits of Hilton Head's African-American residents, Moore was fond of both the scenic and the descriptive image. He also made portraits of soldiers and numerous views of buildings, vessels, and island scenery, as well as photographs of the federal warships and iron-clads that moored in Hilton Head harbor. Issued as 5 ½-x-8-inch prints after Moore returned to Concord, these images later drew international notice. Although a fleet of ships can be seen in the distance, this image of a lone figure fishing—a peacetime activity—is different from the usual picture of military life.

JOHN MORAN 1831 ENGLAND–1903 USA

Tropical Scenery: The Terminus of the Proposed Canal—Limon Bay, 1871
albumen print
20.3 x 27.6 cm (8 x 10 ⅞ in.)
Gift of Charles Isaacs

A prominent landscape and architectural photographer in Philadelphia during the 1860s and 1870s, John Moran was the brother of the renowned painters Edward and Thomas Moran. In the March 1865 issue of *Philadelphia Photographer*, John Moran compared photography to the fine arts, writing that it "speaks the same language, and addresses the same sentiments. It is our simple and unselfish delight in nature which is the foundation of all the

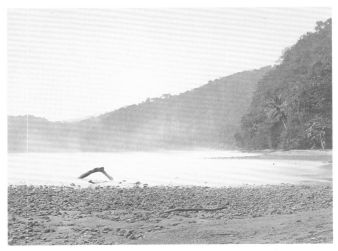

JOHN MORAN, *Tropical Scenery: The Terminus of the Proposed Canal—Limon Bay*

beautiful or fine arts, and which distinguishes them from science or mechanical arts."

In 1871 Moran replaced Timothy O'Sullivan as the official photographer for the second U.S. expedition, led by Commander Thomas O. Selfridge, to survey and assess the possibility of constructing a canal across the Isthmus of Darien in Panama. Despite the oppressive heat and humidity in which he had to work, Moran conveyed in his photograph the beauty of this tropical landscape at the terminus of the proposed canal.

WILLIAM JAMES MULLINS 1860–1917

Ploughman in Landscape, ca. 1900
platinum print
6.3 x 9.5 cm (2 ½ x 3 ¾ in.) PLATE 61

Trees Reflected in a Pond, Twilight, ca. 1900
platinum print
7.9 x 10.5 cm (3 ⅛ x 4 ⅛ in.)

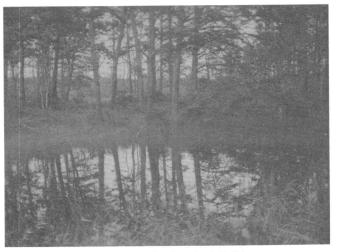

WILLIAM JAMES MULLINS, *Trees Reflected in a Pond, Twilight*

Like many members of the Photo-Secession, Mullins began his artistic career as a painter, counting Childe Hassam and Louis Comfort Tiffany among his closest friends. Mullins began taking photographs in the 1890s, and by 1898 his work was included in the Philadelphia Photographic Salon at the Pennsylvania Academy of the Fine Arts. His work appeared in the October 1901 issue of *Camera Notes*, and twelve of his photographs were included in the "International Exhibition of Pictorial Photography" at the Albright Art Gallery in Buffalo, New York, in 1910.

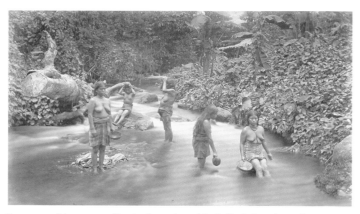

EADWEARD MUYBRIDGE, *Evening Recreations of the Coffee Pickers, San Isidro*

EADWEARD MUYBRIDGE 1830 ENGLAND–1904 ENGLAND

Valley of the Yosemite from Union Point, 1872
albumen print
43.2 x 54.6 cm (17 x 21 ½ in.) PLATE 25
Gift of Dr. and Mrs. Charles T. Isaacs

Born Edward Muggeridge in England, Muybridge came to the United States in 1850 as a publishing representative. By 1856 he had opened a bookstore in San Francisco. After an extended trip to England, he returned to California in 1867 as an accomplished photographer. That same year he made his first trip to the Yosemite Valley.

In direct competition with Carleton Watkins's acclaimed Yosemite views of 1861–62 (Plate 26), Muybridge's fifty-one mammoth plates, made in 1872, confirmed his reputation as a preeminent landscape photographer. They were offered for sale by the San Francisco gallery of Bradley and Rulofson the following year. Perhaps to distinguish his work from that of other photographers of Yosemite, such as Watkins and Charles Leander Weed (Plate 27), Muybridge chose points of view that heighten dramatic intensity. His photographs are notable for the inaccessibility of the subject matter. "He has gone to points where his packers refused to follow him," wrote one observer.

In 1872 Muybridge accompanied landscape painter Albert Bierstadt and geologist Clarence King, who was completing his survey of the fortieth parallel. Public response to the 1872 photographs was highly favorable. According to one critic, the photographs "surpassed in artistic excellence, anything that has yet been published in San Francisco." Muybridge's stereo-card business, which made his images available in a popular format, flourished.

Muybridge's views of Yosemite attracted the attention of Leland Stanford, former governor of California and president of the Central Pacific Railroad, who in 1872 commissioned him to photograph Stanford's horse Occident at a gallop in order to determine if a running horse's feet are ever off the ground simultaneously. These studies led to the extensive stop-action photographs of humans and animals in motion, for which Muybridge is now most famous.

Evening Recreations of the Coffee Pickers, San Isidro, 1877
albumen print
13.6 x 23.8 cm (5 ⅜ x 9 ⅜ in.)

In 1875 Muybridge traveled to Central and South America as a photographer for the Pacific Mail Steamship Company. During the trip he photographed these San Isidro coffee pickers.

ROBERT NEWELL 1822–1897

Clarence Howard Clark Estate, ca. 1870
albumen print
18.1 x 23.5 cm. (7 ⅛ x 9 ¼ in.)

From 1855 to the mid-1890s, Newell recorded important events in Philadelphia, such as the 1864 Great Central Fair for the U.S. Sanitary Commission. His reputation as a landscape photographer persuaded Clarence Howard Clark, president of the banking and insurance firm E. W. Clark and Company, to commission Newell to make a photographic portfolio of the family's West Philadelphia estate, Chestnutwold. The house no longer exists, but part of his vast property survives as Clark Park.

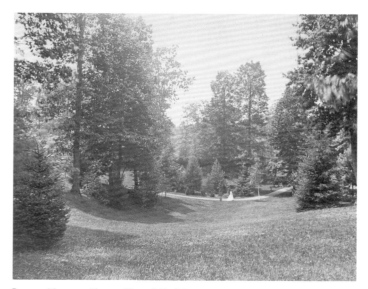

ROBERT NEWELL, *Clarence Howard Clark Estate*

TIMOTHY O'SULLIVAN 1840 IRELAND–1882 USA

Exterior of Fort Fisher, North Carolina, ca. 1864
albumen print
18.4 x 23.5 cm (7 ¼ x 9 ¼ in.)

Quarters of Men in Fort Sedgwick, Known as Fort Hell, 1865
albumen print
19.4 x 25.4 cm (7 ⅝ x 10 in.) PLATE 17

O'Sullivan began his photography career as an apprentice in Mathew Brady's Fulton Street gallery in New York City and then moved on to the Washington, D.C., branch managed by Alexander Gardner. In 1861, at the age of twenty-one, O'Sullivan joined Brady's team of Civil War photographers. When Gardner left Brady, O'Sullivan went with him, working for Gardner until the end of the war. Several of his images were included in *Gardner's Photographic Sketch Book of the War*. O'Sullivan built his reputation on images that conveyed the destructive power of modern warfare. His photographs of Forts Fisher and Sedgwick suggest the dismal psychological as well as physical effect of continual barrages of distant cannon fire on the soldiers behind the barricades.

Tufa Domes, Pyramid Lake, Nevada, 1867
albumen print
20 x 27 cm (7 ⅞ x 10 ⅝ in.) PLATE 34

Austin, Nevada, 1868
albumen print
19.7 x 26.7 cm (7 ¾ x 10 ½ in.)

In 1867 O'Sullivan joined Clarence King's geological survey of the fortieth parallel—the first federal expedition in the West after the Civil War. The letter of authorization, dated March 21, 1867, from Brigadier General A. A. Humphreys, chief of engineers, Department of War, charged King "to direct a geological and topographical exploration of the territory between the Rocky Mountains and the Sierra Nevada Mountains, including the route or routes of the Pacific railroad." O'Sullivan was strongly influenced by King's interest in the arts (he was a member of the Ruskinian group, the Society for the Advancement of Truth in Art), as well as by contemporary science and its attendant controversies. His work for the King survey often functioned as both objective scientific documentation and a personal evocation of the fantastic and beautiful qualities of the western landscape.

Rock Carved by Drifting Sand, below Fortification Rock, Arizona, 1871
albumen print
20.3 x 27.6 cm (8 x 10 ⅞ in.)

Cañon de Chelle, Walls of the Grand Cañon About 1200 Feet in Height, 1873
albumen print
20.3 x 27.6 cm (8 x 10 ⅞ in.) PLATE 36

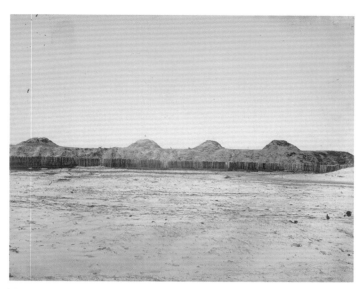

TIMOTHY O'SULLIVAN, *Exterior of Fort Fisher, North Carolina*

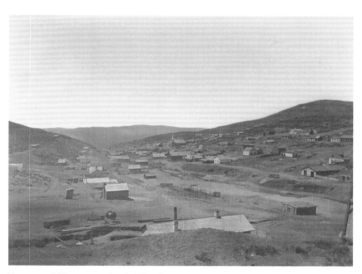

TIMOTHY O'SULLIVAN, *Austin, Nevada*

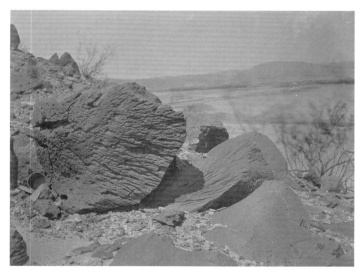

TIMOTHY O'SULLIVAN, *Rock Carved by Drifting Sand, below Fortification Rock, Arizona*

Historic Spanish Record of the Conquest, South Side of Inscription Rock, New Mexico, No. 3, 1873
albumen print
20.3 x 27.6 cm (8 x 10 ⅞ in.) PLATE 35

Shoshone Falls, Snake River, Idaho, View Across the Top of the Falls, 1874
albumen print
20.4 x 27.3 cm (8 x 10 ¾ in.) PLATE 39

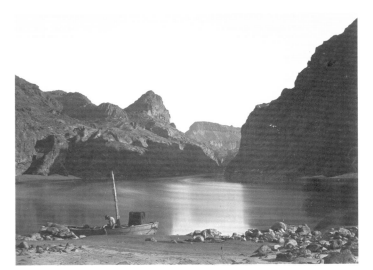

TIMOTHY O'SULLIVAN, *Black Cañon, Colorado River, from Camp 8, Looking Above*

In 1871 O'Sullivan joined the geological surveys west of the one hundredth meridian, under the command of Lieutenant George M. Wheeler of the U.S. Corps of Engineers. An army man rather than a civilian scientist like King, Wheeler insisted on a survey that would be of practical value. His reports included information likely to be useful in the establishment of roads and rail routes and the development of economic resources. Wheeler's captions for O'Sullivan's pictures provide geological information but also emphasize that the West was a hospitable place for settlers. For example, he compared Shoshone Falls favorably to Niagara Falls, the most popular American symbol of nature's grandeur. Indeed, O'Sullivan's 1874 image of Shoshone Falls, a version of a nearly identical image of the falls he made for King six years before in 1868, emphasized perspective as picturesque as it was dramatically precipitant.

Black Cañon, Colorado River, from Camp 8, Looking Above, 1871
albumen print
20.3 x 27.6 cm (8 x 10 ⅞ in.)

Flat-bottomed boats were used to go up the Colorado River through the Grand Canyon to the mouth of Diamond Creek. O'Sullivan commanded one of the boats, which he christened *The Picture*. Many of his negatives on glass plates were lost in transport, but surviving views of the Colorado's canyons are among his finest.

View on Apache Lake, Sierra Blanca Range, Arizona, with Two Apache Scouts in Foreground, 1873
albumen print
27.6 x 20.3 cm (10 ⅞ x 8 in.)

In 1873 O'Sullivan led an independent expedition for Wheeler, visiting the Zuni and Magia pueblos and the Canyon de Chelly, with its remnants of a cliff-dwelling culture. O'Sullivan's 1873 images of Apache scouts are among the few unromanticized pictures of the western Indian, unlike those of many ethnographic photographers who posed Indians in the studio or outdoors against neutral backgrounds.

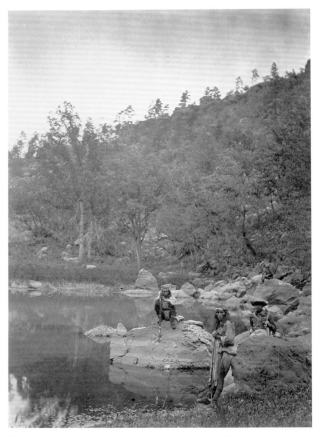

TIMOTHY O'SULLIVAN, *View on Apache Lake, Sierra Blanca Range, Arizona, with Two Apache Scouts in Foreground*

GOTTHELF PACH ACTIVE 1870s–80s

Views of Charlestown, New Hampshire, 1888
34 albumen prints in bound album
each 27.9 x 35.6 cm (11 x 14 in.)

The Pach brothers, Gustavus, Gotthelf, and Oscar, operated one of the most successful photographic studios in New York City, with branches throughout the East Coast. Their business included individual and group portraits as well as school photography. By 1878 the university class photographs that had been the specialty of George K. Warren were being made by the Pach Brothers studio.

Perhaps commissioned by Charles S. Symonds, whose signature appears on the album's title page, these photographs were made by Gotthelf Pach in August 1888. The date and the photographs themselves—the first image shows an arriving train, the last the village schoolhouse, implying the end of a summer idyll—suggest that the album was meant as the record of a holiday or as an advertisement to attract tourists. A view of the Eagle Hotel, a scene of a stickball match on Main Street, and a surrounding landscape of shady trees and gracious mansions all suggest the pleasures of vacationing in Charlestown, New Hampshire.

WILLIAM B. POST 1857–1925

Path in the Snow, ca. 1897
platinum print
12.7 x 18.1 cm (5 x 7 ⅛ in.)

Apple Trees in Blossom, ca. 1897
platinum print
19.1 x 23.8 cm (7 ½ x 9 ⅜ in.) PLATE 58

Post began exhibiting his photographs about 1893. A respected member of the Camera Club of New York, he worked with a variety of subjects but was most praised for his snow scenes. Opting for a more restricted viewpoint than other amateur landscapists, he used a shallow and impressionistic focus. His sharp description of foreground elements and the carefully controlled softness in the rest of the picture resulted in a relatively abstract, two-dimensional rendering. The critic Sadakichi Hartmann compared Post's apple-blossom series to the simplified style of Japanese paintings. Commenting on the snowscapes, he stated, "It almost seems like an insult to Dame Nature that she can be expressed in terms of such simplicity."

WILLIAM H. RAU 1855–1920
PUBLISHER: WILLIAM H. RAU

Sampson's Fleet, A Gunner of the "Iowa," 1898
albumen print (stereograph card)
8.3 x 15.5 cm (3 ¼ x 6 ⅛ in.)

GOTTHELF PACH, *Views of Charlestown, New Hampshire*

WILLIAM B. POST, *Path in the Snow*

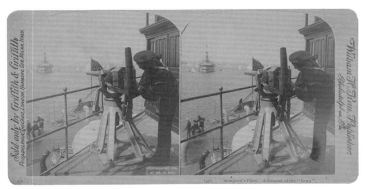

WILLIAM H. RAU, *Sampson's Fleet, A Gunner of the "Iowa"*

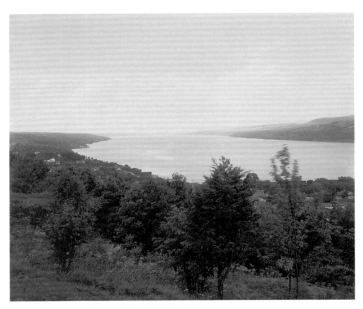

WILLIAM H. RAU, *Seneca Lake and Watkins Glen*

In 1877 William H. Rau, the son of Philadelphia photographer George Rau, purchased the stereograph company of his father-in-law, William Bell, a photographer with the U.S. Geological Survey. Rau continued to publish stereographs as well as lantern slides under his name, though some of the photographs were probably taken by assistants until the company was acquired by Underwood & Underwood in 1901. In 1898 the company's most popular subject was the Spanish-American War, including scenes such as this one of a gunner aboard the USS *Iowa*. Part of Rear Admiral William T. Sampson's fleet, the *Iowa* won fame in the battle of Santiago de Cuba. The popularity of the stereocards led to the publication of an illustrated supplement to Rau's annual catalogue.

Cathedral Rocks, Susquehanna River near Meghoppen, 1899
albumen print
43.8 x 51.8 cm (17 ¼ x 20 ⅜ in.) PLATE 40

Seneca Lake and Watkins Glen, 1899
albumen print
43.8 x 51.7 cm (17 ¼ x 20 ⅜ in.)

Towanda from Table Rock, 1899
albumen print
43.8 x 52 cm (17 ¼ x 20 ½ in.) PLATE 52

Rau was appointed official photographer of the Lehigh Valley Railroad in 1895. Traveling in a lavishly equipped passenger car, complete with a darkroom, parlor, and roof-mounted camera platform, he surveyed the length of the line, from New York City through Pennsylvania to upstate New York. Using familiar conventions of earlier western landscape photography, Rau combined scenic views with details of industrial progress. Rau's photographs describe a modern landscape with little nostalgia for an Edenic

past, showing, in the words of the railroad company report, "that which the regular traveler flying by on a fast express cannot see."

As part of the railroad's campaign to promote the region to businessmen and tourists, many of the photographs were printed with the slogan "Lehigh Valley: The Switzerland of the United States." According to Rau, "The photographs conveyed and revealed much better than guidebooks or conversation possibly could, the territory of wealth and beauty [made possible by] iron bands of the main line and branches" of the railroad.

JOHN REEKIE ACTIVE 1860s

Ruins of Gaines' Mill, Virginia, 1865
albumen print
17.8 x 22.9 cm (7 x 9 in.)

Reekie was briefly employed during the Civil War by Mathew Brady, but his work is best known to us as part of *Gardner's Photographic Sketch Book of the War*. Acompanying this image was a caption written by Alexander Gardner:

Gaines' Mill is the place from which the battle of June 27th, 1862 takes its name. Situated near the center of our line, it was the scene of severe fighting, and at the close of that bloody day, the building was used as a hospital. All of the structure that would burn, was destroyed in one of the raids around Richmond, leaving only the brick superstructure, above which, scorched by the fire, the dead trees spread their blackened branches. In front, the partially exposed skeleton illustrates the hasty manner of the soldier's burial, it being by no means uncommon for the rains to wash away the shallow covering, and bring to view the remains of the dead. The owner of the mill did not have a creditable reputation in the army.... If this is true, he suffered no more than his deserts, in the destruction of his property.

JOHN REEKIE, *Ruins of Gaines' Mill, Virginia*

Isaac A. Rehn (attributed to) 1845–1875

Lygodium Icandeus, ca. 1865
albumen photogram
35.5 x 43.8 cm (14 x 17 ¼ in.)

Rehn first appears in Philadelphia city directories in 1845 as a painter, but in 1849 he turned to the profession of photographer and traveled to Boston to become the partner of the daguerreotypist James A. Cutting. With Cutting, Rehn became part owner of patents for a variety of photographic processes, including one for a wet collodion negative process that became known as the ambrotype. Returning to Philadelphia in 1853, he traveled for several years to promote this invention.

 With the declining popularity of the ambrotype, Rehn continued his technical experiments in photographic processes. He became involved in photolithography and the production of paper prints ranging in size from the very small stereoscopic print to life-size enlargements made with a solar camera. His unique photogram of a fern suggests British photography pioneer William Henry Fox Talbot's first experiments in the mid-1830s. Like Rehn's later trials, Talbot had placed plant leaves directly onto sensitized paper, which slowly turned dark when exposed to sunlight, leaving the paper beneath the leaves white.

James Bartlett Rich 1866–1942

Winter Scene in Fairmount Park, Philadelphia, ca. 1910
silver print
15.6 x 21 cm (6 ⅛ x 8 ¼ in.)

In the Pumpkin Field at Lewes (The Photographer's Wife, His Daughter, and Friends), 1898
silver print
12.1 x 16.5 cm (4 ¾ x 6 ½ in.) PLATE 49

Rich was a talented amateur who matured into a successful professional photographer. In 1901 he opened a photography studio in downtown Philadelphia, but little of his commercial work survives. One of his major commissions was to accompany a 1908 expedition to Yellowstone, sponsored by Rodman Wanamaker, to photograph the landscape and Native American life. In Philadelphia he took photographs in the city's parks and public areas. Fairmount Park, the largest park in the city, became the definitive Philadelphia view and a favorite subject for photographers, including Rich. Winter was his favorite season to photograph. He used a variety of equipment, from small hand cameras to large studio view cameras, developing and printing his own work. His landscapes were usually made with a portable camera and medium-size negatives. Most of Rich's surviving prints are unique, printed to his exacting standards of quality.

 Rich, like other amateur photographers, also sought opportunities to make pictures during family outings. A weekend trip to a New Jersey pumpkin patch shows his wife, Hazel (bending to lift a pumpkin), his daughter Sarah (sitting on top of a pumpkin), and several family friends.

Isaac A. Rehn, *Lygodium Icandeus*

James Bartlett Rich, *Winter Scene in Fairmount Park, Philadelphia*

Frank A. Rinehart 1861–1928
possibly **Adolf F. Muhr** ACTIVE 1880s

In Winter, Kiowa, 1898
platinum print
23.5 x 19.1 cm (9 ¼ x 7 ½ in.)

Buried Far Away, Cocapah, 1899
platinum print
24.2 x 18.8 cm (9 ½ x 7 ⅜ in.) PLATE 2

Specializing in commercial portraits, Rinehart opened a studio in Omaha, Nebraska, in 1886. Commissioned by the government, in 1898 he became the official photographer of the Trans-Mississippi and International Exposition in Omaha. Many mid-nineteenth-century expositions exhibited American Indians as

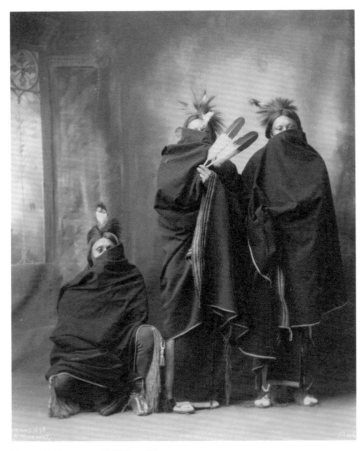

FRANK A. RINEHART, *In Winter, Kiowa*

Russell served as a captain in the U.S. Military Railroad Construction Corps. Like many other photographers during the Civil War, he later became a survey photographer in the western territories. He was also a skilled painter and journalist, reporting on local events for the Omaha *Nunda News*. In photography, however, Russell found a medium that suited his western subject. Describing a mountain scene in Utah, he wrote, "The sun reveals untold beauties.... Words cannot express or describe it. But the truthful camera tells the tale, and tells it well."

In 1865 Russell became the official photographer for the Union Pacific Railroad. With an artist's eye, he often selected views that juxtaposed monumental geological elements to manmade structures such as railroad and telegraph poles. Men and women appear in Russell's pictures, although they are often dwarfed by the vast landscape. Acknowledging both the technological triumph of the railroad and the scenic grandeur of the landscape, the photographs suggest the possibility of their coexistence.

In 1869 the railroad published an album of Russell's photographs of railroad construction in Wyoming and Utah titled *The Great West Illustrated in a Series of Photographic Views Across the Continent Taken Along the Line of the Union Pacific Railroad, West from Omaha, Nebraska*. Both images, *Sphinx of the Valley* and *Weber from One Thousand Feet Elevation*, are included in this book. In the early 1870s Russell left the Union Pacific Railroad and returned to New York.

curiosities of the past, but this one planned an "Indian Congress" to include all the tribes who had advanced under the national policy of assimilation. However, much of this intention was lost when the emphasis shifted from education to a Wild West style of entertainment.

Working with his assistant, Adolf Muhr, Rinehart set up a studio and gallery at the exposition. Because Rinehart was occupied with recording other exposition events, it is likely that Muhr made many of the nearly five hundred portraits of the Indians attending the Congress. The portraits are staged depictions in which some of the Indians are posed in ceremonial dress in front of incongruous studio backdrops of painted architectural settings. Others, like the image of Buried Far Away, suggest the harsher reality of the romanticized Native American.

ANDREW JOSEPH RUSSELL 1830–1902

Sphinx of the Valley, 1869
albumen print
23.2 x 31.4 cm (9 ⅛ x 12 ⅜ in.) PLATE 37

Weber from One Thousand Feet Elevation, 1869
albumen print
22 x 27.3 cm (8 ⅝ x 10 ¾ in.)

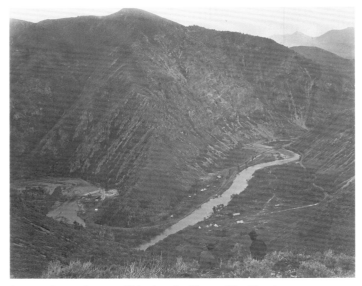

ANDREW JOSEPH RUSSELL, *Weber from One Thousand Feet Elevation*

LEWIS MORRIS RUTHERFURD, *Mary Pierrepont on Silvertail,*
with Rutherfurd Stuyvesant and Dog

LEWIS MORRIS RUTHERFURD 1816–1892

Mary Pierrepont on Silvertail, with Rutherfurd Stuyvesant and Dog,
ca. 1863
albumen print
22.9 x 17.2 cm (9 x 6 ¾ in.)

Rutherfurd's formal training was in law, but throughout his life he
remained devoted to the study of science and became one of the
founders of the National Academy of Science. He was among the
first to take photographs through a telescope, producing images of
the moon and distant planets in previously unimagined detail.

This informal image deviates from Rutherfurd's typical reper-
toire of scientific photographs. It depicts his son Rutherfurd (his
surname was that of an uncle, from whom he inherited a consider-
able fortune) and the young man's fiancée, Mary Pierrepont, at
Tranquility Farms, the Rutherfurd family estate in New Jersey.
The subjects are curiously placed at a distance from the camera,
perhaps a space dictated by the camera's fixed lens, or the habit of
a photographer accustomed to a more distant, planetary subject.

SAMUEL W. SAWYER ACTIVE 1860s

River Drivers, Maine, ca. 1867
tintype
17.8 x 12.7 cm (7 x 5 in.) PLATE 4

In the mid-nineteenth-century lumber industry, logs traveled on
the river from the forests where they were cut to the mills for
processing. Walking the floating logs to keep them from getting
jammed was dangerous work for a river driver. Dressed well for
outdoorsmen at the time, these young men are attired for a photo
session with a tintype photographer successful enough to have a
carpet on the floor and fringed velvet chairs. Although the reason
for making this tintype is now unknown, the photographer took
great care to pose the river drivers to display their distinctive
boot nails.

GEORGE SEELEY 1880–1955

Still Life with Vase and Apples, 1916
gum print
38.1 x 50.2 cm (15 x 19 ¾ in.) PLATE 70

As a student at the Massachusetts Normal School (later known
as Massachusetts College of Art), Seeley was encouraged by his
teacher, Boston School painter Joseph DeCamp, to explore the
effects of natural light. Upon being introduced to photography by
F. Holland Day, Seeley discovered a medium that well suited his
commitment to Impressionism. Compositional arrangement was
equally important to him, both as a teacher of drawing in the pub-
lic schools of Stockbridge, Massachusetts, and as a photographer.
Not surprisingly, he favored still-life arrangements.

Like other members of the Photo-Secession (Seeley became a
member in 1904), he frequently produced his photographs as gum
bichromate prints. This process involved the brushed application
of a pigmented solution onto a paper support, which gave photog-
raphers the opportunity for hand manipulation and produced a
richly toned, impressionistic effect.

CLARA ESTELLE SIPPRELL 1880–1975

Lucy Sipprell, ca. 1913
platinum print
15.9 x 11.4 cm (6 ¼ x 4 ½ in.) PLATE 71

Throughout her seventy-year career Sipprell created photographs
that typify Pictorialism: expressive rather than narrative or docu-
mentary, suggesting in her portraits the spiritual quality of the
subject rather than a physical likeness.

Even before she began her studies at the Clarence White
School in New York City, Sipprell learned about the medium in
the Buffalo, New York, portrait photography studio of her older
brother Frank Sipprell. At sixteen she ended her formal education
in order to work at the studio full time to prepare herself for a ca-
reer in photography. Sipprell's work reflects not only the early in-
fluence of her brother and his colleagues of the Buffalo Camera
Club but also her appreciation of Gertrude Käsebier and other
members of the New York Pictorialist community. She enjoyed a
close relationship with her brother and, later, his wife, Lucy, who is
the subject of this portrait. Sipprell was fond of saying that she
learned photography from Frank and aesthetics from Lucy.

STADLER PHOTOGRAPHING COMPANY ACTIVE 1847–1900

Babies' Lawn Caps, ca. 1900
silver print
24.8 x 30.5 cm (9 ¾ x 12 in.)

The rise of the department store and the continued success of mail-order shopping—partly due to the abundance of mass-produced clothing—had great impact on the democratization of fashion in the 1880s. Advertising photographs, such as this layout of baby caps by the Chicago-based Stadler Photographing Company, were increasingly used. Printed in catalogues, magazines, and newspapers as engraved illustrations, they influenced the consumers' clothing choices and helped popularize fashion.

STADLER PHOTOGRAPHING COMPANY, *Babies' Lawn Caps*

EDWARD STEICHEN 1879 LUXEMBOURG–1973 USA

Jean Walker Simpson, 1923
palladium print
24.8 x 19.7 cm (9 ¾ x 7 ¾ in.)

As a co-founder, with Alfred Stieglitz, of the Photo-Secession in 1902, Steichen adopted the Pictorialist style in his early photographs and was also influenced by the romantic themes of the Symbolists. A painter as well as a photographer, Steichen lived in Paris in the first decade of the twentieth century, where he briefly studied at the Académie Julian and was also well acquainted with avant-garde artists such as Cézanne, Picasso, and Matisse. During World War I, from 1917 to 1918, Steichen served with the U.S. Army in France as an aerial reconnaissance photographer. Rejecting Pictorialism after the war, Steichen showed a new appreciation for the straightforward photograph with its distinctive clarity.

In 1923 Steichen was appointed chief photographer for Condé Nast publications, including *Vogue* and *Vanity Fair*, and became known for his portraits of fashionable Americans. He met Jean Walker Simpson at Auguste Rodin's studio in Paris, and the two became close friends. She was the daughter of John Walker Simpson, a prominent New York lawyer and art collector who owned at least two paintings by Steichen. In this picture, he merges fashion photography with the tradition of the Renaissance painted portrait, depicting Simpson in profile, wearing an amber necklace and a gold headband.

EDWARD STEICHEN, *Jean Walker Simpson*

SENECA RAY STODDARD 1844–1917

Englewood Cliffs, New Jersey, ca. 1889
albumen print
24.8 x 33.3 cm (9 ¾ x 13 ⅛ in.)

The Antlers, Open Camp, Raquette Lake, ca. 1889
silver print
15.6 x 20.7 cm (6 ⅛ x 8 ⅛ in.) PLATE 50

Although Stoddard began his career as a railroad-car decorator, an 1867 issue of the Glen Falls, New York, newspaper referred to him as a landscape photographer. He is best known for his work in

SENECA RAY STODDARD, *Englewood Cliffs, New Jersey*

the Adirondack wilderness. Produced as both single prints and stereographs, Stoddard's photographs contributed to a mythic appreciation of the Adirondacks, even as they describe the development of the area. His photographs of evening camp life, made with a magnesium flash, are a reminder of the intrusion of the sportsman.

Working for William West Durant's Adirondack Railway, he documented the construction of a northern route to an area increasingly visited by urban tourists. In this photograph of *Englewood Cliffs, New Jersey*, Stoddard integrates the sublime attractions of nature with the effects of railroad construction.

WILLIAM STROUD ACTIVE CA. 1860

Sarah Howard, 1860
salted paper print with applied color
20 x 14.6 cm (7 ⅞ x 5 ¾ in.)

According to an advertisement in the Norristown, Pennsylvania, *Register*, Stroud—the town's first resident photographer—opened his daguerreotype studio on September 3, 1850. His advertisements urged clients to "call as early in the day as possible...avoid [wearing] light blue, or too much WHITE." Stroud's business soon expanded to include other photographic processes, including paper prints made from negatives. The ability to make many copies of an image quickly eclipsed the popularity of the unique daguerreotype, and studios like Stroud's did a brisk business reproducing the older images. As in early daguerreotypes, color was delicately applied to the surface of the finished photograph.

A note on the back of this portrait indicates it was made after a daguerreotype by the important Philadelphia studio of William and Frederick Langenheim. Curiously, it was the Langenheim brothers who purchased the American patent rights to the paper process from its Britsh inventor, William Henry Fox Talbot. This eventually put them, and other early American daguerreotypists, out of business.

KARL STRUSS 1886–1981

The Attic Window, Dresden, 1909
platinum print
23.5 x 19 cm (9 ¼ x 7 ½ in.)

Karl Struss, who studied with Clarence White, was known for the complex tonalities of his platinum prints. His work was represented in Alfred Stieglitz's important "International Exhibition of Pictorial Photography" in Buffalo, New York, in 1910. Two years later he became a member of the Photo-Secession and was featured in Stieglitz's journal, *Camera Work*. Struss's concern for sophisticated composition is evident in this modest image of plants on a windowsill. Gently muted, it evokes the nostalgic mood of Pictorialism. However, the geometry of the window—the frame within the frame of the photograph—suggests a more modern artistic idea. Beyond his work in photography, Struss also was a noted Hollywood cinematographer, winning an Oscar for *Sunrise* in 1927.

WILLIAM STROUD, *Sarah Howard*

KARL STRUSS, *The Attic Window, Dresden*

LOUIS COMFORT TIFFANY 1848–1933

Fishermen Unloading a Boat, Sea Bright, New Jersey, 1887
albumen print
15 x 20.7 cm (5 ⅞ x 8 ⅛ in. PLATE 45

Although Tiffany is better known for his work in the decorative arts and painting, he made significant use of photography. Like many of his contemporaries, he turned to the camera to obtain an immediate record of the world around him. Photographs, many taken on his numerous trips abroad, provided studies for his paintings and also served as inspiration for decorative motifs. He is known to have made many photographic studies in Sea Bright, New Jersey, in the late 1880s.

Tiffany also photographed the stained-glass windows, furniture, lamps, and artifacts made by Tiffany & Company, which were published in the firm's brochures. He also experimented with the camera in an effort to capture the grace of animal and human movements. Like his paintings and stained glass, they reveal the artist's interest in form and detail.

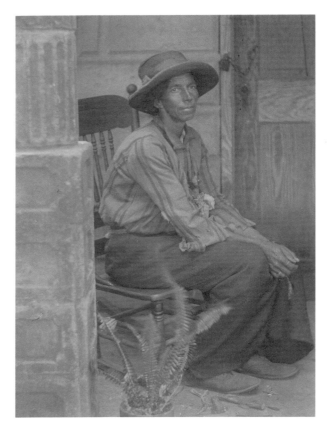

DORIS ULMANN, *Woman on a Porch*

DORIS ULMANN 1882–1934

Corn Shocks and Sky, ca. 1925
platinum print
18.4 x 15.3 cm (7 ¼ x 6 in.) PLATE 62

Man Leaning against a Wall, ca. 1930
platinum print
20.3 x 15.3 cm (8 x 6 in.) PLATE 77

Woman on a Porch, ca. 1930
platinum print
21.3 x 16.5 cm (8 ⅜ x 6 ½ in.)

A native of New York City, Ulmann had a diverse education: teacher's training with Lewis Hine at the Ethical Culture School, studies in psychology and law at Columbia University, and photography classes at the Clarence H. White School of Photography. Independently wealthy, she became a professional portrait photographer in New York. Her subjects included friends such as Ruth St. Denis, Albert Einstein, and President Calvin Coolidge.

Ulmann is best known, however, for her photographic projects in the Appalachian Mountains of the South. Taking the same large view camera and soft-focus lens that she had used for her New York portraits, she traveled thousands of miles through this region during the summers of the 1920s and early 1930s until her death in 1934. Assisted by her friend the folklorist and singer John Jacob Niles, Ulmann sought to document what she believed was America's vanishing cultural past.

UNDERWOOD & UNDERWOOD ACTIVE 1881–1900s
Publisher: Underwood & Underwood

Evolution of the sickle and flail—33-horse team combined Harvester—Walla Walla, Washington, 1902
mounted albumen prints (stereograph card)
each 8.3 x 7.9 cm (3 ¼ x 3 ⅛ in.) PLATE 48

Stereo pictures enjoyed enormous popularity in nineteenth-century America, heightening the illusion of reality seen in a daguerreotype or photograph. As these three-dimensional images quickly became big business, many photographers turned to distribution as well as production. Illustrating a vast range of subjects and sold to a wide popular audience, as well as to schools and libraries, these images functioned as visual encyclopedias. By the end of the nineteenth century, sets of mass-produced stereographs were manufactured by large companies such as Keystone, the American Stereoscopic Company, and Underwood & Underwood.

Elmer (1859–1947) and Bert (1862–1943) Underwood went into business in Ottawa, Kansas, in 1881. By 1901 they were selling ten million stereo views a year. In addition to their own pictures, they were the sole agents for Charles Bierstadt's views of Niagara Falls, J. F. Jarvis's views of Washington, D.C., George Barker's views, including his well-known images of the Johnstown Flood, and the entire output of the Littleton View Company of New

Hampshire. The views sold for under twenty cents each, the stereoscope for as little as ninety cents.

Nearly all aspects of farming—especially planting, harvesting, and processing products—were depicted in stereo views. Those showing horse-drawn farm equipment, wagons, and homesteads presented a turn-of-the-century way of life that would soon disappear.

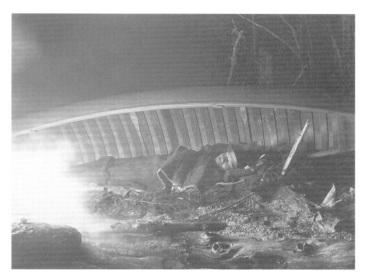

WILLIAM LYMAN UNDERWOOD, *Joe Mell, Asleep in His Canoe*

WILLIAM LYMAN UNDERWOOD 1864–1929

Joe Mell, Asleep in His Canoe, ca. 1895
platinum print
14.9 x 17.5 cm (5 ⅞ x 6 ⅞ in.)

William Lyman Underwood and his brother Loring (1874–1930) were early leaders in nineteenth-century nature photography. Loring, trained as a horticulturist, focused on the cultivated landscapes of parks and estate gardens, while William preferred the wilderness of northeastern America. A renowned public speaker, William gave more than forty lectures a year about his experiences as "a camera hunter," accompanied by a lantern slide show of his photographs. This turn-of-the-century entertainment instructed audiences about an environment that Underwood feared was vanishing.

In 1927 Underwood published *Wilderness Adventures*, a book that describes his experiences with his Passamaquoddy Indian guide, Joe Mell. Invoking the spirit of Thoreau and Emerson, whose New England had already suffered the effects of industrial progress, Underwood described Mell's skills and knowledge as an outdoorsman, testifying to the still vital character of the American wilderness experience.

UNIDENTIFIED ARTIST

Artists' Excursion, Sir John's Run, Berkeley Springs, 1858
salted paper print
17.2 x 15.6 cm (6 ¾ x 6 ⅛ in.) PLATE 23

In the late spring of 1858 the Baltimore and Ohio Railroad invited a group of artists, illustrators, and photographers to go on a "pleasure excursion." The photographers who documented the trip for the railroad were given a special car complete with darkroom and studio space. Starting in Baltimore, the train traveled west through what was then Virginia (becoming West Virginia in 1863). According to "Artists' Excursion Over the Baltimore-Ohio Rail Road," the account published in the June 1859 issue of *Harper's New Monthly Magazine*, "the guests were to travel at their leisure, stopping at all the prominent points of interest long enough to examine the most notable productions of human science and labor; to enjoy the magnificent natural scenery for which the line is so famous; and if so disposed, to exercise their talents." The travelogue was illustrated with woodcuts made from photographs taken to document the expedition. The trip was a remarkable feat of advertising for the railroad's new western line. As the writer declared: "For the first time in our history had the great embodiment of utilitarianism extended the hand to the votaries of the beautiful."

UNIDENTIFIED ARTIST

Baby in a Chair, ca. 1870
tintype with applied color
18.4 x 12.7 cm (7 ¼ x 5 in.)

UNIDENTIFIED ARTIST, *Baby in a Chair*

UNIDENTIFIED ARTIST

Barge, ca. 1895
cyanotype
10.2 x 12.7 cm (4 x 5 in.)

UNIDENTIFIED ARTIST

View of a Stream with Figures, ca. 1895
cyanotype
10.5 x 11.1 cm (4 ⅛ x 4 ⅜ in.)

UNIDENTIFIED ARTIST

Disadvantages of a Trestle, ca. 1915
cyanotype
20.3 x 25.4 cm (8 x 10 in.)

By the late nineteenth century, photographs were routinely included as illustrations for construction manuals, factory reports, and instruction manuals in manufacturing. An entire volume of *The Complete Self-Instruction Library of Practical Photography*, published in 1909 by the American School of Art and Photography of Scranton, Pennsylvania, was devoted to *Commercial, Press, and Scientific Photography*. The manual began: "A record of every important detail of business—a record that has a meaning and a use—that is one of the purposes of *system*. Business today is developing a new kind of record—automatic, accurate, incontrovertible—the photograph. To manufacturers and builders, to engineers and contractors, who are carrying out the vast constructive enterprises of the day, the photograph is coming to be a most important record." Companies usually made several sets of photographs—often in a uniform size as cyanotypes, or "progress blueprints"—one for the files, one for the work site, and one for the client.

UNIDENTIFIED ARTIST, *Barge*

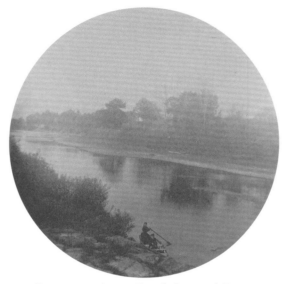

UNIDENTIFIED ARTIST, *View of a Stream with Figures*

UNIDENTIFIED ARTIST, *Disadvantages of a Trestle*

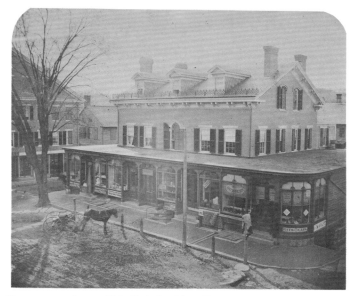

UNIDENTIFIED ARTIST, *Blake Block, Brattleboro, Vermont*

UNIDENTIFIED ARTIST

Blake Block, Brattleboro, Vermont, 1860
salted paper print
19.7 x 24.1 cm (7 ¾ x 9 ½ in.)

CALEB LYSANDER HOWE 1811–1895

Blake Block, Brattleboro, Vermont, After the Fire, 1869
mounted albumen prints (stereograph card)
each 7.6 x 7.6 cm (3 x 3 in.)

One of the finest homes in Brattleboro, Vermont, Blake Block was built as a residence in 1810. For many years it was the home of John W. Blake, one of Vermont's foremost lawyers, and of Blake's eldest son, John R. Blake. Also an important figure in Brattleboro's history, the younger Blake was a businessman who was influential in promoting the construction of the Vermont and Massachusetts Railroad, which connected Brattleboro with Boston, furthering Vermont's trade and tourism. Perhaps because it was on the main street of a bustling village, the house was transformed into a commercial building in 1853, housing the village druggists, grocers, librarian, and booksellers.

October 1869 was a disastrous month for the city of Brattleboro. Unseasonable flooding tore away bridges and destroyed underground cisterns. Weeks later, when a fire in a saloon could not be contained, the buildings on a large part of Main Street, including the commercial property known as Blake Block, were destroyed.

The identity of the person who photographed Blake Block before the fire is unknown; at that time, Brattleboro had many local photographers. Caleb Lysander Howe's stereocard, made after the fire, was probably produced to be sold in a set of town views. Typical of many nineteenth-century photographers, Howe found his trade by chance rather than design. A farmer and music teacher, he became fascinated with the medium when an itinerant photographer set up a temporary studio near the Howe family farm in 1852. Howe offered to buy him out for three hundred dollars and, thus equipped, launched a new career that was profitable enough to become a family business.

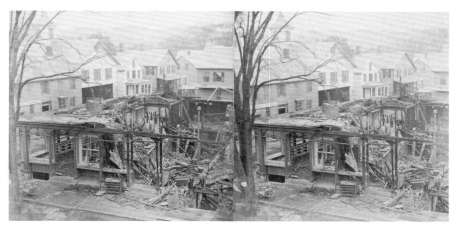

CALEB LYSANDER HOWE, *Blake Block, Brattleboro, Vermont, After the Fire*

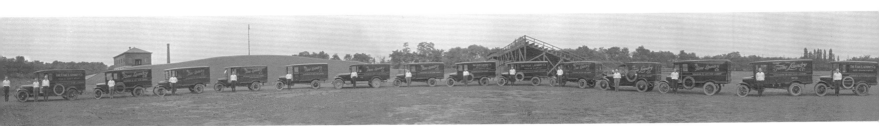

UNIDENTIFIED ARTIST, *Delivery Vehicles and Staff of the Fame Laundry Company*

UNIDENTIFIED ARTIST

Caroline Greig and Sister Julia, ca. 1855
daguerreotype
half plate PLATE 3

UNIDENTIFIED ARTIST

Delivery Vehicles and Staff of the Fame Laundry Company, ca. 1915
silver print
15.3 x 106.7 cm (6 x 42 in.)

UNIDENTIFIED ARTIST

Dentist, ca. 1855
daguerreotype
quarter plate

UNIDENTIFIED ARTIST

Editor, ca. 1855
daguerreotype
quarter plate PAGE 12

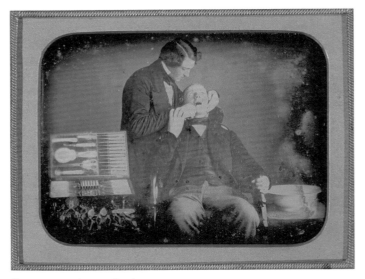

UNIDENTIFIED ARTIST, *Dentist*

Sometimes known as occupational portraits, individuals with the tools of their trade were often more elaborately posed pictures than the straightforward studio portrait. The difference is often in the tools themselves or in the ingenuity with which the photographer has made them part of the portrait. In some occupationals, such as the quarter-plate portrait of the dentist, it is the tools themselves that seem to be the main focus. Their neat arrangement suggests that the portrait may have been commissioned by the salesman for the instruments rather than to display the dentist's practice of tooth extraction.

In most occupational portraits the instruments of the sitter's profession are casually held in the hand or discreetly placed on a table at his or her elbow. In the case of this editor, the profusion of tools threatens—appropriately enough in view of his occupation—to overwhelm the sitter. The long strips of typeset proofs, the sharpened quill pen for corrections, scissors for deletions, a paste pot for additions, and books within reach for reference all describe the profession. The editor's pipe and plumed hat, however, better suggest the sitter's, and the photographer's, whimsical sense of humor.

UNIDENTIFIED ARTIST

Echo Lake, North Conway, Franconia, White Mountains, ca. 1870
albumen print
21 x 16.5 cm (8 ¼ x 6 ½ in.)

UNIDENTIFIED ARTIST

Folk Artist with Carved Wooden Chain, ca. 1855
daguerreotype
sixth plate

Made as tokens of love or wedding presents, continuous chains carved from a single piece of wood are a unique form of American carving. Like other daguerrean portraits in which the sitter is characterized by the tools of his or her trade, this image shows the craftsman smoothing the edges of his lengthy chain with a file. Because the chain in this daguerreotype is adorned with caged balls—a complex and decorative variation on the carved link—the image may be a portrait of the accomplishment itself rather than a simple likeness.

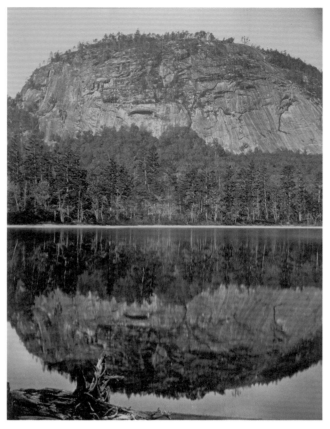

UNIDENTIFIED ARTIST, *Echo Lake, North Conway, Franconia, White Mountains*

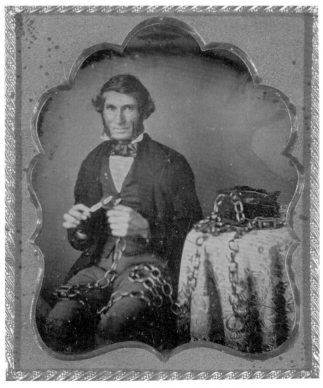

UNIDENTIFIED ARTIST, *Folk Artist with Carved Wooden Chain*

UNIDENTIFIED ARTIST

"Forty-niner," Street Advertiser in Studio, San Francisco, 1890
albumen print
18.7 x 12.4 cm (7 ⅜ x 4 ⅞ in.) PLATE 54

A reference to the hardy pioneers who had gone west during the gold rush, by the last decade of the nineteenth century the well-known caricature of the California "Forty-niner" was frequently used in advertisements for a variety of products, from hotels and restaurants to hardware and blue jeans. The model, wearing full gold-rush regalia, stands incongruously before the photographer's painted studio backdrop of a pastoral eastern landscape complete with garden urn. Perhaps, after reading the signs he carries— "Flapjacks & Sausages for Lunch"—a visitor to San Francisco might have been enticed to dine in gold-rush style.

UNIDENTIFIED ARTIST

The Grape-Vine Swing, ca. 1895
platinum print
21 x 15.9 cm (8 ¼ x 6 ¼ in.)

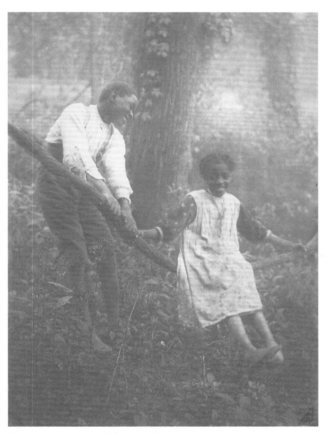

UNIDENTIFIED ARTIST, *The Grape-Vine Swing*

UNIDENTIFIED ARTIST

House with White Fence and Trees, ca. 1855
daguerreotype with applied color
quarter plate

UNIDENTIFIED ARTIST

Mother and Son, ca. 1855
daguerreotype with applied color
half plate

UNIDENTIFIED ARTIST

Niagara Panorama, Summer, ca. 1885
albumen prints
left: 42.2 x 41.6 cm (16 ⅝ x 16 ⅜ in.)
right: 41.9 x 53.3 cm (16 ½ x 21 in.)

By the late nineteenth century, views of Niagara Falls were being produced in every photographic medium for a prosperous middle class eager to have a memento of their experience with "Nature's Grandest Scene," as Charles Dickens observed. Photographers of Niagara Falls chose the vantage points used by painters, attracted not only to the two enormous waterfalls but also the mile-long stretch of rapids upstream and the whirlpools below.

Earlier images by photographers such as Charles Bierstadt and George Barker had emphasized the contrast between the turbulence of the Falls and the order provided by human constructions, but by the end of the nineteenth century the Falls had been bridged and their power harnessed for industry. Composed of two photographs, this panoramic view of the Falls by an anonymous photographer (perhaps an amateur in light of the irregular match of the horizon line) is aimed at picturesque contemplation rather than sublime excitement.

UNIDENTIFIED ARTIST, *House with White Fence and Trees*

UNIDENTIFIED ARTIST, *Mother and Son*

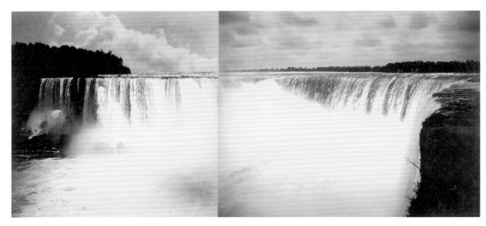

UNIDENTIFIED ARTIST, *Niagara Panorama, Summer*

UNIDENTIFIED ARTIST

Night-Blooming Cereus, Closed after Blooming, 1884
albumen print
20.3 x 14.6 cm (8 x 5 ¾ in.)

Night-Blooming Cereus in Bloom, 1885
albumen print
14.9 x 19.9 cm (5 ⅞ x 7 ⅞ in.)

Once every year under cover of darkness, the night-blooming cereus (Selenicereus Grandiflorus) blossoms. The 1884 picture shows the flower closed after blooming. This suggests that the photographer, having missed his chance to capture the flower in its brilliance, had to wait an entire year to make his image of the cereus in full bloom.

UNIDENTIFIED ARTIST

The Ohio Star *Buggy*, ca. 1850
daguerreotype
sixth plate PLATE 22

Specially fitted with drawers and compartments, this newspaper delivery wagon was used by the *Ohio Star* in the town of Ravenna. Perhaps the reason for taking this daguerreotype—unusual because the photographer was working out of the studio—was the arrival of the wagon. The custom design suggests the latest in newspaper delivery in Ohio and also implies the commercial success of the publication. The six women and girls standing in the background beside the porch—perhaps the newspaper owner's wife and daughters—make this a variation on the usual family portrait.

UNIDENTIFIED ARTIST

Pennsylvania Railroad Locomotive at Altoona Repair Facility, ca. 1868
albumen print
27.3 x 43.2 cm (10 ¾ x 17 in.)

This grand "portrait" of a locomotive not only documents but also monumentalizes the subject. Following the divisiveness of the Civil War, its appearance was of national importance: "To build the railroad," Samuel Bowles wrote in 1865, "is the cheapest, surest and sweetest way to preserve our nationality, and continue the Republic as a unit from ocean to ocean." Railroad tracks, bridges, and terminals added new elements to the natural landscape. Many photographers were employed by the railroad companies, those interested in opening up the West and others who sought to develop lines in the East. As the photographer positioned his camera to photograph the light reflecting off the pristine engine of locomotive No. 43, we may suppose that the picture represents its "launching."

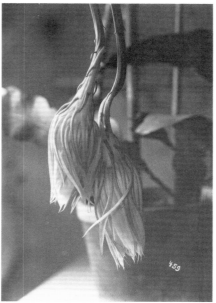

UNIDENTIFIED ARTIST, *Night-Blooming Cereus,
Closed after Blooming*

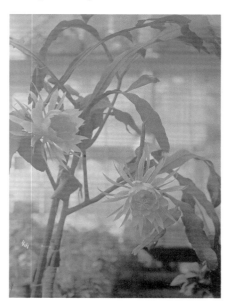

UNIDENTIFIED ARTIST, *Night-Blooming Cereus in Bloom*

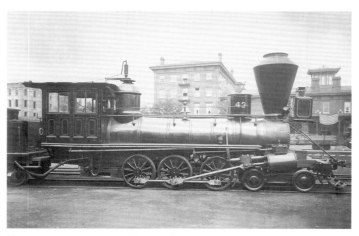

UNIDENTIFIED ARTIST, *Pennsylvania Railroad Locomotive at Altoona Repair Facility*

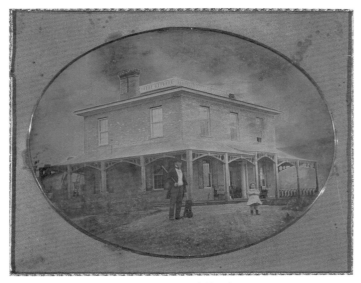

UNIDENTIFIED ARTIST, *Square House, Man, Child, and Dog on Lawn*

UNIDENTIFIED ARTIST

Seneca Falls, New York (upstream), ca. 1850
daguerreotype
half plate PLATE 5

Seneca Falls, New York (downstream), ca. 1850
daguerreotype
half plate PLATE 6

Probably made on the same day, these two views of the Seneca River represent one of the earliest portraits of industrial progress photographed in America. By the mid-nineteenth century the town of Seneca Falls, ideally situated on both banks of the river, had developed as a center of commerce. Cowing & Co., one of America's first manufacturers of fire engines, and Sash & Blind Factory are crowded together on a small island, which no longer exists.

UNIDENTIFIED ARTIST

Square House, Man, Child, and Dog on Lawn, ca. 1855
daguerreotype
half plate

UNIDENTIFIED ARTIST

Still Life with Pumpkin, Book, and Sweet Potato, ca. 1855
daguerreotype
ninth plate PAGE 166

Still lifes were not often composed for the daguerreotype camera, which usually focused on the more pragmatic description of faces or geographical locations. This enigmatic combination of a pumpkin, a sweet potato, and a volume of Shakespeare's works nonetheless provides a revealing aspect of life in nineteenth-century America. Shakespeare's popularity during the daguerrean era led

door-to-door salesmen to peddle copies of his works along with pots and pans. In homes from the western frontier of Kentucky to New York City, a copy of the bard's plays often occupied a place next to the family Bible. Burlesque parodies of Shakespeare's plays were as popular as the new invention of photography. In one satirical soliloquy Macbeth asks his wife, "Or is that dagger but a false Daguerreotype?"

UNIDENTIFIED ARTIST

Three Friends in a Field, ca. 1900
silver print
9.5 x 12.1 cm (3 ¾ x 4 ¾ in.) PLATE 74

UNIDENTIFIED ARTIST

Beatrice Thom on Tree, Haddonfield, New Jersey, 1893
silver print
11.5 x 16.5 cm (4 ½ x 6 ½ in.)

UNIDENTIFIED ARTIST

Rafting Party, ca. 1910
silver print
12.1 x 16.8 cm (4 ¾ x 6 ⅝ in.)

In 1881, under the slogan "Cameras for the Millions," the E. & H. T. Anthony firm began marketing to the modern amateur photographer small box cameras that could easily be hand held and George Eastman's commercial dry plates. Soon many other simple portable cameras flooded the market, making the formerly complicated process of photography a pastime for thousands of Americans. According to an 1883 article in the *New York Times*, it was now common to see "nicely dressed young fellows loaded down with cameras and tripods at the trains and steam-boats" on their way to the country to photograph "a bit of romantic landscape, river, or mountainside." With shutter speeds of about 1/20th a second, amateurs delighted in making "instantaneous" pictures of family and friends. The Kodak—Eastman's first successful film camera, introduced in 1888—gave everyone the means to document his or her life as well as pursue an artistic hobby. Photography was regarded as a healthful pastime, best practiced in sunlight and fresh air.

UNIDENTIFIED ARTIST

Two Workmen Polishing a Stove, ca. 1865
albumen print
35.9 x 28 cm (14 ⅛ x 11 in.) PLATE 11

UNIDENTIFIED ARTIST

View at Gervanda Looking Downstream from the Bridge, ca. 1880
albumen print
22.2 x 29.8 cm (8 ¾ x 11 ¾ in.) PLATE 46

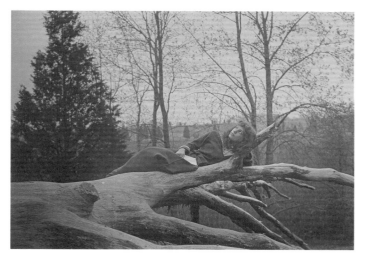

UNIDENTIFIED ARTIST, *Beatrice Thom on Tree, Haddonfield, New Jersey*

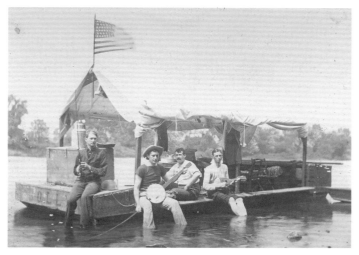

UNIDENTIFIED ARTIST, *Rafting Party*

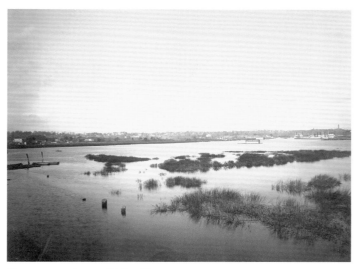

UNIDENTIFIED ARTIST, *Harlem River*

UNIDENTIFIED ARTIST

Harlem River, ca. 1875
albumen print
25.7 x 34.9 cm (10 ⅛ x 13 ¾ in.)

While late nineteenth-century commercial and journalistic photographers produced records of the nation's technological progress, amateur photographers focused on its idyllic pre-industrial past. A growing, increasingly leisured middle class provided ample subjects for photographs, such as outings on a river. Given the compositional aspects of some of these romantic images, it is possible that a number of photographers had training as painters. Like well-known photographers such as Rudolf Eickemeyer, Jr., Gertrude Käsebier, and John G. Bullock, many accomplished amateurs, whose identities are now unknown, favored seemingly timeless pastoral subjects.

UNIDENTIFIED ARTIST

Wilderness Battlefield, 1864
albumen print
14 x 10.1 cm (5 ½ x 4 in.)

The Battle of the Wilderness was fought May 5–7, 1864, in a nearly impenetrable forest near Chancellorsville, Virginia, between the Union forces of General Ulysses S. Grant and the Confederate

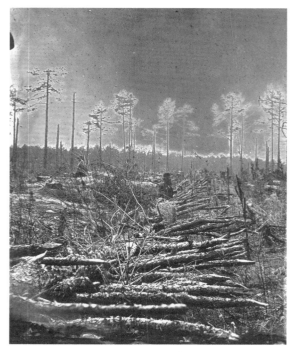

UNIDENTIFIED ARTIST, *Wilderness Battlefield*

forces of General Robert E. Lee. The site of a battle the previous year, the ground was already littered with skulls, and the underbrush was so dense that both armies fought blindly, often mistakenly firing on their own men. Musket fire ignited the underbrush into flames. Wounded men burned to death as their comrades could not reach them. The number of wounded and killed was second only to that at Gettysburg.

This image, similar to a group of twenty-eight in the Gilman Paper Company's collection, was made during the cleanup operation after the battle. Whether the inadvertent result of faulty processing in a field darkroom or deliberate manipulation of the negative to produce a dramatic print descriptive of the battle's firestorm, the photograph is solarized and tonally reversed.

UNIDENTIFIED ARTIST

Young Boy, n.d.
salted paper print with applied color
22.5 x 16.2 cm (8 ⅞ x 6 ⅜ in.)

UNIDENTIFIED ARTIST

Young Girl, n.d.
salted paper print with applied color
21.6 x 16.5 cm (8 ½ x 6 ½ in.)

UNIDENTIFIED ARTIST

Young Man Looking at Daguerreotype, ca. 1855
daguerreotype
quarter plate PLATE I

The daguerreotype opened up new possibilities for double portraits even if one of the sitters was absent, presumably deceased. In some cases, the painted portrait of a loved one accompanied the portrait of a living sitter. In others, such as this quarter plate, in which a young man contemplates the portrait of an older man, possibly a relative, the daguerreotype within a daguerreotype helped convey the impression that the individuals were together, at least in spirit.

JULIAN VANNERSON 1827–AFTER 1875
Shining Metal, 1858
salted paper print
22.2 x 16.5 cm (8 ¾ x 6 ½ in.) PLATE 13

Vannerson's portraits of Native Americans were part of a systematic effort to document members of treaty delegations who came to Washington, D.C. Delegation photography was a routine part of every state visit. Many portrait studios, including that of James McClees, for whom Vannerson worked, profited from the business. At the height of the winter season of 1857–58, for example, approximately ninety delegates from thirteen tribes were in the city. Bound as albums or offered as single, hand-colored prints, the portraits, including the standing portrait of Shining Metal, a chief of the Mdewakanton Dakota, were sold to a curious public.

UNIDENTIFIED ARTIST, *Young Boy*

UNIDENTIFIED ARTIST, *Young Girl*

160

ADAM CLARK VROMAN 1856–1916

Around Moki Towns, The Tewa Trail, 1900
platinum print
16.5 x 21.6 cm (6 ½ x 8 ½ in.)

Around Zuni, From Northeast of Pueblo "99," 1899
platinum print
16.5 x 21.6 cm (6 ½ x 8 ½ in.) PLATE 53

A collector of Southwest Indian artifacts and an amateur archaeologist, Vroman took his first trip to the Southwest in 1895, motivated by a desire to see the Hopi Snake Dance. Between 1895 and 1904 he made at least eight trips to Arizona and New Mexico from his home in Pasadena, California, to photograph among the Hopi and Navajo tribes.

In 1899 he accompanied an expedition to the Southwest organized by the Bureau of American Ethnology. According to the Sante Fe *New Mexican* of July 28, 1899, the purpose was "to visit as many pueblos of New Mexico as possible and to obtain a large and complete series of photographs." As part of the survey, many of the pueblos were given identifying numbers.

Vroman often turned his camera on the surrounding landscape. Used by the survey, such encompassing views made it possible to prove previous habitation on the mesa. Contrasting the small circle of a corral with the vastness of the land and sky, it is an evocative document.

GEORGE KENDALL WARREN CA. 1824–84

Campus Buildings, Williams College, Massachusetts, ca. 1860
salted paper print
15.5 x 20.6 cm (6 ⅛ x 8 ⅛ in.)

Born in Nashua, New Hampshire, Warren was making daguerreotypes in Lowell, Massachusetts, by 1851. Most of his career, however, was spent as a photographer for schools and universities such as Harvard, Yale, and Princeton. Warren also made many scenic cartes de visite of historic sites in the Cambridge, Concord, and Boston areas.

This view of Williams College includes Lawrence Hall, built in 1846 as the library, and East College, built in 1789 as a dormitory.

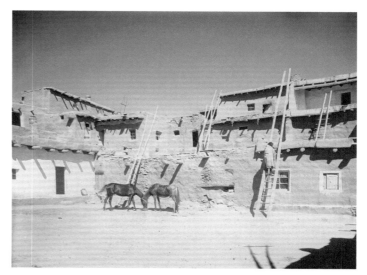

ADAM CLARK VROMAN, *Around Moki Towns, The Tewa Trail*

GEORGE KENDALL WARREN, *Campus Buildings, Williams College, Massachusetts*

CARLETON E. WATKINS 1829–1916

Cascade, Nevada Falls, Yosemite, California, ca. 1861
albumen print
39.6 x 53 cm (15 ⅝ x 20 ⅞ in.) PLATE 26

Few landscape photographers gained such national acclaim as
Carleton Watkins. Born in Oneonta, New York, he left for
California in 1851 at the age of twenty-two. After a brief
apprenticeship in a portrait photography gallery, he was in busi-
ness for himself by 1861. Unlike most studio owners, however,
Watkins gave up the financial security of gallery portraiture for the
more sporadic opportunities in landscape photography. He made
his first trip to Yosemite in the fall of 1861, producing thirty mam-
moth-plate and one hundred stereoscopic negatives. They were
among the first photographs of the valley sent back east. It was
partly based on this material that President Lincoln signed a bill in
1864 banning development in the valley, which led to the establish-
ment of the national-parks system. Over the next twenty years
Watkins returned to the valley at least seven times. His achieve-
ment prompted others, such as photographer Charles R. Savage, to
refer to Watkins as "the most advanced in the photographic
art...who has produced, with his camera, results second to none in
either the eastern or western hemispheres."

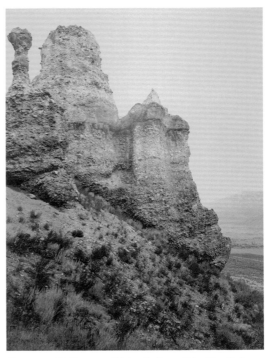
CARLETON E. WATKINS, *Witches Rock near Echo City, Utah*

Union Diggings, Columbia Hill, Nevada County, ca. 1871
albumen print
40.3 x 54.9 cm (15 ⅞ x 21 ⅝ in.) PLATE 30

In the early 1860s Watkins began photographing mines for cli-
ents who required views of geographic features as evidence in legal
cases involving land. *The Mining & Scientific Press,* always interested
in the content of such images, especially praised Watkins's work:
"[The pictures]...are really masterpieces of the photographic art,
and present the most perfect and life-like representations of hy-
draulic mining we have ever seen on paper." The *Press* was even more
enthusiastic about the utility of the photographs for the mining
industry itself: "The accurate distinctness with which [the sites]
are shown, in connection with the topography of the country, tim-
ber, etc., is really remarkable, and affords another instance of the
value of the photographic art in aiding the engineer to describe the
progress and condition of his work." When the mining operation
caused pollution and destructive flooding, Watkins's photographs
became the first used as court evidence in an environmental law-
suit.

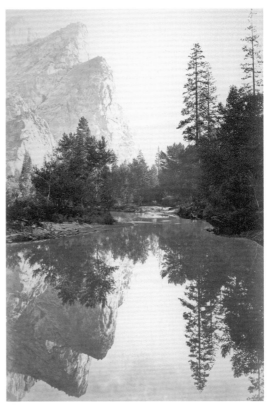
CARLETON E. WATKINS/I. W. TABER & CO.,
The Three Brothers, Yosemite

Witches Rock near Echo City, Utah, 1873
albumen print
54.3 x 41.6 cm (21 ⅜ x 16 ⅜ in.)
Gift of Dr. and Mrs. Charles T. Isaacs

In the winter of 1873–74 Watkins traveled to Utah with the
landscape painter William Keith. On this expedition his photo-
graphic wagon rode "piggyback" on a specially designed car on the
Union Pacific Railroad. A newspaper reporter described the trip:
"They chartered two railroad cars...one of which contained horses,

wagon, hay, and feed, while the other was supplied with all the
appointments requisite for domestic life." Along the way, Watkins
photographed geological formations, among them Witches Rock.

CARLETON E. WATKINS/I. W. TABER & CO.

The Three Brothers, Yosemite, ca. 1865–66/printed ca. 1875
albumen print
31.7 x 20.6 cm (12 ½ x 8 ⅛ in.)

The Grizzly Giant, Mariposa Grove, Yosemite, 1861/printed ca. 1875
albumen print
30.5 x 20 cm (12 x 7 ⅞ in.) PLATE 79

Yosemite Falls, ca. 1865–66/printed ca. 1875
albumen print
30.5 x 20.3 cm (12 x 8 in.)

ANNA K. WEAVER ACTIVE 1870S

No Cross, No Crown, 1874
albumen print of a photogram
26.3 x 21.5 cm (10 ⅜ x 8 ½ in.) PLATE 57

Like the intricate designs of mid-nineteenth-century cross-stitched embroidery samplers, Weaver's photograms—unique images made in the darkroom without a camera by arranging objects directly on photographic paper—incorporated phrases from hymns or Scripture. From her small Quaker town of Salem, Ohio, Weaver appropriately chose the title of a book by William Penn. As the Quaker founder of the proprietary colony of Pennsylvania, Penn sympathized with persecuted members of this religious group living in New Jersey and promised them religious freedom in his colony. *No Cross, No Crown*, an intricate arrangement of fern and plant leaves, suggests that the burdens one encounters in an earthly life will serve to deepen spiritual peace. Copied from the original photogram, a print of this image, like others made by Weaver in the 1870s, was sent to the Library of Congress in order to register copyright, suggesting that she hoped to make the images available for publication.

CHARLES LEANDER WEED 1824–1903

Mirror Lake and Reflections, Yosemite Valley, Mariposa County, California, 1865
albumen print
39.4 x 51.4 cm (15 ½ x 20 ¼ in.) PLATE 27

Weed, who moved west to Sacramento, California, in 1854, made his first photographs of the Yosemite region in 1859. His mammoth-plate views of the valley, however, were not made until 1865, possibly with Eadweard Muybridge working as his assistant. Employed by Lawrence and Houseworth, a photographic publishing firm, Weed produced views for a growing audience of tourists who had been exploring the Yosemite Valley since the mid-1850s.

Weed's photograph of Mirror Lake is, in fact, two landscapes: the sharp silhouette of mountain and tree line and a dreamier rendering of this subject reflected in the water. The sharp line of a dead tree branch defines the difference between "real" and "reflection." Both, however, convey the nineteenth-century reverence for sublime beauty.

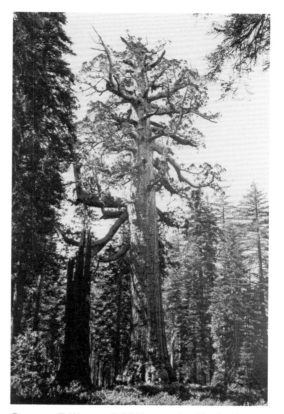

CARLETON E. WATKINS/I. W. TABER & CO., *The Grizzly Giant, Mariposa Grove, Yosemite*

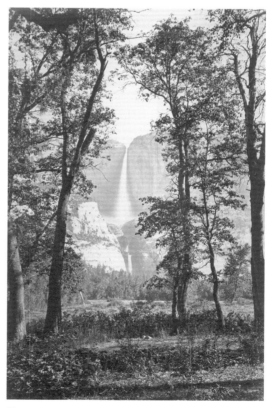

CARLETON E. WATKINS/I. W. TABER & CO., *Yosemite Falls*

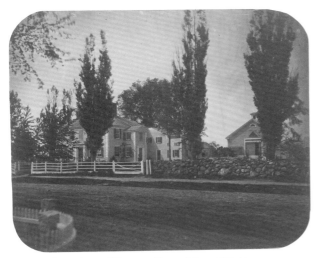

JOHN ADAMS WHIPPLE, *House of General Washington,*
Cambridge, Massachusetts

JOHN ADAMS WHIPPLE (ATTRIBUTED TO) 1822–1891

House of General Washington, Cambridge, Massachusetts, ca. 1855
salted paper print
23.5 x 29.2 cm (9 ¼ x 11 ½ in.)

An innovative member of photography's first generation, Whipple
attempted his first daguerreotype in the winter of 1840, "using a
sun-glass for a lens, a candle box for a camera, and the handle of a
silver spoon as a substitute for a plate." He experimented widely
with the photographic process. With his partner, James Wallace
Black, he developed the process for making paper prints from glass
negatives (crystalotypes). His photographs of the moon and
planets, made as early as 1848, were among the first taken of these
subjects.

 In addition to making portraits for the Whipple and Black
studio, Whipple photographed important buildings in and around
the Boston area, including the house occupied by General George
Washington in 1775 and 1776.

CLARENCE H. WHITE 1875–1925 MEXICO

Clarence H. White, Jr., ca. 1910
platinum print
23.5 x 17.2 cm (9 ¼ x 6 ¾ in.)

Before White was able to become a full-time artist and teacher, he
worked for nearly a decade in Newark, Ohio, balancing a book-
keeping job with his avocation as a photographer. Featured in the
third issue of *Camera Work,* White received international recogni-
tion for his work. His strength was composition, prompting one
critic to write: "Study White carefully for what he can teach you
about the proper adjustment of subjects to the spaces they occupy."
In 1906 he moved to New York and assisted Alfred Stieglitz in the
operation of his newly opened gallery.

 White's work often features his wife and children as models and
frequently captures an intimate moment. This study of his young

CLARENCE H. WHITE, *Clarence H. White, Jr.,*

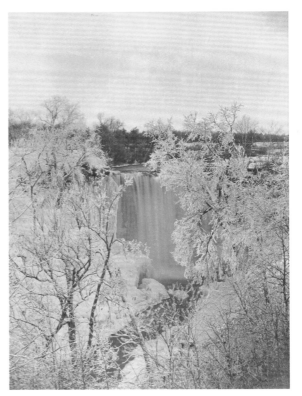

JOEL E. WHITNEY and CHARLES A. ZIMMERMAN,
Falls of Minnehaha in Winter

164

son combines the spontaneity of a family snapshot with the beauty of a well-made portrait. On the wall hangs a framed print of White's 1902 photograph *The Orchard*, a neat compositional balance to the child.

Rest Hour (Columbia Teachers College), 1912
silver print
24.8 x 19.7 cm (9 ¾ x 7 ¾ in.) PLATE 73

Best known as co-founder, along with painter Max Weber, of the Clarence H. White School of Photography in New York in 1907, White was a tireless teacher and advocate for the fine art of photography. The school's curriculum offered instruction in the various methods of photography, with particular emphasis on composition. Critiques of the students' work and lectures on photography were given by such well-known artists as Gertrude Käsebier, F. Holland Day, Edward Steichen, and Stieglitz. Among White's notable students were Laura Gilpin, Dorothea Lange, Ralph Steiner, and Doris Ulmann. For many years he was also a lecturer in art at Columbia Teachers College, where he took this picture in 1912.

FRANKLIN WHITE 1813–1870

Trapped Boulder, White Mountains, 1859
salted paper print
16.5 x 13 cm (6 ½ x 5 ⅛ in.) PLATE 28

Originally a landscape painter, White began to take photographs in the mid-1850s, focusing his camera on the White Mountains near his home in Lancaster, New Hampshire. Taking advantage of interest in a region that by the mid-nineteenth century had already begun to develop a tourist industry, White published several photographic and stereoscopic albums of his pictures in 1859 and 1860. These "viewbooks," as he called them, were among the first comprehensive attempts to document a specific region. They included close-up views of natural phenomena, such as the trapped boulder, as well as panoramic views of Mount Washington and the Franconia range.

JOEL E. WHITNEY 1822?–1886
CHARLES A. ZIMMERMAN 1844–AFTER 1873

Falls of Minnehaha in Winter, ca. 1870
albumen print
22.9 x 17.2 cm (9 x 6 ¾ in.)

Working together in St. Paul in the 1860s and 1870s, Whitney and Zimmerman are best known for their extensive series of views of the Minnehaha Falls. They produced both summer and winter views, black-and-white as well as with additional hand-coloring. Like Niagara Falls in the East, Minnesota's Minnehaha was a popular and evocative subject for mid-nineteenth-century photographers (see Alex Hesler).

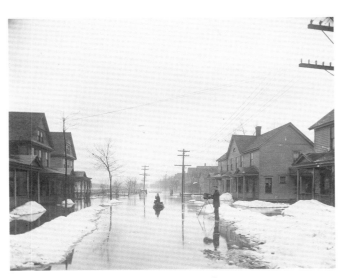

ZINTSMASTER STUDIO, *Flood, Herkimer, New York*

WILLIAMS STUDIO 1900?–1937?

A Group of Chairs, Haverhill, Massachusetts, ca. 1924
silver print
15.9 x 20.6 cm (6 ¼ x 8 ⅛ in.) PLATE 55

Born in England in 1877, Arthur H. Williams immigrated to the United States in 1893, listing his occupation as shoe cutter. By 1901 he had learned photography and subsequently operated the Williams Studio in Haverhill, Massachusetts, until 1937—the last year for which any official record of his studio exists. Williams concentrated on advertising photography for local businesses, for example, W. B. Spaulding, a shop specializing in the sale and reproduction of antique chairs. Perhaps because of poor lighting in the shop, this photograph was taken outdoors on a snowy street. The numbers, scratched directly onto the negative, would have referred to descriptions of each chair in the accompanying advertising copy.

ZINTSMASTER STUDIO 1885–1945

Flood, Herkimer, New York, 1910
silver print
20 x 24.5 cm (7 ⅞ x 9 ⅝ in.)

On February 28, 1910, a major part of Herkimer County in New York State was inundated. The first floors of houses were flooded, and streets were navigable only by boat. Though only nineteen, Albert P. Zintsmaster (1880–after 1920) took a photograph that describes the condition of the town as well as the ability and determination of the photographer to record the disaster. A similar Zintsmaster photograph was published in the Utica, New York, *Observer Dispatch*. It is an image both newsworthy and promotional, suggesting that the Zintsmaster Studio, which eventually grew to include Albert's nephew Daniel and his son Max, was available for every occasion requiring a photograph. It remained in business under the name Zintsmaster until 1945.

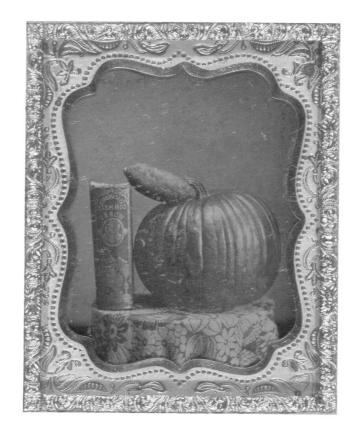

UNIDENTIFIED ARTIST
Still Life with Pumpkin, Book, and Sweet Potato, ca. 1855,
daguerreotype, ninth plate

Afterword

Somewhere on the long strand of DNA must sit a twisted little gene that turns otherwise normal people into collectors. Mine surfaced one day as a boy when I discovered, in a newly plowed field, an Indian arrowhead. This discovery led to my first collection, propelling me on a continuing search for objects and images of beauty and significance.

Such moments of recognition, of isolating something wonderful from its mundane surroundings, are the building blocks for any collection. In photography, where the pictures number untold millions, this process of selection is paramount.

Working as a young photojournalist, I discovered the critical importance of selection and editing. My artistic and expressive intentions led me to look carefully at the world and to think quickly and incisively about the moments frozen into photographs. I developed an understanding of what is necessary to make an image and acquired a sympathetic attitude toward the photographer who must mediate between the demands of art and commerce. The mental and visual lessons learned in that career have greatly influenced my choices as a collector.

In the mid-1970s I became interested in the history of my chosen medium and began gathering the pictures that became this collection. At that time, there were relatively few experts, histories, monographs, or other guides to the field. But as many people focused great energy and interest on photography and argued for its acceptance as an art form, the idea of collecting took hold.

For me, as for so many others, the first photographs that caught my attention were by Ansel Adams; my first major purchases were several of his large modern prints. But as my interest in the history of photography grew, I discovered the thrill of uncovering new images. I bought more and more nineteeth-century pictures, finding them at flea markets, auctions, bookstores, and, later on, specialist dealers. Intuition, vision, courage, luck, and hard work were as important as money. Within a few years, the Adams prints had been sold to fund purchases of prints by Talbot, O'Sullivan, and others. I was hooked; photography entirely took over my life.

Then, as now, there was greater interest in European works, primarily those that reflect the rich artistic and cultural traditions of France and England. I have long been fascinated by the arts, both foreign and homegrown, but pride in this country led me to surround myself with American things. Happily, few other collectors seemed as thrilled to acquire American photographs. Perhaps their familiarness made them easier to ignore, while the supposed sophistication and presumed rarity of European works seemed more compelling.

American work before the Photo-Secession was rarely considered a priority for serious collections. So it was possible for a novice to find and afford wonderful things. Despite the high prices paid for American furniture and painting from the same period, American photographs were generally unrecognized and, to my mind, undervalued in their homeland.

American pictures were, to a great extent, made for straightforward commercial or prosaic reasons by camera operators with few pretensions to being artists. At their best, a heightened sense of the power of the vernacular permeates them. To my eye, something in their unadorned, if sometimes surreal, honesty makes them appealing. At the same time, some photographers made pictures that are sublimely beautiful, inspired perhaps by the idea of art but just as surely by the beauty of their often still-wild and natural surroundings. This combination of understated lyricism and romance, with the oddball leavening of the commonplace, is what, to me, makes American photographs so unique.

It has proved to be notoriously difficult to categorize, define, or interpret the first century of photography in America in a traditional art-historical manner; European works fit more easily and elegantly into existing frameworks. Coming into photography without any grand theory, but with a naive and curious eye, I began gathering these pictures driven only by a sense of what I found compelling. With few exceptions, the pictures that most interested me were ones I had not seen before, that were not part of the existing canon of imagery.

When I began collecting, photography was considered to be an upstart medium. However, nurtured by a few pioneering curators, collectors, and dealers, a small group of zealots, primarily from my generation, carved out a vibrant, exciting field, with increasingly widespread acceptance. Many of us in that vanguard combined multiple roles; we were students, collectors, dealers, researchers, and cheerleaders all at once.

The last two decades have seen enormous changes in the way that photography is perceived. Those of us who became involved twenty or more years ago have watched it mature; exhibitions have drawn millions of people, scholarship has flourished, and the market has amazed everyone.

Our extraordinary success has limited the number of roles that any one person can fill. Though this has reduced some of the spontaneity, it has been replaced by delight in achieving the goal of legitimizing our chosen medium. It has been a challenge and pleasure to have been part of the process.

I have been fortunate to know many of those whose passion, knowledge, and connoisseurship made, and continue to make, this an exciting and collegial field.

John Szarkowski's writings, and later his good-humored generosity with ideas and time, have influenced me greatly. Sam Wagstaff's exhibitions and example encouraged alternatives to the classic histories. Cliff Ackley and Harry Lunn have, in very different ways, helped form my eye and career. Many other colleagues and rivals in the collecting and dealing fields have helped shape this collection in important ways; to all of those friends I am grateful.

My parents were courageous enough to trust me, all those years ago, to invest in the entirely unfashionable and untested project of making a photograph collection. Without their trust and love this collection would not exist. The love and pride my grandparents Martha and Louis Isaacs felt for this country, and their strongly held values, have helped shape both the collection and collector. Carol Nigro has been an inspirational sounding board, editor, and companion; her love, enthusiasm, and intellectual rigor are much appreciated.

Few collectors are fortunate enough to see their vision preserved intact. Even fewer see something they love so passionately become part of their country's cultural patrimony, at an institution whose goals and achievements they heartily endorse. For this I am deeply grateful to Elizabeth Broun, director of the National Museum of American Art, and to Merry Foresta, senior curator. Their visual and intellectual appreciation of this collection, their vision of the place of photography within the arts, and their persuasiveness will, I trust, enrich the lives of many people who will in the future share my love for these pictures.

—Charles Isaacs

Bibliography

American Daguerreotypes from the Matthew R. Isenburg Collection. Introduction by Matthew Isenburg and essay by Alan Trachtenberg. New Haven, Conn.: Yale University Art Gallery, 1989.

Bannon, Anthony, with C. Robert McElroy. *The Photo-Pictorialists of Buffalo.* Buffalo, N.Y.: Media Study/Buffalo, 1981.

_____. *The Taking of Niagara: A History of the Falls in Photography.* Buffalo, N.Y.: Media Study/Buffalo, 1982.

Barnes, Lucinda, with Jane K. Bledsoe and Constance Glenn, eds. *A Collective Vision: Clarence H. White and His Students.* Long Beach: University Art Museum, California State University, Long Beach, 1985.

Bastoni, Gerald, ed. *William Herman Rau: Lehigh Valley Railroad.* Essay by Stephen Perloff. Bethlehem, Pa.: Lehigh University Art Galleries, 1989.

Beck, Tom. *An American Vision: John G. Bullock and the Photo-Secession.* Foreword by William Innes Homer. New York: Aperture and the University of Maryland, Baltimore County, Albin O. Kuhn Library and Gallery, 1989.

Becker, William, and John B. Cameron. *Photography's Beginnings: A Visual History.* Albuquerque: University of New Mexico Press, 1989.

Bronner, Simon J. *Chain Carvers: Old Men Crafting Meaning.* Lexington: University Press of Kentucky, 1985.

Brown, Julie K. *Contesting Images: Photography and the World's Columbian Exposition.* Tucson: University of Arizona Press, 1994.

Bunnell, Peter. *The Art of Pictorial Photography, 1890–1925.* Princeton, N.J.: Princeton University Press, 1992.

Buerger, Janet E. *American Photography: 1839–1900.* Rochester, N.Y.: International Museum of Photography at George Eastman House, 1989.

Davis, Keith F. *George N. Barnard: Photographer of Sherman's Campaign.* Kansas City, Mo.: Hallmark Cards, Inc., 1990.

_____. *An American Century of Photography: From Dryplate to Digital.* Kansas City and New York: Hallmark Cards, Inc. and Harry N. Abrams, 1995.

Edkins, Diana E., and Beaumont Newhall, *William H. Jackson.* Essay by William L. Broecker. Dobbs Ferry, N.Y.: Morgan and Morgan, 1974.

Ehrens, Susan. *A Poetic Vision: The Photographs of Anne Brigman.* Santa Barbara, Calif.: Santa Barbara Museum of Art, 1995.

Featherstone, David. *Doris Ulmann, American Portraits.* Albuquerque: University of New Mexico Press, 1985.

Fels, Thomas Weston. *O Say Can You See: American Photographs, 1839-1939: One Hundred Years of American Photography from the George R. Rinhart Collection.* Cambridge, Mass.: MIT Press, 1989.

_____. *Watkins to Weston: 101 Years of California Photography 1849–1950.* Introduction by Derrick Cartwright and essays by Therese Heyman and David Travis. Niwot, Colo.: Santa Barbara Museum of Art and Roberts Rinehart Publishers, 1992.

Finkel, Kenneth. *Nineteenth-Century Photography in Philadelphia.* Philadelphia: Library Company, 1980.

Fleming, Paula Richardson, and Judith Lynn Lusky. *The North American Indians in Early Photographs.* New York: Harper & Row, 1986.

_____. *Grand Endeavors of American Indian Photography.* Washington, D.C.: Smithsonian Institution Press, 1993.

Foresta, Merry A., and John Wood. *Secrets of the Dark Chamber: The Art of the American Daguerreotype.* Washington, D.C.: National Museum of American Art and Smithsonian Institution Press, 1995.

Garner, Gretchen. *Reclaiming Paradise: American Women Photograph the Land*. Duluth: Tweed Museum of Art, University of Minnesota, 1987.

Gardner, Alexander. *Phototgraphic Sketch Book of the Civil War*. New York: Dover, 1959.

Goldberg, Vicki, ed. *Photography in Print: Writings from 1816 to the Present*. New York: Simon & Schuster, 1981.

Greenough, Sarah, Joel Snyder, David Travis, and Colin Westerbeck. *On the Art of Fixing a Shadow: One Hundred and Fifty Years of Photography*. Washington, D.C.: National Gallery of Art, 1989.

Gutman, Judith Mara. *Lewis W. Hine and the American Social Conscience*. New York: Walker, 1967.

Hafen, Leroy R., ed. *The Diaries of William Henry Jackson, Frontier Photographer*. Introduction and notes by Ann W. Hafen and Leroy R. Hafen. Glendale, Calif: Arthur C. Clark, 1959.

Hambourg, Marie Morris, et. al. *The Waking Dream: Photography's First Century*. New York: Metropolitan Museum of Art and Harry N. Abrams, 1993.

Himelfarb, Harvey, and Roger D. Clisby. *Large Spaces in Small Places: A Survey of Western Landscape Photography, 1850–1980*. Sacramento, Calif.: Crocker Art Museum, 1980.

Homer, William Innes, ed. *Pictorial Photography in Philadelphia: The Pennsylvania Academy's Salons, 1898–1901*. Philadelphia: Pennsylvania Academy of the Fine Arts, 1984.

Isaacs, Charles, and Carol A. Nigro, *The Strange and the Sublime: American Photography 1850–1920*. Bethlehem, Pa: Kemerer Museum of Decorative Arts, 1989.

Jackson, William Henry. *Time Exposure: The Autobiography of William Henry Jackson*. New York: G. P. Putnam, 1940.

Jareckie, Stephen B. *American Photography: 1840–1900*. Worcester, Mass: Worcester Art Museum, 1976.

Levine, Lawrence W. *Highbrow/Lowbrow: The Emergence of Cultural Hierarchy in America*. Cambridge, Mass.: Harvard University Press, 1988.

Manhood, Ruth, ed. *Photographer of the Southwest, Adam Clark Vroman 1856–1916*. Los Angeles: Ward Ritchie, 1961.

Mann, Margery. *Imogene!...Photographs 1910–1973*. Seattle: University of Washington Press, 1974.

McCabe, Mary Kennedy. *Clara Sipprell: Pictorial Photographer*. Fort Worth, Tex.: Amon Carter Museum, 1990.

Michaels, Barbara L. *Gertrude Käsebier: Her Photographic Career, 1890–1920*. Ph.D. diss., City University of New York, 1985.

Naef, Weston J., with James Wood, *Era of Exploration: The Rise of Landscape Photography in the American West, 1860–1885*. Essay by Therese Thau Heyman. Buffalo, N.Y.: Albright-Knox Art Gallery and New York Graphic Society, 1975.

Newhall, Beaumont. *The History of Photography, 1839–1939*, 5th ed. New York: Museum of Modern Art and New York Graphic Society, 1982.

Niles, John Jacob. *The Appalachian Photographs of Doris Ulmann*. Preface by Jonathan Williams. Penland, N.C.: Jargon Society, 1971.

Panzer, Mary. *Philadelphia Naturalistic Photography, 1865–1906*. New Haven, Conn.: Yale University Art Gallery, 1982.

Rabb, Jane M., ed. *Literature and Photography: Interactions 1840–1990*. Albuquerque: University of New Mexico Press, 1995.

Robinson, William F. *A Certain Slant of Light*. Boston: New York Graphic Society, 1980.

Rule, Amy. *Imogen Cunningham: Selected Texts and Bibliography.* Boston: G. K. Hall, 1992.

Sandweiss, Martha A., ed. *Photography in Nineteenth Century America.* Essays by Keith A. Davis, Sarah Greenough, Peter Bacon Hales, Barbara McCandless, and Alan Trachtenberg. Fort Worth and New York: Amon Carter Museum and Harry N. Abrams, 1991.

Szarkowski, John. *Photography Until Now.* New York: Museum of Modern Art, 1989.

Sichel, Kim. *Mapping the West: Nineteenth-Century American Landscape Photographs from the Boston Public Library.* Boston: Boston University Art Gallery, 1992.

Steichen, Edward. *A Life in Photography, Edward Steichen.* Garden City, N.Y.: Doubleday, 1963.

Sullivan, Constance. *Landscapes of the Civil War.* New York: Alfred A. Knopf, 1995.

Taft, Robert. *Photography and the American Scene,* 2nd ed. New York: Dover, 1964.

Tilden, Freeman. *Following the Frontier with F. Jay Haynes.* New York: Alfred A. Knopf, 1964.

Trachtenberg, Alan. *Reading American Photographs: Images as History, Mathew Brady to Walker Evans.* New York: Hill & Wang, 1989.

Travis, David. *Photography Rediscovered: American Photographs, 1900–1930.* New York: Whitney Museum of American Art, 1979

University of Arizona. *Forman Hanna: Pictorial Photographer of the Southwest.* Flagstaff: Northland Press, 1989.

Wagstaff, Sam. *A Book of Photographs from the Collection of Sam Wagstaff.* New York: Gray Press, 1978

Welling, William. *Photography in America: The Formative Years, 1839–1900.* New York: Thomas Y. Crowell, 1978.

Wilson, Michael. *Pictorialism in California: Photographs, 1900–1940.* Essay by Dennis Reed. Malibu and San Marino, Calif.: J. Paul Getty Museum and Huntington Library Art Gallery, 1994.

Wolf, Daniel, ed. *The American Space: Meaning in Nineteenth-Century Landscape Photography.* Introduction by Robert Adams. Middletown, Conn.: Wesleyan University Press, 1983.

Wood, John, ed. *America and the Daguerreotype.* Essays by Dolores A. Kilgo, John R. Stilgoe, David E. Stannard, Brooks Johnson, John F. Graf, Peter E. Palmquist, and Jeanne Verhulst. Iowa City: University of Iowa Press, 1991.

This catalogue was
designed and composed by Steve Bell for the
National Museum of American Art, Smithsonian Institution,
Washington, D.C. The typeface is Adobe Jenson.

The catalogue was printed by The Stinehour Press
in Lunenburg, Vermont. The paper is Monadnock
Dulcet, 100 pound text.